D0087129

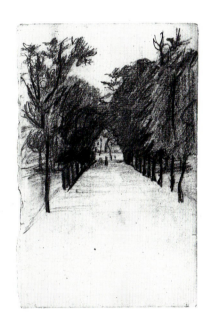

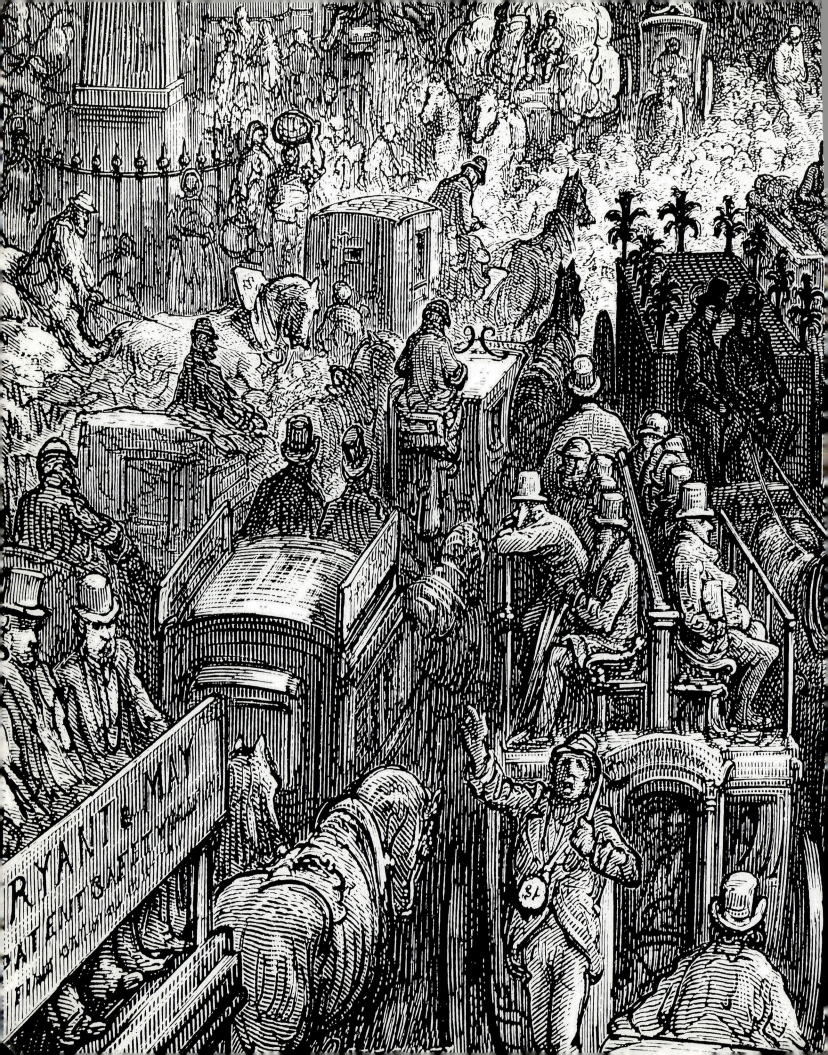

VAN GOGH

PORTRAIT OF THE ARTIST AS A YOUNG MAN

IN ENGLAND

Exhibition selected and introduced by

MARTIN BAILEY

Essay by

Debora Silverman

BARBICAN ART GALLERY

Barbican Art Gallery gratefully acknowledges the support of

The organisers are grateful to Her Majesty's Government for agreeing to indemnify the exhibition under the National Heritage Act 1980 and the Museums & Galleries Commission for their help in arranging this indemnity.

Published February 1992 in an edition of 4,000 copies on the occasion of Barbican Art Gallery's exhibition:
Van Gogh in England – Portrait of the Artist as a Young Man
27 February – 4 May 1992

Exhibition selected by Martin Bailey

Exhibition organised by Jane Alison and Brigitte Lardinois, Barbican Art Gallery

Catalogue edited by Jane Alison and Martin Bailey

Designed by Tim Harvey

Printed by BAS Printers, Hampshire

Catalogue distributed by Lund Humphries
ISBN 0 85331 617 1

Half-title: Vincent van Gogh: from the *Third Sketchbook for Betsy Tersteeg*, July 1874
(Rijksmuseum Vincent van Gogh [Vincent van Gogh Foundation], Amsterdam)

Frontispiece: Gustave Doré *Ludgate Hill* from *London – A Pilgrimage*, 1872 (detail) (cat.127)

Front cover: Luke Fildes *Houseless and Hungry*, 1869 (detail) (cat.84) and *Portrait photograph of Vincent van Gogh aged 19*, 1873
(Rijksmuseum Vincent van Gogh [Vincent van Gogh Foundation], Amsterdam)

Back cover: Vincent van Gogh *A Pair of Boots*, Autumn 1886 (cat.31)

Contents

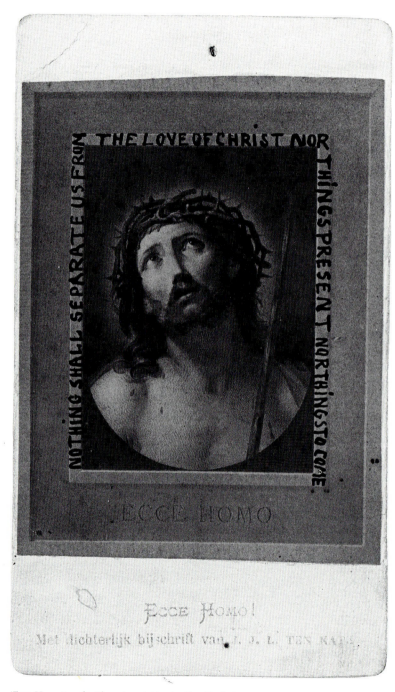

'Ecce Homo' card with an inscription by Van Gogh (cat.104)

Foreword

Van Gogh in England – Portrait of the Artist as a Young Man charts a significant and little considered part of the artist's life – the English years, 1873-76. In the exhibition, Van Gogh is presented as an impressionable and idealistic young man, a dislocated figure thrust into the teeming metropolis of Victorian London. Always travelling and searching for meaning and purpose in existence, Van Gogh came to view life as a pilgrimage, and along the way he began to empathise with the dispossessed, the labouring poor and the craft worker.

Van Gogh's letters home from London report experiences of love and travel as well as his passion for art. He eagerly immersed himself in the world of Goupil's, the art dealers for whom he went to work, and set about discovering English art, visiting the National Gallery and the Royal Academy. However, his admiration of Paul Delaroche and Ary Scheffer – their prints were sold through Goupil's and hung in Van Gogh's bedroom in Isleworth – testify not so much to the young man's love of art but to the intensity of his religious feelings. The inscription in English, 'Nothing shall separate us from the love of Christ', written by Van Gogh around Christ's head on the *Ecce Homo* card sent to his brother Theo, is one of the most arresting and telling of the items in this exhibition.

Van Gogh in England attempts to show in an intriguing and accessible way the significance of Van Gogh's personal experiences, his growing religious commitment and to set these within the context of English art and culture. Selected by Martin Bailey, a writer on *The Observer, Van Gogh in England* builds upon research work that culminated in his book, *Young Vincent* (1990). We are, however, indebted to Professor Ronald Pickvance whose exhibition and publication *The English Influences on Vincent van Gogh* (1974) laid the essential scholarly foundations. We also owe much to Julian Treuherz's exhibition, *Hard Times* (1987) which dealt in part with the influences on Van Gogh of the so-called 'Social Realists' and especially their illustrative work for the *Graphic* and *Illustrated London News* magazines.

Martin Bailey's research into Van Gogh's time in England emphasises the biographical. He describes how rejection in love cast a dark shadow on Van Gogh's life in England. By contrast, Debora Silverman's contribution to this publication offers a broader picture of the cultural climate which shaped the young artist's sensibility. She does this by first taking a specific case, that of Van Gogh's reading of Bunyan's *Pilgrim's Progress*. Van Gogh's own religious and philosophical position is set out in the sermon he gave in England in 1876, published here on p.116-7.

This exhibition would truly not have been possible without the encouragement, generosity and co-operation of the staff of the Rijksmuseum Vincent van Gogh, Amsterdam and the Rijksmuseum Kröller-Müller, Otterlo, in particular, Ronald de Leeuw, Louis van Tilborgh, Evert van Straaten and Johannes van der Wolk. We would like to express our appreciation to them and to all those people who have generously contributed to the exhibition. Martin Bailey has shown tireless commitment and enthusiasm at all stages of the exhibition's planning and we would like to express our warmest thanks to him for all his hard work and for the good natured and helpful way he has undertaken this collaboration.

John Hoole
Curator, Barbican Art Gallery

Jane Alison
Exhibition Organiser, Barbican Art Gallery

Preface

VINCENT VAN GOGH came to London in May 1873, at the age of twenty, to work for an art dealer in Covent Garden. His first year in England was to be the happiest of his entire adult life. He enjoyed discovering a new city, did well at work, and fell in love. Then misfortune befell him. He suffered the pangs of an unrequited love when his landlady's daughter rejected his advances. Van Gogh sank into a deep depression, his work suffered badly, and he was eventually sacked as an art dealer. He then became a teacher, first in Ramsgate and later in Isleworth. Turning to Christianity for solace, he preached his first sermon in Richmond Methodist Church. At Christmas 1876, nearly four years after his arrival, Van Gogh returned to Holland.

This exhibition and accompanying publication focuses on Van Gogh's period in England, presenting a 'portrait of the artist as a young man'. Van Gogh's later years, as an artist, have been examined in great detail in both books and exhibitions. In contrast, his early life, particularly his period in England, has been relatively neglected. As the Dutch scholar Abraham Hammacher pointed out, 'the early part of Van Gogh's adult life – his life as a non-artist – is of fundamental importance in relation to his work, and deserves as close study as the later, creative phase of his career.'

One of the highlights of this exhibition will be the chance to see Van Gogh's early drawings dating from his period in England. A substantial number of these sketches have survived, many of which have only recently come to light. Some have never been on show before and others are being brought back to England for the first time since the 1870s. The exhibition also explores the influence of Goupil's, where Van Gogh worked in Covent Garden. The gallery played a major part in shaping his early artistic tastes. When Van Gogh came to London he was

Vincent van Gogh *Austin Friars Church,*
November 1876 (cat.14)

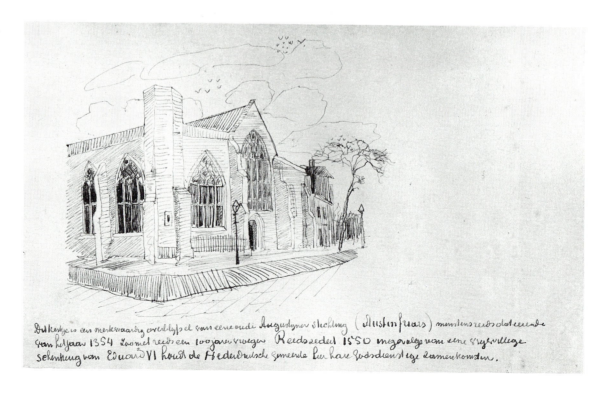

fascinated to find out more about contemporary English painters. To illustrate these important influences, the exhibition brings together many of the paintings which Van Gogh enjoyed at the Royal Academy.

The impact of Van Gogh's exposure to English culture was not always immediate. It was not until nearly a decade later in The Hague that he was attracted to the English Black-and-White illustrators who worked for the *Graphic* and the *Illustrated London News*. Similarly with literature, his love for Dickens deepened long after he had left England. Having been here at an impressionable age, and knowing fluent English, Van Gogh retained a great interest in England.

Van Gogh was the only major Post-Impressionist painter to be steeped in English culture. However, it would be wrong to over-emphasise the importance of English influences. The impact of Dutch and French culture on Van Gogh was obviously more important. Nevertheless, I believe that looking at the impact of English art and literature on Van Gogh sheds a revealing light. In particular, the work of English artists, illustrators and writers gave him great encouragement and stimulation in the early 1880s, when he set out to become an artist. I hope, therefore, that this exhibition will add a new dimension to our understanding and appreciation of Van Gogh.

I would like to thank all those who helped mount this exhibition, particularly the staff of the Barbican Art Gallery. John Hoole, the Curator, was enthusiastic right from the start and saw the potential of an ambitious show. Brigitte Lardinois was involved in the early planning stages. Joost Jonker undertook important research on Goupil's in The Hague and Paris. Above all, however, I would like to thank Jane Alison, who handled the complicated organisation of the exhibition with great flair and efficiency. It has been a pleasure and privilege to work with the Barbican Art Gallery.

I owe a great debt to Professor Ronald Pickvance, whose research on this period of Van Gogh's early life was invaluable. Among others who helped me in various ways were Dr Ronald de Leeuw, Dr Leo Ewals, Elaine Hart, Dr Jan Hulsker, Ralph Hyde, Stephanie Knapp, Lionel Lambourne, John Leighton, Jeremy Maas, Yoke Matze, Kathleen Maynard, Fieke Pabst, Debora Silverman, Julian Treuherz, Sjraar van Heugten, Louis van Tilborgh, Linda Whiteley, Christopher Wood, and Molly Woods. I would also pay special tribute to Jaap Woldendorp, who helped translate the unpublished Van Gogh family letters. Alison Booth provided great encouragement and support throughout the long preparations for the exhibition.

Van Gogh always regarded his life as a journey. Initially he saw it in religious terms, as a 'pilgrim'. After he rejected Christianity he turned to art, struggling to develop his potential. Van Gogh was also a traveller, always on the move. When he came to London he was leaving his youth behind and stepping out into the world as a man. This exhibition tells the story of the first part of his journey.

Martin Bailey

REFERENCES

References to Van Gogh letters are to the three-volume 1958 edition published by Thames & Hudson *(The Complete Letters of Vincent van Gogh)*. Volume and page numbers are given (e.g. [II 27], can be found in the second volume, page 27). The Dutch edition of the letters, published in 1990 *(De Brieven van Vincent van Gogh)*, contains some references missing from the English translation. Dating of the letters normally follows those given in the Dutch edition. Unpublished Van Gogh family letters, owned by the Van Gogh Foundation in Amsterdam, are referred to by their inventory number, prefixed by 'U' (e.g. [U 2747]).

Van Gogh's drawings, lithographs and paintings are referred to by the numbers given to them in the De la Faille and Hulsker catalogues, prefixed with 'F' and 'H'. Footnotes are given at the end of each chapter. For full references to books and articles, see Bibliography, pp.149-50. Where prints of paintings are illustrated in the text section, the date given refers to the original painting and not the print.

Chronology

30 March 1853
Birth of Vincent van Gogh at Zundert (Markt 26). He was the eldest son of Dutch Reformed Church pastor Theodorus van Gogh (1822-85) and Anna Carbentus (1819-1907), who had married on 21 May 1851.

17 February 1855
Birth of Vincent's sister, Anna van Gogh (d 1930).

1 May 1857
Birth of Vincent's brother, Theo van Gogh (d 1891).

16 March 1859
Birth of Vincent's sister, Elisabeth (Lies) van Gogh (d 1936).

16 March 1862
Birth of Vincent's sister, Wilhelmien (Wil) van Gogh (d 1941).

September 1861
Van Gogh attends the village school in Zundert (until summer 1862) and is then taught at home. Thirteen drawings (mostly copies) executed between January 1862 and February 1864 survive (as well as one from 1867).

1 October 1864
Attends Jan Provily's school at Zevenbergen (until August 1866).

3 September 1866
Attends state secondary school at Tilburg (until March 1868).

17 May 1867
Birth of Vincent's brother, Cornelis (Cor) van Gogh (d 1900).

March 1868
Van Gogh leaves school at Tilburg and returns to his family in Zundert.

30 July 1869
Starts work at Goupil's in The Hague (Plaats 14) as an apprentice, at the branch once owned by Uncle Vincent (Cent) van Gogh (1820-88). At Goupil's he works for

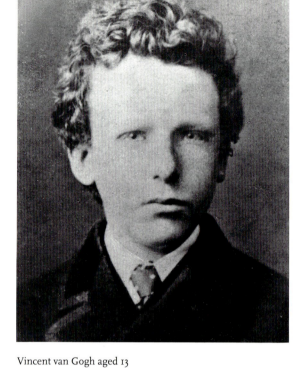

Vincent van Gogh aged 13

Hermanus Tersteeg (1845-1917). He lodges with the Roos family (Lange Beestenmarkt 32).

January 1871
Van Gogh's family moves to Helvoirt (Torenstraat 47).

1 January 1873
Theo van Gogh joins Goupil's as an apprentice at their Brussels branch. The branch had originally been owned by Uncle Hendrik (Hein) van Gogh (1814-77).

Early 1873
Van Gogh starts to draw again, mainly landscapes.

12 May 1873
Leaves for Paris, where he visits Goupil's head office, the Salon, the Louvre and the Luxembourg Museum before going on to London.

Vincent's father, Theodorus

Vincent's mother, Anna

Vincent's brother, Theo

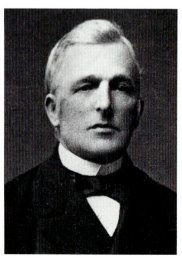

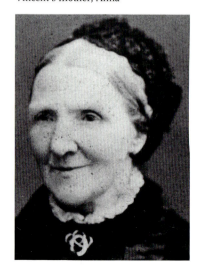

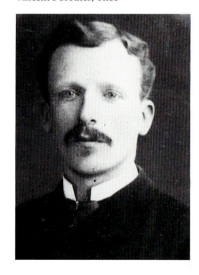

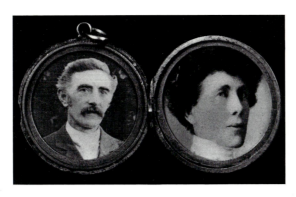

A gold locket with photographs of Samuel Plowman and Eugenie Loyer (cat.110a)

The English Years

c 19 May 1873
Starts work at Goupil's in London (17 Southampton St), for its manager Charles Obach. Lodges in the suburbs (address unknown).

June 1873
Visits the Royal Academy (RA) Summer Exhibition.

4 August 1873
Visits Dulwich Picture Gallery.

Late August 1873
Moves to new lodgings at the house of Ursula Loyer (c1815-95) and her daughter Eugenie (1854-1911). They run a small school at their home in Brixton (87 Hackford Road).

12 November 1873
Theo is transferred to Goupil's in The Hague, taking over the job previously done by his brother.

25 December 1873
Van Gogh spends Christmas with the Loyers.

February 1874
Eugenie Loyer becomes engaged to Samuel Plowman (1852-c1904). They eventually marry on 10 April 1878.

7 May 1874
Death of Van Gogh's grandfather Vincent, a retired pastor, at Breda (b1789).

Early June 1874
Van Gogh visits RA Summer Exhibition, where he sees *God Speed!* by George Boughton (1833-1905).

27 June 1874
Leaves for a short summer holiday with his family in Helvoirt.

15 July 1874
Arrives back in London, accompanied by his sister Anna.

3 August 1874
Visits Dulwich Picture Gallery with his sister Anna.

Early August 1874
Declares his love for Eugenie and faces rejection.

Mid August 1874
Moves to new lodgings in Kennington at the house of John Parker, a publican (Ivy Cottage, 395 Kennington Road).

c 23 August 1874
Anna van Gogh moves to Welwyn, where she takes up a job as an assistant teacher at Caroline Applegarth's

school (Ivy Cottage, High St). She lodges at Rose Cottage, High St.

c 2 November 1874
Van Gogh is transferred temporarily to Goupil's in Paris (9 rue Chaptal).

26 November 1874
Van Gogh's cousin Jet Carbentus (1856-94) marries Anton Mauve (1838-88), a leading Hague School artist.

c 24 December 1874
Van Gogh leaves Paris to spend Christmas with his family in Helvoirt.

c 2 January 1875
Arrives back in London. Goupil's takes over Holloway & Sons, moving into their gallery at 25 Bedford St.

January 1875
Visits RA Winter Exhibition of Old Masters.

17 January 1875
Death of French artist, Jean-François Millet (b1814).

22 February 1875
Death of French artist, Camille Corot (b 1796).

11 April 1875
Death of his landlady's daughter Elizabeth Parker, in Kennington.

24 April 1875
Sees *Chill October* by Millais at Christie's.

Early May 1875
Probably visits RA Summer Exhibition.

24 May 1875
Goupil's opens its first exhibition of Continental paintings at their new gallery, including *The Drawbridge* by Jacob Maris.

Late May 1875
Transferred to Paris for a second time, initially for two months. His stay in Paris is later prolonged until Christmas.

Mid June 1875
Sees Millet's drawings at the Drouot auction house.

15 August 1875
Anna van Gogh returns to Welwyn after a short holiday in Helvoirt. She is accompanied by their sister Wil, who attends Miss Applegarth's school. Wil stays until May 1876 and Anna until December 1876.

October 1875
Harry Gladwell (1857-1927), the son of a London art dealer, who also works for Goupil's, becomes a close friend of Van Gogh. Gladwell moves into Van Gogh's lodgings in Montmartre. They frequently visit the Louvre and Luxembourg Museum.

18 October 1875
The Van Gogh family moves to Etten (Roosendaalseweg 4).

24 December 1875
Van Gogh leaves Paris to spend Christmas with his family at Etten.

c 3 January 1876
Arrives back in Paris.

c 4 January 1876
Meeting with Léon Boussod (1826-1893) leads to Van Gogh's resignation from Goupil's, after three months notice.

87 Hackford Road, Brixton, London

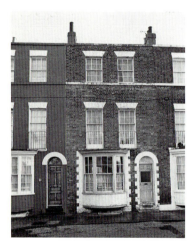

Spencer Square, Ramsgate, *c* 1900

11 Spencer Square, Ramsgate

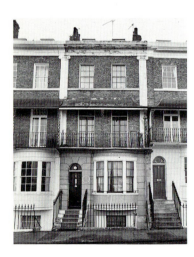

6 Royal Road, Ramsgate

Early January 1875
Van Gogh reads George Eliot's *Felix Holt*.

27 March 1876
Visits Durand-Ruel's gallery and buys a print of Millet's *Angelus*.

30 March 1876
Van Gogh's last day at work. Learns that he has been offered a teaching job at Ramsgate.

31 March 1876
Leaves Paris for a short holiday with his family at Etten.

16 April 1876
Arrives at Ramsgate, to take up a job as a teacher with William Stokes (*c* 1832-90). The school is at 6 Royal Road and he lodges nearby at 11 Spencer Square.

12 June 1876
Sets off to walk to Welwyn (via London) to visit his sister, Anna.

***c* 20 June 1876**
Arrives at Isleworth, where Stokes has moved his school (Linkfield House, 183 Twickenham Rd).

Late June 1876
Makes several visits to London and probably sees the RA Summer Exhibition.

Late June 1876
Visits Hampton Court and praises the Old Masters in the collection.

3 July 1876
Moves to the school of the Revd. Thomas Slade-Jones (1829-83) at Holme Court, 158 Twickenham Rd, Isleworth. Slade-Jones is a Congregationalist Minister with a church at Turnham Green (Chiswick High Rd).

17 August 1876
Visits London, including Gladwell family in Lewisham (114 Lee High Rd).

23 September 1876
Visits London, including Goupil's.

2 October 1876
Speaks at prayer meeting at Richmond Methodist Church (Kew Rd/Evelyn Rd). From then on regularly attends on Monday evenings.

7 October 1876
Visits London, including St Paul's Cathedral, Goupil's, French Gallery (120 Pall Mall), Cottier's Gallery (8 Pall Mall) and Gladwell's (20-1 Gracechurch St).

29 October 1876
Delivers first sermon at Richmond Methodist Church.

18 November 1876
Visits London, including Goupil's and the Loyer and Gladwell families.

19 November 1876
Accepted as a volunteer worker at Turnham Green Congregational Church. Attends Petersham Methodist Chapel (Petersham Rd).

4 December 1876
Attends Turnham Green meeting and agrees to visit pupils with a view to encouraging them to attend Thursday evening services.

***c* 20 December 1876**
Van Gogh and his sister Anna leave England.

The Later Years

21 December 1876
Arrives at Etten for Christmas. Van Gogh's parents urge him not to return to Isleworth.

***c* 1 January 1877**
Starts work at Blussé and Van Braam bookshop in Dordrecht (Voorstraat 256). Lodges at Tolbrugstraat Waterzijde 24.

14 May 1877
Moves to Amsterdam, where he stays with his Uncle Jan van Gogh (1817-1885) at 3 Grote Kattenburgerstraat. He studies Greek and Latin for university entrance.

16-17 July 1878
Visits Brussels with Revd. Slade-Jones to inquire about theological training.

24 August 1878
Abandons studies in Amsterdam and enrols for a short course at theological college at Laeken, near Brussels.

25 November 1878
Fails to qualify at Laeken Theological College.

Early December 1878
Leaves for the Belgian coal-mining area of the Borinage, becoming a preacher in Wasmes (near Mons). He lives at 221 rue du Petit-Wasmes

Summer 1879
Decides to try to become an artist.

August 1879
Moves from Wasmes to nearby Cuesmes, to work on his own as a preacher. He lodges with a miner, Charles Decrucq, at 3 rue du Pavillon.

***c* Mid 1880**
Theo is transferred to Goupil's in Paris.

August 1880
Van Gogh abandons missionary work to become an artist. Theo starts to support him financially.

October 1880
Moves to Brussels and enrols at the Art Academy. He

Holme Court, Isleworth

stays at 72 boulevard du Midi. Meets his artist friend Anthon van Rappard (1858-92).

April 1881

Returns to his family at Etten, where he continues to draw. From April 1881 to November 1882 he titles many of his most important drawings in English (including *The Bearers of the Burden,* and *Sorrow*).

August 1881

Falls in love with his cousin, Kee Vos (1846-1918). She immediately rejects his advances.

Late November 1881

Visits The Hague, where he soon meets the prostitute Sien Hoornik (1850-1904). Starts to paint, encouraged by Mauve. During this period Van Gogh is strongly influenced by the Black-and-White English illustrators.

c 1 **January 1882**

Moves into a small studio at 138 Schenkweg, where he lives with Sien and her five-year-old daughter Maria. Acquires back issues of the *Graphic*.

2 July 1882

Sien has a son, Willem. Van Gogh and Sien move next door to larger accomodation at 136 Schenkweg.

7 August 1882

Van Gogh's family moves to Nuenen (Berg 27).

Mid January 1883

Acquires a collection of the *Graphic* 1869-80, which is to inspire many of his own works during the course of the year.

11 September 1883

Breaks with Sien and leaves for Drenthe, in the north of the Netherlands, where he stays at Hoogeveen and Nieuw-Amsterdam.

5 December 1883

Returns to Nuenen.

May 1884

Because of tensions with his parents he rents his own studio in Nuenen at the house of Johannes Schafrat (Park 49).

September 1884

Margot Begemann (1841-1907), who lives in the house next to the parsonage, falls in love with Van Gogh. When he rejects her, she tries to commit suicide.

Winter 1884-5

Van Gogh paints a series of 'heads of the peasants', inspired by the *Graphic's* series of the same title.

6 March 1885

Father Theodorus van Gogh dies.

April 1885

Van Gogh finishes his first masterpiece, *The Potato Eaters.*

1 May 1885

Relations with his mother worsen, he leaves home and moves into his studio.

24 November 1885

Leaves for Antwerp, where he stays at 194 rue des Images.

18 January 1886

Enrols at the Art Academy in Antwerp.

c 1 **March 1886**

Arrives in Paris, where his brother, Theo, is manager of Goupil's branch at 19 boulevard Montmartre. They live together at Theo's flat at 25 rue Laval (now rue Victor-Massé). Van Gogh joins the studio of Fernand Cormon (1845-1924), where he meets Emile Bernard (1868-1941). His paintings become much brighter, under the influence of the Impressionists.

Early June 1886

Theo and Van Gogh move to 54 rue Lepic.

20 February 1888

Van Gogh arrives in Arles to set up his 'Studio of the South'. Takes a room at Hotel Carrel, 30 rue Cavalerie.

1 May 1888

Rents the Yellow House at 2 place Larmartine (although he does not sleep there until 16 September). In the meantime lodges at Café Ginoux, 30 place Lamartine.

23 October 1888

Paul Gauguin (1848-1903) joins Van Gogh in Arles.

November 1888

Van Gogh paints the 'empty chair' of Gauguin and himself, inspired by a print by Luke Fildes (1843-1927) of Dickens' chair.

Mid December 1888

Theo becomes engaged to Jo Bonger (1862-1925).

23 December 1888

Van Gogh mutilates his ear, following a row with Gauguin.

24 December 1888

Van Gogh is hospitalised (until 7 January 1889).

February 1889

Van Gogh is in hospital 7-17 February and again from *c* 25 February.

18 April 1889

Marriage of Theo van Gogh to Jo Bonger in Amsterdam.

8 May 1889

Van Gogh moves to the asylum of Saint-Paul-de-Mausole in Saint-Rémy-de-Provence. He suffers four major relapses over the next year.

31 January 1890

Birth of Vincent (1890-1978), son of Theo and Jo van Gogh

March-April 1890

Van Gogh paints *At Eternity's Gate*, based on an earlier lithograph of November 1882.

16 May 1890

Leaves St-Rémy and stays four days with Theo and Jo in Paris.

20 May 1890

Arrives at Auvers-sur-Oise, where he takes accomodation at Café Ravoux (place de la Mairie).

27 July 1890

Shoots himself in the stomach.

29 July 1890

Dies with his brother Theo at his side. Theo's mental and physical health quickly deteriorates, and he dies on 25 January 1891 in Utrecht.

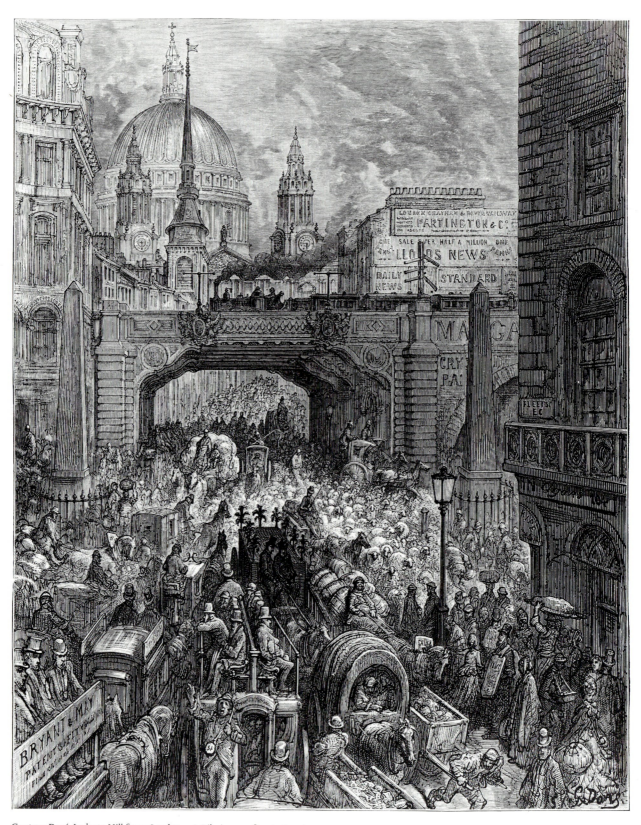

Gustave Doré *Ludgate Hill* from *London – A Pilgrimage*, 1872 (cat.127)

Discovering England

'I AM LOOKING FORWARD very much to seeing London, as you can imagine... It will be splendid for my English – I can understand it well enough, but I cannot speak it as well as I should wish,' he told his brother Theo, clearly excited by the prospect of coming to London. [I 3] Van Gogh was doing well as an assistant at Goupil's in The Hague, but their gallery in England was expanding and the new job represented a promotion. Equally important, he would have an opportunity to discover the English capital.

Van Gogh arrived in London in May 1873, a pleasant time of the year to explore the city. 'One of the finest sights I have seen is Rotten Row in Hyde Park, where hundreds of ladies and gentlemen ride on horseback. In all parts of the town there are beautiful parks with a wealth of flowers such as I have never seen,' he wrote back to friends in Holland. [I 9] Typically, however, Van Gogh was less interested in the conventional tourist attractions. 'I have visited neither Crystal Palace nor the Tower yet, nor Tussaud's; I am not in a hurry to see everything. For the present I am quite satisfied with the museums, parks, etc; they interest me more,' he explained. [I 11]

Art and nature were already the focus of his interest. On the August Bank Holiday Van

Charles Green *Holiday Folks at the National Gallery* (cat.88)

'This picture of London life represents a scene which may be observed any Saturday afternoon, when, owing to unfavourable weather, indoor amusements are specially in favour. The two figures in the centre represent a couple of Greenwich pensioners, who are gazing at Turner's picture of the death of Nelson.'
From the *Graphic Portfolio*, 1874

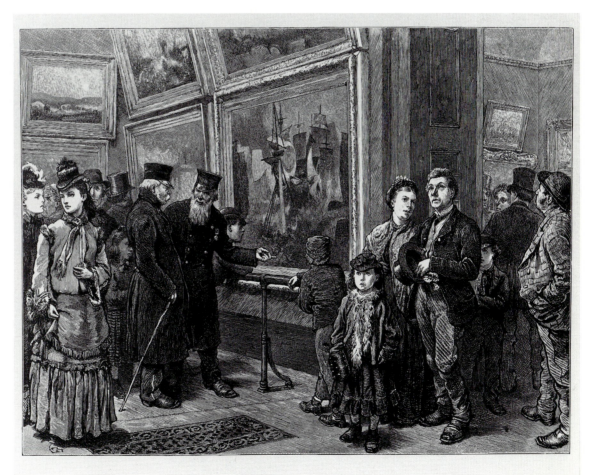

HOLIDAY FOLKS AT THE NATIONAL GALLERY.

DRAWN BY CHARLES GREEN.

Fig.1 *The New Rooms at the National Gallery*, showing the wing designed by Edward Barry which was opened in 1876. Published in the *Illustrated London News*, 19 November 1876.

Gogh went with one of the German boys from his lodgings to visit Dulwich Picture Gallery:

> *I went with one of the Germans to Dulwich, an hour and a half outside London, to see the museum there, and after that we took about an hour's walk to another village. The country is so beautiful here; many people who have their business in London live in some village outside London and go to town by train every day; perhaps I shall do the same shortly.* [I 11]

The bustle and pace of London could hardly have been in greater contrast to the sedate way of life Van Gogh had been accustomed to in The Hague. London's population had already reached four million and its sprawling suburbs were fast engulfing the outlying villages. The atmosphere of the British capital was skilfully captured by Gustave Doré in his *London – A Pilgrimage* (cat.127), a book which Van Gogh greatly admired. Published just the year before his arrival, Van Gogh later recommended Doré's illustrations to his brother, Theo, particularly those of 'the wharves of the Thames, Westminster, Whitechapel, the underground railway.' [I 92]

Doré's illustrations give a vivid impression of the city which the young Dutchman discovered. *London – A Pilgrimage* includes the famous historic sites, such as the Tower of London, Westminster Abbey and the Houses of Parliament. It shows the wealthy at play: in the stalls of the Covent Garden Opera, on horseback in Rotten Row, watching cricket at Lord's and dancing at the Mansion House. The sources of London's great wealth and the capital's trading role, as the hub of the largest empire the world had ever seen, are illustrated by warehouses lining the Thames, the crowded docks of St Katherine's, the bustling markets of Covent Garden and Billingsgate, as well as industrial premises such as the Lambeth Gas Works and the breweries of Southwark.

What perhaps comes over most powerfully in Doré's illustrations are the crowds, epitomised by a rush-hour scene in Ludgate Hill, with the road leading up to St Paul's Cathedral filled with a seething mass of pedestrians, carts and horse-drawn omnibuses. Another scene shows third-class passengers running for an already crowded carriage in the newly-completed underground railway which ran from Paddington to the City (fig.5). Alongside all this progress, Doré did not flinch from exposing the darker side of London life: the overcrowded houses beneath the railway arches, poverty in Seven Dials, Houndsditch and Whitechapel, orphans and flower girls, and homeless people waiting outside a night shelter (fig.7).

All of this added up to the great city that greeted Van Gogh. As he walked through London in his top hat, he must have realised that his £90-a-year salary put him among the privileged elite. An ordinary workman, with a family to support, might only receive a quarter of this sum. Despite his financial security, Van Gogh still had to fend for himself for the first time in a strange country. Just before his arrival, he confided in Theo: 'It will be quite a different life for me in London, as I shall probably have to live alone in rooms. I'll have to take care of many things I don't have to worry about now. I am looking forward very much to seeing London, as you can imagine.' [I 3]

His first lodgings were in the suburbs, but after three months he moved to Brixton, then a relatively well-to-do area on the southern outskirts of the capital. The house, at 87 Hackford Road, belonged to Ursula Loyer, a widow who ran a small school. 'I now have a room such I always longed for... I live with a very amusing family now; they keep a school for little boys,' Van Gogh told Theo. [I 13] From Brixton Van Gogh would walk the two miles to Goupil's, taking a route along the Thames Embankment for much of the way.

Van Gogh's sister-in-law later claimed that his first year in London was 'the happiest in his life' [I xxiv] and he himself later described the period as one of 'high spirits.' [II 320] The main

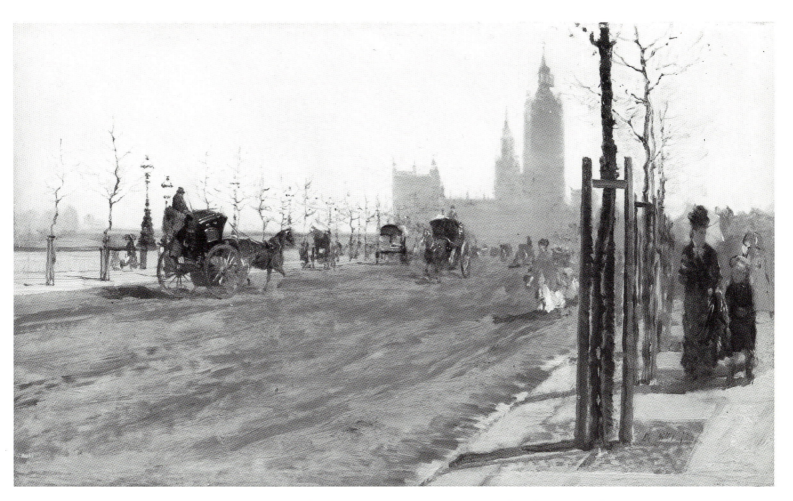

Fig.2 Giuseppe de Nittis *Westminster*, 1875. The Italian Impressionist artist sold his work through Goupil's.

'A few days ago we received a picture by De Nittis, a view of London on a rainy day, including Westminster Bridge and the Houses of Parliament. I used to pass Westminster Bridge every morning and every evening, and I know how it looks when the sun sets behind Westminster Abbey and the Houses of Parliament, and how it looks early in the morning, and in winter in snow and fog. When I saw the picture I felt how much I had loved London.'
Van Gogh to Theo, 24 July 1875 [I 30]

Fig.3 Vincent van Gogh: sketch of De Nittis' painting of Westminster and the Embankment included in his letter to Theo, 24 July 1875 [Fxxiii/I 31]

reason for Van Gogh's joy was Eugenie Loyer, his landlady's daughter. A cache of family correspondence, only recently opened up to scholars, gives the first indications of what happened at Hackford Road. Writing on 6 January 1874, Van Gogh's sister Anna told Theo that she suspected the two were in love.[1] The situation was complicated by the presence of another young suitor, Samuel Plowman, the previous lodger, who became engaged to Eugenie the following month. Eugenie continued to be friendly towards Van Gogh, who may well have interpreted this as something more. Throughout the spring, he still seems to have been optimistic about winning her back.

In July 1874, after a short holiday with his family, Van Gogh returned to Hackford Road with his sister Anna, who was looking for a job as a teacher. The Loyers were very welcoming, and Anna wrote back home, saying that Ursula and Eugenie were 'good people who are trying to make us as comfortable as possible'. She added: 'I wish you could visit me in my little room. Yesterday evening, Vincent put up a lot of prints. It is very nice and comfortable'. [U 2713] Nothing she said gave any indication of the problems that lay just ahead.

The crisis with Eugenie finally came to a head over the August Bank Holiday weekend. On the Friday Van Gogh wrote an enigmatic letter to Theo, suggesting that questions of love were on his mind. 'A woman is quite a different being from a man, and a being that we do not yet know,' he told his brother. Marriage, he added, could change this: 'Man and wife can be one, that is to say, one whole and not two halves'. [I 21-2] That week Van Gogh and his sister suddenly left Hackford Road. He then wrote an impassioned letter to Theo, questioning the importance of sexual purity: 'Virginity of soul and impurity of body can go together,' he insisted. [I 22]

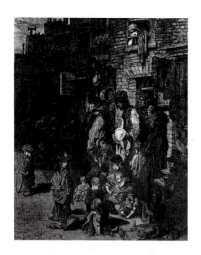

Fig.4 Gustave Doré *Wentworth Street, Whitechapel* from *London – A Pilgrimage*, 1872 (cat.127)

Fig.5 Gustave Doré *The Workman's Train* from *London – A Pilgrimage*, 1872 (cat.127)

Exactly what occurred over the Bank Holiday weekend remains a mystery. Eugenie was still friendly towards Van Gogh, and he seems to have again mistaken this for deeper sentiments. The tantalising scraps of evidence suggest that he wanted Eugenie to give up Samuel and marry him. It was not until seven years later that Van Gogh felt able to write openly to Theo about his feelings:

What kind of love did I feel when I was twenty?... I wanted only to give, but not to receive. Foolish, wrong, exaggerated, proud, rash – for in love one must not only give, but also take... I made that mistake once: I gave up a girl and she married another, and I went away, far from her, but kept her in my thoughts always. Fatal. [I 265]

In the middle of August Van Gogh and Anna moved to new lodgings at 395 Kennington Road, a mile north of the Loyers. Just over a week later Anna left, taking up a job as an assistant teacher at Welwyn. Van Gogh was now alone. It seems as though rejection in love made him look inwards and cut himself off from the outside world, which in turn had a disastrous effect on his work. He became a withdrawn and awkward employee. As Van Gogh's mother explained, 'he has turned himself away from the world and people.' [U 2729]

Van Gogh's family initially blamed his depression on the London fog, but it soon became clear that the problems ran much deeper. The directors at Goupil's decided that a change of scene might be the answer to the young man's depression and in early November 1874 they sent him for a few weeks to the gallery's head office in Paris. Van Gogh then went on to Holland to spend Christmas with his family.

At the beginning of January 1875 Van Gogh returned once more to London, but remained

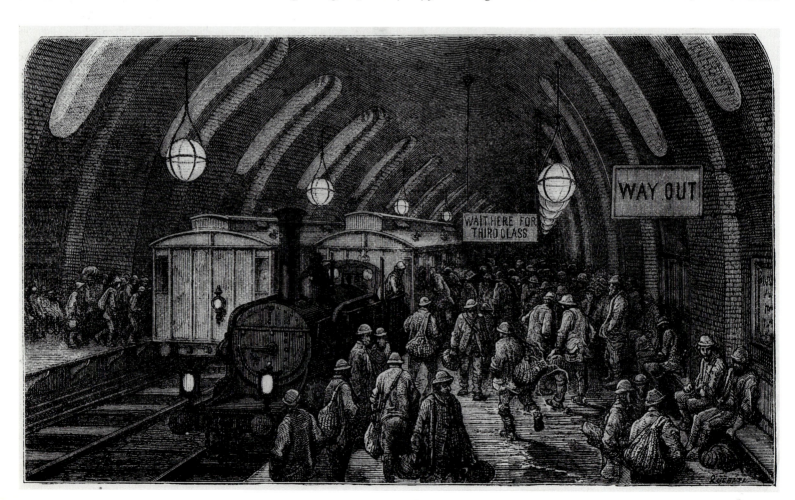

Fig.2 Giuseppe de Nittis *Westminster,* 1875. The Italian Impressionist artist sold his work through Goupil's.

'A few days ago we received a picture by De Nittis, a view of London on a rainy day, including Westminster Bridge and the Houses of Parliament. I used to pass Westminster Bridge every morning and every evening, and I know how it looks when the sun sets behind Westminster Abbey and the Houses of Parliament, and how it looks early in the morning, and in winter in snow and fog. When I saw the picture I felt how much I had loved London.'
Van Gogh to Theo, 24 July 1875 [I 30]

Fig.3 Vincent van Gogh: sketch of De Nittis' painting of Westminster and the Embankment included in his letter to Theo, 24 July 1875 [Fxxiii/I 31]

reason for Van Gogh's joy was Eugenie Loyer, his landlady's daughter. A cache of family correspondence, only recently opened up to scholars, gives the first indications of what happened at Hackford Road. Writing on 6 January 1874, Van Gogh's sister Anna told Theo that she suspected the two were in love.[1] The situation was complicated by the presence of another young suitor, Samuel Plowman, the previous lodger, who became engaged to Eugenie the following month. Eugenie continued to be friendly towards Van Gogh, who may well have interpreted this as something more. Throughout the spring, he still seems to have been optimistic about winning her back.

In July 1874, after a short holiday with his family, Van Gogh returned to Hackford Road with his sister Anna, who was looking for a job as a teacher. The Loyers were very welcoming, and Anna wrote back home, saying that Ursula and Eugenie were 'good people who are trying to make us as comfortable as possible'. She added: 'I wish you could visit me in my little room. Yesterday evening, Vincent put up a lot of prints. It is very nice and comfortable'. [U 2713] Nothing she said gave any indication of the problems that lay just ahead.

The crisis with Eugenie finally came to a head over the August Bank Holiday weekend. On the Friday Van Gogh wrote an enigmatic letter to Theo, suggesting that questions of love were on his mind. 'A woman is quite a different being from a man, and a being that we do not yet know,' he told his brother. Marriage, he added, could change this: 'Man and wife can be one, that is to say, one whole and not two halves'. [I 21-2] That week Van Gogh and his sister suddenly left Hackford Road. He then wrote an impassioned letter to Theo, questioning the importance of sexual purity: 'Virginity of soul and impurity of body can go together,' he insisted. [I 22]

Fig.4 Gustave Doré *Wentworth Street, Whitechapel* from *London – A Pilgrimage*, 1872 (cat.127)

Exactly what occurred over the Bank Holiday weekend remains a mystery. Eugenie was still friendly towards Van Gogh, and he seems to have again mistaken this for deeper sentiments. The tantalising scraps of evidence suggest that he wanted Eugenie to give up Samuel and marry him. It was not until seven years later that Van Gogh felt able to write openly to Theo about his feelings:

What kind of love did I feel when I was twenty?... I wanted only to give, but not to receive. Foolish, wrong, exaggerated, proud, rash – for in love one must not only give, but also take... I made that mistake once: I gave up a girl and she married another, and I went away, far from her, but kept her in my thoughts always. Fatal. [I 265]

In the middle of August Van Gogh and Anna moved to new lodgings at 395 Kennington Road, a mile north of the Loyers. Just over a week later Anna left, taking up a job as an assistant teacher at Welwyn. Van Gogh was now alone. It seems as though rejection in love made him look inwards and cut himself off from the outside world, which in turn had a disastrous effect on his work. He became a withdrawn and awkward employee. As Van Gogh's mother explained, 'he has turned himself away from the world and people.' [U 2729]

Van Gogh's family initially blamed his depression on the London fog, but it soon became clear that the problems ran much deeper. The directors at Goupil's decided that a change of scene might be the answer to the young man's depression and in early November 1874 they sent him for a few weeks to the gallery's head office in Paris. Van Gogh then went on to Holland to spend Christmas with his family.

At the beginning of January 1875 Van Gogh returned once more to London, but remained

Fig.5 Gustave Doré *The Workman's Train* from *London – A Pilgrimage*, 1872 (cat.127)

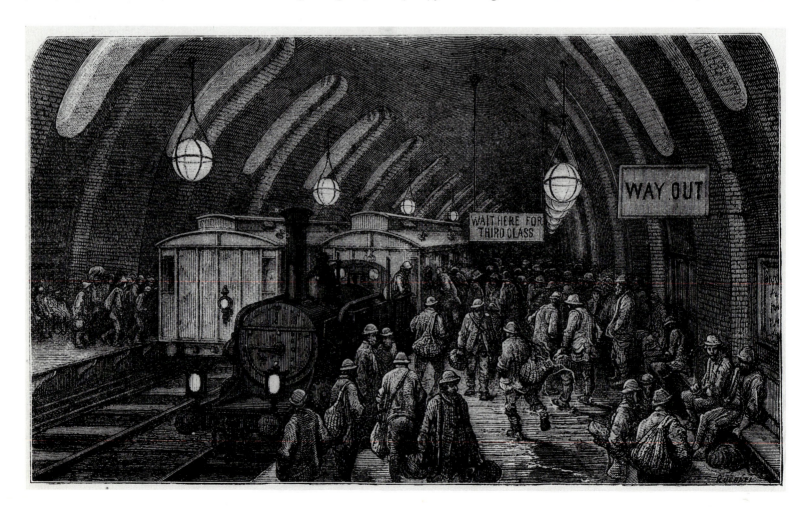

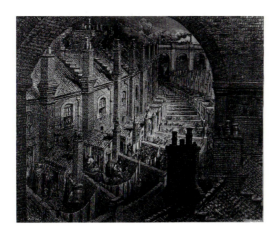

Fig.6 Gustave Doré *Over London – By Rail* from *London – A Pilgrimage*, 1872 (cat.127)

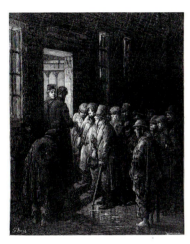

Fig.7 Gustave Doré *Refuge – Applying for Admittance* from *London – A Pilgrimage*, 1872 (cat.127)

1 Anna used a Dickensian parallel, saying that there was 'a love between those two as between Agnes and David Copperfield.' In the Dickens novel they are brought up together, although not brother and sister, and later marry. Anna added that between Vincent and Eugenie 'there is more than a brother's love between them'. [U 2679] For a more detailed account of Van Gogh's love affair, see *Young Vincent*, pp. 26-49.

in a melancholy mood, and the gallery became increasingly frustrated with his behaviour. Once again it was decided to send him to Paris, and at the end of May he was transferred for another two months. This was later prolonged, and he remained in France until the end of the year, when he returned to his family in Holland for Christmas.

On his return to Paris in January 1876 Van Gogh was summoned into the director's office and told he would have to hand in his notice, leaving in three months. Van Gogh's parents were very upset, but still wanted him to remain in the art world. His mother suggested that he look for work 'in one or other museum in London'. [U 2741] His father proposed that he consider 'opening a small art gallery' of his own. [I xxvi] However, during his time in England Van Gogh had become a committed Christian and what he really wanted was a post with the Church. Among his ideas were working as an evangelist in an English coal-mining town or going to Latin America as a missionary. [I 177, U 2756] More realistically, he applied for jobs as an assistant teacher.

On 30 March 1876, Van Gogh's last day at Goupil's, he was offered a post at a school in Ramsgate in return for board-and-lodging. After a short holiday in Holland he arrived in Ramsgate on 16 April. A few weeks later the headmaster William Stokes announced that he was moving his school to Isleworth, a village on the Thames, ten miles west of London. Van Gogh was persuaded to accompany Stokes, after being promised a small salary.

In the end, no salary proved forthcoming, and Van Gogh was fortunate in finding a paid post at a nearby school run by the Reverend Thomas Slade-Jones. There he was offered £15 a year, together with the opportunity of being involved in religious work at Slade-Jones' Congregational church at Turnham Green. Throughout that autumn Van Gogh's religious convictions grew, and he not only helped at the Congregational Church but also regularly attended Methodist churches in Richmond and Petersham. Christianity became Van Gogh's consolation after the rejection he had faced in love and the art business.

His salary as a teacher was very small compared with what he had earned at Goupil's, and he was forced to live a much simpler life. It was during this period that Van Gogh began to discover the 'darker side' of London. Occasionally his work involved being sent on errands to the poverty-stricken East End. On 18 November 1876, for example, he told Theo he was going to Whitechapel, 'that very poor part which you have read about in Dickens.' [I 75] There he saw at first hand the slums which he had seen in Doré's illustrations (fig.4,6 and 7).

Despite his job as a teacher, and his part-time church work, Van Gogh still felt unfulfilled. When he returned to Holland for Christmas at the end of 1876 his family found him moody and depressed, a lonely and isolated young man who had become deeply obsessed by religion. Van Gogh followed his parents advice and decided not to return to England.

Vincent van Gogh *Houses at Isleworth*, July 1876 (cat.13)

Early Drawings

Van Gogh's early drawings provide a fascinating insight into his period in England. These sketches, although executed in a conventional style, reveal much about his initial artistic interests. Some, in their sensitivity to line and atmosphere, already bear the signs of Van Gogh's later genius. Many of them are of motifs which came to dominate his later works.

It is only recently that the extent to which Van Gogh drew in his youth has become clear. Although a few early sketches were known, many previously unknown works have emerged since the 1950s. Unpublished family letters, which again have only recently become available, reveal details of lost drawings. This new evidence makes it possible to reconstruct Van Gogh's early artistic development, showing that he began to draw as a young boy and continued to do so for much of his early life.[1]

As a young child Van Gogh was probably encouraged to draw by his mother, who was a competent painter of flowers in her early twenties. Van Gogh's sister Elisabeth recalled that at the age of eight he gave his mother 'a sketch of a cat, who with wild leaps was trying to climb the apple tree in the garden'.[2] J. Franken, who grew up in Zundert, claims to remember seeing him 'draw pictures, with lead pencil, and at times in colours too'. [III 594] Van Gogh himself only once mentioned his childhood efforts, admitting that he 'made little sketches when a boy'. [I 222]

Van Gogh's earliest surviving drawings date from the ages of eight to ten, when he was in Zundert. These childhood works, mostly copies from drawing excercises, are very carefully executed.[3] After two years at boarding school at Zevenbergen Van Gogh moved to the Tilburg State Secondary School, where the well-known drawing master Constantijn Huysmans taught. One work by Van Gogh has recently been found from this period, a drawing of two farmers dated 1867 which was probably again a copy from an exercise book. There is then a gap of nearly six years until the main body of Van Gogh's surviving work begins, on the eve of his move to London. These adolescent sketches, unlike the childhood drawings, are mainly drawn from life, revealing much more about his artistic interests and ability.

Five works have been dated to early 1873, immediately before Van Gogh left for London. *Lange Vijverberg* (cat.4) depicts a view of the historic centre of The Hague, drawn just a minute's walk from Goupil's gallery. There are also three landscapes which reflect his early love of the Dutch countryside, a subject which had a deep personal significance and is central to his later art (cat.1,2 and 3). The last of the five is a copy of a humorous illustration by Félicien Rops of an elderly Breton woman in church, entitled *Waiting for Confession* (cat.5).

Just before leaving The Hague, Van Gogh filled a little book with amusing sketches for Betsy Tersteeg, the young daughter of his boss (cat.6). His choice of subjects, lovingly recorded, again reflects his interest in nature. A second sketchbook, dated 1873-74, was completed after he arrived in England.[4] These playful sketches reveal an amusing touch which rarely emerges in Van Gogh's later works.

The excitement of the move to London must have encouraged Van Gogh to record his impressions. Ten years later he recalled the frustrations of these early efforts: 'In London how often I stood drawing on the Thames Embankment, on my way home from Southampton

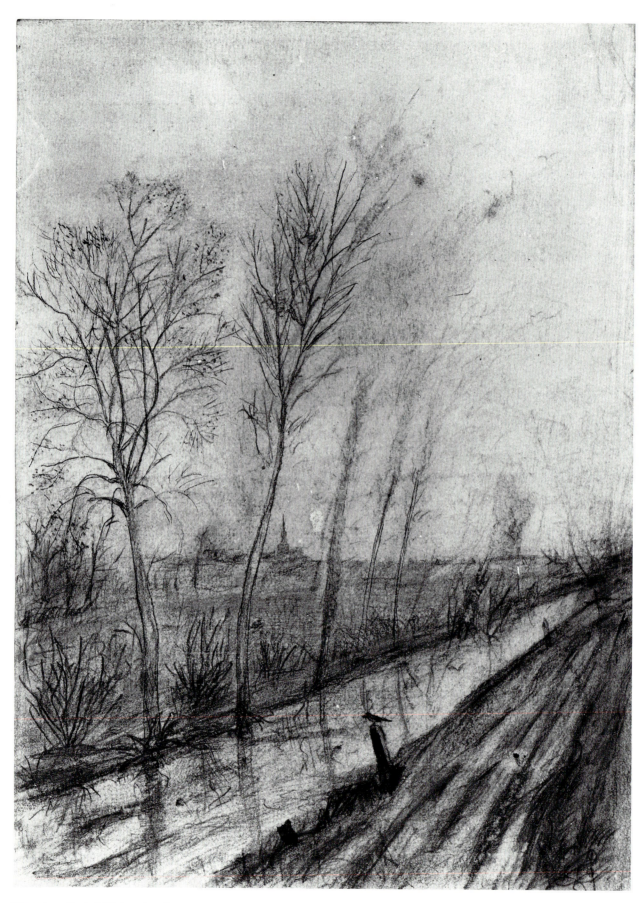

Vincent van Gogh *A Ditch*, spring 1873 (cat.3)

Street in the evening, and it came to nothing. If there had been somebody then to tell me what perspective was, how much misery I should have been spared, how much further I should be now!'. [II 163]

Working at Goupil's brought him in close contact with art. It was at the gallery, probably in the autumn of 1873, that he sketched a painting by George Boughton, *The Heir* (cat.60a). 'I saw it at the Royal Academy and later at Goupil's. At the time I admired it so much that I made a little sketch of it for an acquaintance in Holland,' he later explained. [III 345]

Van Gogh also made a number of drawings of the Loyers' house in Hackford Road. In November 1873, just a few weeks after moving in, he sketched both his bedroom and the exterior for his parents. 'Vincent sent us such a nice drawing of the street and the house where he lives and of the interior of his room so that we really can imagine how it looks,' his father told Theo. [U 2673] Although these two sketches are now lost, another drawing of Hackford Road was discovered in Devon in 1972, in the attic of one of Eugenie Loyer's granddaughters (cat.7).

In the spring of 1874 Van Gogh began to sketch more regularly. On 16 June he explained to Theo, 'lately I took up drawing again, but it did not amount to much.' [I 20] When he returned to Holland at the end of the month he took with him another drawing of the view from his

Vincent van Gogh: two drawings from the *First Sketchbook for Betsy Tersteeg*, spring 1873 (cat.6)

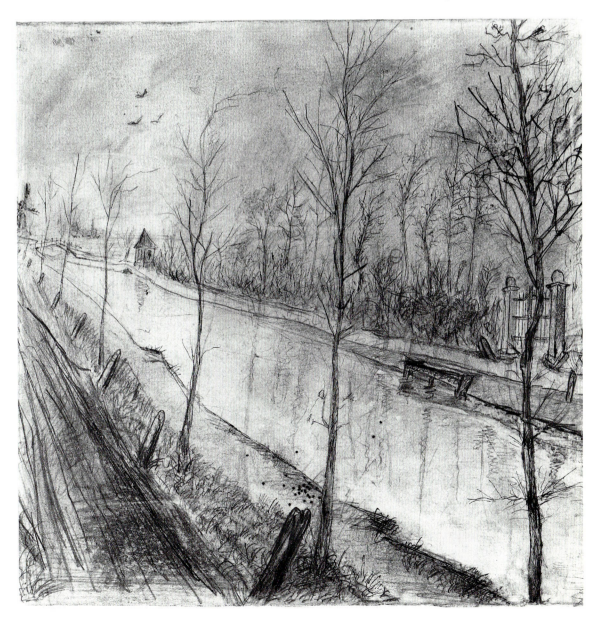

Vincent van Gogh *A Canal*, spring 1873 (cat.2)

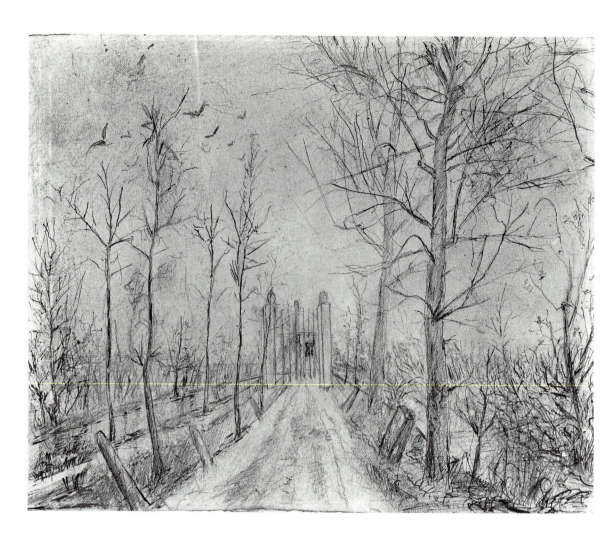

Fig.8 Vincent van Gogh: sketch of Corot's *Ville d'Avray: L'étang au batelier* [Fxx/I 25]

bedroom at Hackford Road, which his mother described as 'a large sketch of the houses which their window looks out on.' [U 2710]

During the few days that Van Gogh was on holiday he drew 'a great deal', according to his sister-in-law, Jo Bonger. [I xxv] Two surviving drawings are views of Helvoirt. The first, which is dominated by swirling trees in the foreground, shows his father's church (fig.9). The drawing is clearly the result of working direct from nature and the assured handling and fine composition anticipates Van Gogh's landscapes of the early 1880s. The second work is another view of the church, this time with a field and the woods behind. Van Gogh also drew what his mother described as a 'very nice' drawing of the parsonage where the family lived. [U 2710] Finally, during this busy holiday, Van Gogh filled a third sketchbook for Betsy Tersteeg.[5]

Although Van Gogh's parents are said to have later discouraged him from becoming an artist, they were obviously far more positive about his early attempts as an amateur. After his visit to Helvoirt, where he had spent much of his time with his sketchbook, Van Gogh's mother told Theo that drawing was 'a lovely skill which can be of much use.' [U 2710]

Two weeks after his return to London, following this energetic bout of sketching, Van Gogh wrote that 'my love for drawing has stopped, but perhaps I will take it up again some day or other'. [I 22] There is then a six-month gap in his surviving letters, making it difficult to know when he resumed drawing. The next extant work is from 18 April 1875, when Van Gogh sketched a copy of Camille Corot's etching *Ville d'Avray: L'étang au batelier* at the end of a letter to Theo (fig.8, cat.129). Van Gogh succeeds in bringing Corot's image to life, rather than slav-

Vincent van Gogh *Ramsgate*, May 1876 (cat.12)

ishly copying it. He loved Corot's work, which was later to be an inspiration for many of his own landscapes.

In the same letter Van Gogh also enclosed a drawing of Streatham Common, sadly now lost. When feeling depressed, sketching nature provided an emotional release. He told Theo about the drawing: 'I made it last Sunday, the morning when my landlady's little daughter died; she was thirteen years old. It is a view of Streatham Common, a large grassy plain with oak trees and gorse. It had been raining overnight; the ground was soaked and the young spring grass was fresh and green. As you will see, it is sketched on the title page of *Poésies* by Edmond Roche'. [I 25]

A month later Van Gogh was transferred to Paris. It was there that he saw *Westminster* (fig.2) by Giuseppe de Nittis at Goupil's, which had triggered off memories of his daily walk to work along the Thames Embankment. Van Gogh made a tiny sketch of the painting at the top of a letter to Theo on 24 July 1875 (fig.3). Interestingly, when Van Gogh copied the De Nittis, he exaggerated the height of the trees, emphasising the effect of the avenue leading towards Westminster.[6]

There is then an eight-month gap before Van Gogh's next known work, which was probably drawn in March 1876. At the back of a poetry book which he made for the Dutch artist Matthijs Maris, he sketched an elderly woman and two smaller portraits (cat.8). From Paris he went on to Etten, spending the first half of April with his family. There are two drawings from this holiday. The larger work shows the parsonage and his father's church (cat.9) and the smaller one depicts a similar view without the church (cat.10).

Two drawings survive from Van Gogh's two-month stay in Ramsgate, both are similar views looking out from the schoolroom window towards the sea (cat.11 and 12). We know from Van Gogh's letters that he particularly enjoyed this view, which must have brought back memories of Holland. At the end of May, Van Gogh sent his parents and Theo sketches of the nearby house in Spencer Square where he lodged. 'We received a letter from Vincent with a nice little drawing of his house,' his Mother reported to Theo. [U 2752]

Vincent van Gogh *Etten Parsonage*, April 1876 (cat.10)

Vincent van Gogh: portrait drawing from a notebook presented to Matthijs Maris, March 1876 (cat.8)

Van Gogh then moved to Isleworth and it was from there, probably on 5 July 1876, that he sent Theo a drawing of a house (cat.13). Three days later he sent another sketch which he asked Theo to pass on to Hille, a Bible teacher in The Hague. 'Tell him that I have become a schoolmaster and am looking out for some situation in connection with the church... And give him the enclosed little drawing from me,' he wrote. [I 63]

The remaining sketches from Van Gogh's period in England are of churches, reflecting his growing religious faith. One of his finest early drawings, dating from November 1876, shows Austin Friars, the Dutch church in the City of London (cat.14). His final drawings from England comprise two small sketches of churches at the bottom of a letter dated 25 November 1876 (fig.20), in which he wrote to Theo about his visit the previous Sunday to Turnham Green Congregational Church and the little Methodist Chapel at Petersham.

A month later Van Gogh returned to Holland. He continued to sketch, although only five drawings survive from the years 1877 to 1879.[7] This gives an added importance to the relative wealth of material from 1873-76. These add up to 18 individual drawings, 44 pages in the sketchbooks for Betsy Tersteeg, and at least 12 lost drawings which can be identified from letters. There must also have been many other sketches which have disappeared without trace.

The drawings from Van Gogh's English period vary considerably in quality, not surprisingly since they were presumably saved for 'sentimental' reasons. Van Gogh drew for his own pleasure, and as gifts for his family and friends. They were very personal works, done with little artistic pretension, and this gives them a freshness and vitality.

Van Gogh's choice of subject matter is revealing. The eighteen surviving individual drawings depict a wide range of motifs, but each has a strong personal significance. In this respect the drawings have interesting links with Van Gogh's later paintings. For instance, he often painted the houses where he lived, culminating in the magnificent view of the Yellow House in Arles. He continued to include churches in the background of many of his later works, long after he had abandoned Christianity; a few weeks before his death he painted the church at Auvers against a powerful blue-purple sky.[8]

There are a few tantalising suggestions that Van Gogh may have started to paint when he was in London, although no examples survive. In December 1883 Van Gogh wrote to his brother to say that when he had been at Goupil's 'both you and I then thought of becoming

Vincent van Gogh *Hackford Road*, spring 1874 (cat.7)

Fig.9 Vincent van Gogh *Church at Helvoirt*, July 1874 (Fxviii)

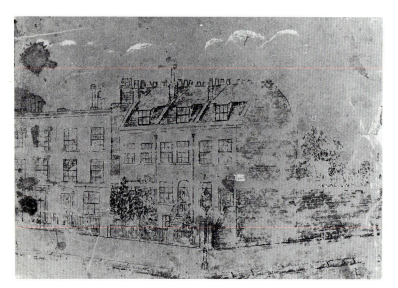

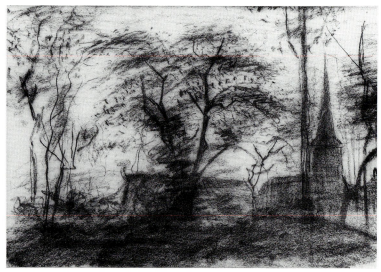

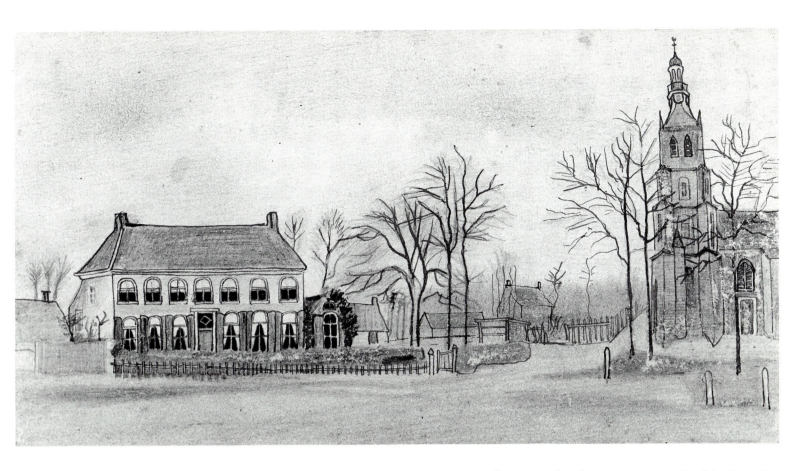

Vincent van Gogh *Etten Parsonage and Church*, April 1876 (cat.9)

painters, but so secretly that we did not dare tell even each other'. [II 239] Van Gogh's sister-in-law Jo Bonger later said that when Van Gogh was sacked from Goupil's, Theo 'had already at that time suggested Vincent's becoming a painter; but for the moment he would not hear of it'. [I xxvi] It is also claimed that when Van Gogh was in Paris in early 1876 he asked Matthijs Maris for advice on whether to become a painter and pursue 'the spiritual in art'. Maris replied that this would only lead to starvation.[9]

1 This is the first major exhibition of these early drawings. It includes all Van Gogh's surviving works from this period, with the exception of two sketchbooks which it has not been possible to borrow for conservation reasons (Tersteeg sketchbooks II and III), three drawings in letters which cannot be lent under the terms they were donated to the Van Gogh Foundation (Fxx, xxiii and xxviii), and two works in private collections (Fxviii and xix). Van Gogh's English drawings have only been shown in Britain on one occasion: four works were exhibited at London's Marlborough Gallery in May-June 1962 (Fxxiv, xxvi, xxvii and xxviii).

2 *Recollections*, p. 7.

3 These drawings, which date from January 1862 to February 1864, are Fi-xii. The Van Gogh Foundation also has a watercolour of a barn, dated 8 March 1862 (not in De la Faille). Fxiia, which dates from 1867, was acquired by Zundert Council in 1990. The authenticity of some of these works has been questioned (Tralbaut, p. 28-34). Van Gelder ('The Beginnings of Vincent's Art' and a revised version 'Juvenilia' in De la Faille) and

Szymanska are the only two important studies on Van Gogh's early drawings.

4 The second sketchbook includes the following drawings: a scarecrow; a dragonfly; stuffed birds under a glass case; a birdcage; a woman knitting in a room; a vase of flowers; a church; a horse and cart; a spider's web; a cat and a dog with a pipe, an insect and a snail; a doghouse and a carriage; a farmyard; a bird in a nest; and a chicken coop.

5 The two drawings of Helvoirt are Fxviii-xix. The third Tersteeg sketchbook has the following inscription by Van Gogh: 'My dear Betsy. I wanted to fill the whole book with drawings for you, but today Theo is leaving and I don't have time. Take it as it is, and when I return next year, I will do a new one. Next Monday I will go with my little sister Anna to London again, back to the house I have drawn for you, and then I will go again on the little steamboat which I have drawn.' The surviving sketches comprise: an avenue of trees (fig.21); a row of trees (fig.21); a woman, trees reflected in a canal, and the spire of Helvoirt church; a young child; and a crude sketch of a house.

6 *Westminster* was sold at Sotheby's on 19 October 1989. Van Gogh's sketch is Fxxiii.

7 *Mills near Dordrecht*, March 1877 (Fxxix, I 103), *Landscape with Bridge*, April 1878 (Fxxx, I 165), *'Au Charbonnage' Inn at Laeken*, November 1878 (Fxxxi, I 178), *Magros' House, Cuesmes*, late 1879 (Fxxxii) and *Zandmennik's House, Cuesmes*, late 1879 (Fxxxiii). It is also possible that *Coal Shovler* (F827) dates from July-August 1879, although it is more likely to have been drawn in the early 1880s. Van Gogh's illustrated map of the surroundings of Etten survives from July 1878 (I 173).

8 *The Yellow House*, September 1888 (F464/H1589) and *The Church at Auvers*, June 1890 (F789/H2006).

9 Fridlander, pp. 27-8.

Goupil print: Albert
Anker *Un vieux
Huguenot (*An Old
Huguenot), 1875
(cat.35)

*'A Swiss who has
painted a variety of
subjects, all equally
intimate and delicate
of feeling.'*
Van Gogh to Van
Stockum family,
October 1873 [I 15]

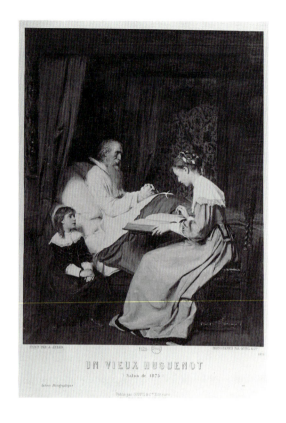

UN VIEUX HUGUENOT
(Salon de 1875)

Goupil print:
Constant Brochart,
*L'heureux anniver-
saire* (Happy
Birthday), 1872
(cat.39)

*'Here the ordinary
engravings after
Brochart do not sell
at all, the good burin
engravings sell pretty
well.'*
Van Gogh to Theo,
19 November 1876
[I 16]

Goupil print: Jules
Goupil *Un jeune
citoyen de l'an V*
(A Young Citizen
in the Year Five),
1873 (cat.46)

*'For a whole week I
have been thinking
of that picture and
the etching after it.
"A Young Citizen in
the Year Five" by
Jules Goupil. I saw
the picture in Paris,
indescribably beauti-
ful and unforgettable.'*
Van Gogh to Theo,
21 October 1877
[I 144]

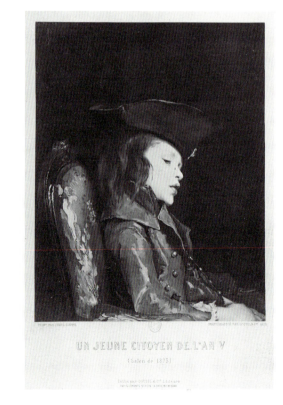

UN JEUNE CITOYEN DE L'AN V
(Salon de 1873)

Goupil print: James
Tissot *Mélancolie,
c*1868 (cat.58)

*'Some good French
painters live here,
including Tissot, of
whose work there are
several photographs
in our Galerie
Photographique.'*
Van Gogh to Theo,
20 July 1873 [I 10]

MÉLANCOLIE

Dealing in Art

Morin *Goupil's Gallery, Paris, c*1860 (cat.113)

Auguste Jourdain *Goupil's Gallery, Paris,* 1859 (cat.114)

right: Fig.10 Goupil's Gallery in The Hague, late nineteenth century

Fig.11 Advertisement for Goupil's first exhibition of paintings in London, from the *Athenaeum,* 22 May 1875

V AN GOGH could hardly have had a better start in the art business. When he joined Goupil's in The Hague, at the age of sixteen, it was already one of the world's leading art galleries. Established by Adolphe Goupil in Paris in 1827, the firm was at first a print publishing house, selling engravings of popular contemporary paintings. Their reproductions were of high quality and the company prided itself on using the very latest printing techniques. In the early years these were engravings, but from the 1850s Goupil's began producing elegant photographic reproductions mounted on card.[1] They also started to buy paintings for reproduction and gradually came to handle a wide range of original works. Goupils expanded, opening branches in The Hague, London, Brussels and New York. By Van Gogh's time they were probably the world's largest publisher of reproduction prints of paintings and one of the most successful galleries of contemporary original works.

Goupil's success was due to the fact it followed popular taste. The gallery soon became renowned for its paintings and prints of fashionable Salon works. Subject matter tended to be historical tableaux, classical scenes, religious works, genre pictures of family life, and many a risqué nude or semi-clad waif. From the 1860s Goupil's also branched out into the increasingly popular landscape paintings of the Barbizon School, and later the works of the Hague School. Its major artists were French, although they also handled works from Germany, Belgium, the Netherlands, Italy and Spain. Among its most successful painters were Jean-Léon Gérôme, Paul Delaroche, Adolphe Bouguereau, Ary Scheffer, and François Compte-Calix.

right: Goupil print: Ary Scheffer *Les saintes femmes au tombeau du Christ* (The Holy Women at the Tomb of Christ),1845 (cat. 56)

'How beautiful that engraving after Ary Scheffer, "The Holy Women at the Tomb of Christ", is – I am so glad I have it. The old woman is especially splendid.'
Van Gogh to Theo, 21 October 1877 [I 144]

far right: Goupil print: Rembrandt van Rijn, *Des pélerins d'Emmaus* (Pilgrims of Emmaus), 1646 (cat.52)

'The Rembrandt, 'The men of Emmaus', which I wrote to you about has been engraved; Messrs. Goupil & Co will publish the engraving... It looks fine, the figure of Jesus especially is beautiful, and the whole is noble.'
Van Gogh to Theo, 2 September and 7 September 1875 [I 33, 34]

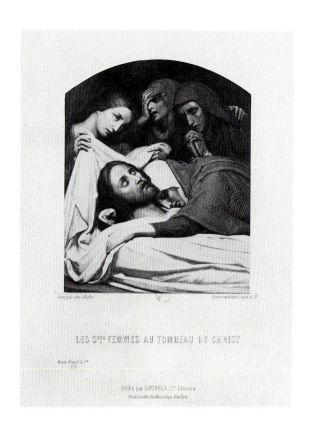

LES Sᵗᵉ FEMMES AU TOMBEAU DU CHRIST

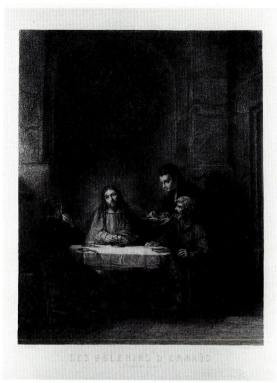

LES PÉLERINS D'EMMAÜS

When Van Gogh joined Goupil's in 1869 his decision to work for an art dealer stemmed not so much from artistic talent or interest, but simply because of family connections. His Uncle Vincent (known as Cent) had originally owned a gallery in The Hague (fig.10), which he had sold to Goupil's in 1861. Uncle Cent continued to oversee the gallery until 1872, when ill-health forced him to give up. He still retained considerable influence and was therefore able to suggest that his young nephew should be taken on. Theo also followed Van Gogh into Goupil's, joining its Brussels branch in January 1873. This gallery had originally been owned by Uncle Hendrik van Gogh, who sold out to Goupil's in 1872.

It was at Goupil's that Van Gogh began to appreciate the works of the Hague School, contemporary Dutch painters who concentrated on sober-coloured landscapes, fishing scenes and streetlife. By the late 1860s the Hague School artists were becoming increasingly popular and Goupil's handled some of their finest paintings. Van Gogh met many of the artists and became well-acquainted with their work. Among his favourite Hague School painters were Jozef Israëls, the three Maris brothers (Jacob, Matthijs and Willem) and Hendrik Weissenbruch. Van Gogh also developed personal ties with Anton Mauve, another leading Hague School artist who married his cousin Jet Carbentus in 1874. Seven years later it was Mauve who encouraged Van Gogh to become an artist and introduced him to oil paints.

In 1873, after nearly four years as an assistant in The Hague, Uncle Cent thought that it was time to widen the horizon of his young nephew. It was decided to send Van Gogh to the London branch which was expanding and needed more staff. Van Gogh left The Hague with excellent references. His boss, Hermanus Tersteeg, wrote to his parents, praising him and saying that everybody liked to deal with him: art lovers, customers and painters alike.

The London branch of Goupil's had been established in 1857 at 17 Southampton Street, between Covent Garden vegetable market and the Strand, and close to many other print sellers and art dealers. When Van Gogh arrived, Goupil's was still simply a wholesale agent, supplying prints for the British market and the occasional painting or drawing. Just before his arrival,

Van Gogh explained to Theo that 'in London, Goupil's has no gallery, but sells directly to art dealers.' [I 4]

Van Gogh's boss was Charles Obach, and his job was serving as his general assistant. As prints were still the main business in London, it was probably Van Gogh's responsibility to handle the engravings and photographic reproductions, taking wholesale orders from print sellers and then despatching the prints. On 19 November 1873 Van Gogh reported back to Theo: 'It is a pleasure to see how well the photographs sell, especially the coloured ones, and there is a big profit in them.' [I 16] Although Goupil's main emphasis was on contemporary art, it also published some Old Masters, such as Rembrandt's *Pilgrims of Emmaus* (cat.52).

Prints provided the core of the business, but plans were afoot to expand the sale of original paintings. On 19 November 1873 Van Gogh explained to Theo: 'Lately we have had many pictures and drawings here; we sold a great many, but not enough yet – it must become something more established and solid. I think that there is much work to do in England, but it will not be successful at once. Of course, the first thing necessary is to have good pictures, and that will be very difficult.' Characteristically, he added a note of uncertainty: 'Although the house [gallery] here is not so interesting as the one in The Hague, it is perhaps well that I am here. Later on, especially when the sale of pictures grows more important, I shall perhaps be of use.

below left: Goupil print: Jean Ingres *Venus Anadyomene*, 1848 (cat.48)

'From the "Venus Anadyomene" after Ingres we have already sold twenty épreuves d'artiste [artist's proofs].' Van Gogh to Theo, 19 November 1873. [I 16]

below right: Goupil print: Adolphe Bouguereau *Le jour* (The Day) 1848, (cat.37)

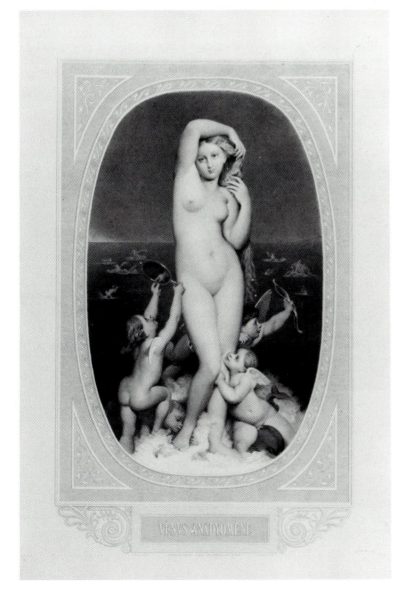

And then, I cannot tell you how interesting it is to see London and English business and the way of life, which differs so much from ours.' [I 16]

Van Gogh initially did well at his work. An unpublished letter from his father in January 1874 reveals that the directors of Goupil's in Paris had been 'so satisfied with Vincent's work that they have given him a rise.' [U 2683] It was to be an important year for the London gallery and plans were being laid for a major expansion programme. In July 1874 Van Gogh explained to Theo: 'Probably we are going to move on January 1, 1875, to take another, larger shop. Mr Obach is in Paris just now to decide whether we shall take over that other business or not.' [I 22] Soon afterwards it was announced that Goupil's was acquiring Holloway & Sons, a print seller based at 25 Bedford Street.

As a result of Van Gogh's depression, he was temporarily sent to the company's Paris head office at the beginning of November 1874, staying there until just before Christmas. He then returned to London at the start of the New Year. By this time Goupil's had already taken over Holloway & Sons. In February 1875 Van Gogh wrote to Theo in great excitement. 'Our gallery is ready now and is very beautiful, we have some splendid pictures: Jules Dupré, Michel, Daubigny, Maris, Israëls, Mauve, Bisschop, etc. In April we are going to have an exhibition. Mr Boussod [in Paris] has promised to send us the best things available,' he wrote. [I 23]

The inaugural exhibition finally opened on 24 May 1875 to critical acclaim. Commenting on the 160 paintings, the *Art Journal* gave it an excellent review:

Goupil print: George Boughton
Puritains allant à l'église (Puritans Going to Church), 1867 (cat.36)

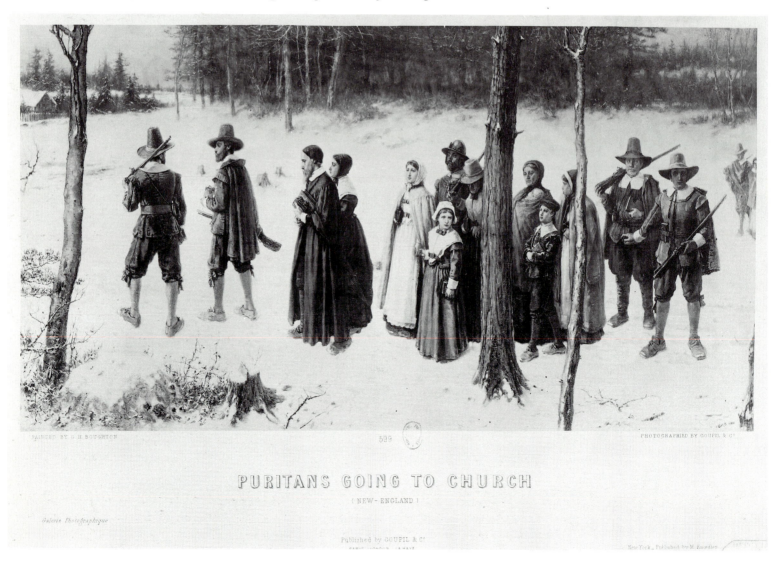

PURITANS GOING TO CHURCH
(NEW- ENGLAND)

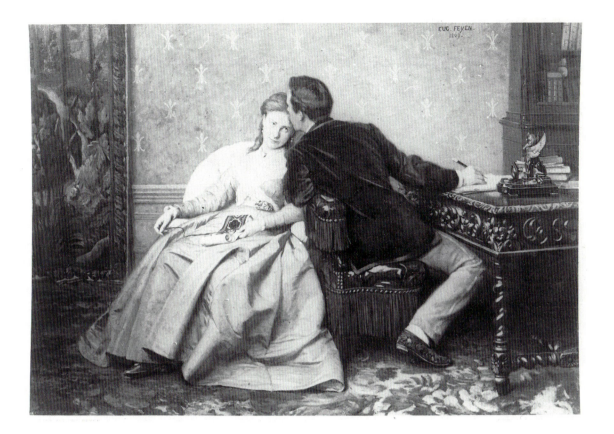

This is an exhibition of high-class Continental pictures by modern artists, the catalogue says; and when the visitor enters he finds that it is so. The name and reputation of such a house as Goupil & Co. would, of course, be sufficient guarantee that any collection of pictures identified with them must be such as art-lovers and connoisseurs would contemplate with profit and delight.[2]

At this very moment of triumph, Van Gogh was sent back to Paris yet again. Ever since his return after Christmas he had continued to be depressed. Now shy and awkward, he lacked the tact that is essential in the art trade and found it difficult to deal with customers. With the opening of the new gallery, and the change-over to a retail operation, these problems were magnified. It was therefore decided that he should go back to Paris, to work as a 'back-room' assistant.

Van Gogh left for Paris in the last week of May, probably a few days after the opening of the London exhibition. Another assistant called Tripp, who was working for Goupil's in Paris, was sent over for the exhibition and the swap was originally intended to last two months. 'For Vincent, it will be quite a disappointment that he cannot work in London, especially at this time,' his father explained to Theo on 24 May 1875. [U 2338]

Van Gogh went back to Goupil's head office at 9 rue Chaptal, where the printing office and main gallery were located. It was there that Van Gogh met Harry Gladwell, the eighteen-year-old son of an English art dealer who had been sent to Paris to gain experience. They spent much of their free time together, visiting art galleries, attending church services and reading. Van Gogh's initial two-month posting was later extended until Christmas, when he went home for a short holiday with his family.

On his first day back at work, probably 4 January 1876, he was summoned into the office of Léon Boussod, the son-in-law of Adolphe Goupil. Boussod expressed dissatisfaction with Van Gogh's behaviour and suggested that his employment would have to end. He was told to hand

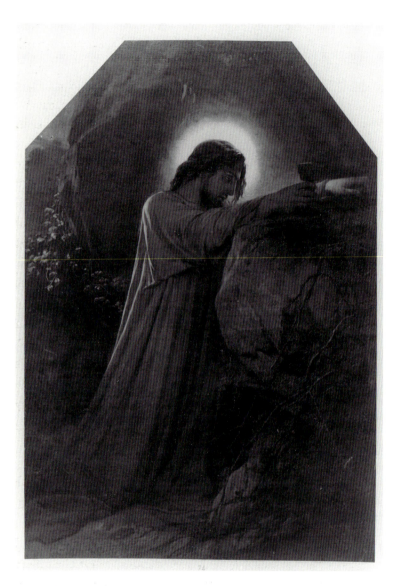

Goupil print: Paul Delaroche *Le Christ au Jardin des Oliviers* (Christ in the Garden of Olives) (cat.41)

'Anna is looking well, and you would like her little room as much as I do, with the... "Christ in the Garden of Olives"... framed in ivy.'

Van Gogh to Theo, 17 June 1876 [I 60]

Goupil print: Paul Delaroche *Mater Dolorosa* (cat.42)

'The photograph "Mater Dolorosa" which you sent me is hanging in my room. Do you remember, it was always hanging in Father's study at Zundert.'

Van Gogh to Theo, 16 March 1877 [I 98]

Goupil print: Jozef Israëls *Dialogue silencieux* (Silent Dialogue), 1882 (cat.49)

in his resignation. As he explained to Theo: 'In the end he [Boussod] forced me... to say that I would leave on the first of April, thanking the gentlemen for all that I might have learned.'[3] [I 45]

Van Gogh served out his three months notice and left Goupil's on 31 March 1876. By this time he had been with the gallery for seven years, not far off the ten years that he would later work as an artist. This long period at Goupil's had a profound influence on his early artistic taste. Evidence for this is a list of sixty contemporary artists whom Van Gogh named in a letter in January 1874 as those he liked 'especially'. Of this number, no less than 26 had their work published as Goupil prints in the period 1870-76.[4] [I 17]

Goupil's had hundreds of reproductions in print, and Van Gogh would therefore have become well acquainted with a wide range of popular Continental artists. At the time he admired these works, although he later began to despise much of this 'commercial' art. In March 1884 he criticised Goupil's for having ignored the paintings of Daumier and Millet before they became famous, and instead having concentrated on successful artists like Brochart and Delaroche. He commented with a touch of sarcasm: 'In Daumier's and Millet's younger days, Messrs G & Co. were busily occupied with... Julien Brochart and *Monsieur* Paul Delaroche.' [II 278] Despite Van Gogh's sneering tone, he himself had originally counted Delaroche among the artists he admired and he had even given his sister Anna a Goupil print of *Mater Dolorosa,* which she hung above her bed in Welwyn. [I 17, 84]

In June 1885 Van Gogh told Theo that 'of all I have learned and heard at Goupil & Co.'s *about* art, nothing has held true.' [II 387] Although he clearly rebelled against the Goupil orthodoxy, at the time he was working for them it held a powerful sway over him. Goupil's had a profound influence in shaping Van Gogh's attitudes towards the commercial art world, intensified by his brother's continued employment with the gallery. Theo worked for Goupil's in The Hague until 1880, when he was sent to Paris, and he was later promoted to manage their branch at 19 boulevard Montmartre. Van Gogh and his brother were not only extremely close, but Theo supported him financially. This meant that after Van Gogh was sacked by Goupil's he was, indirectly, financially dependent on the gallery for most of his life.

This complex situation created ambivalent feelings in Van Gogh. In December 1883 he admitted to Theo that 'Goupil & Co. has an influence on our family, a curious mixture of good and evil.' [II 221] There were moments, particularly when times were hard, when he wished he was back at Goupil's with a steady income. In 1889 he confessed to Theo: 'I often think that if I had done as you did, if I had stayed with Goupil's, if I had confined myself to selling pictures, I should have done better. For in business, even if you yourself do not produce, you make others produce. Just now so many artists need support from the dealers, and only rarely do they find it'.[5] [III 237]

1 Goupil's engravings published in the 1870s were in two main series, estampes-miniatures and the larger estampes-album. Goupil's photographs were sold in the following forms (dimensions in cm):
i) Carte Album: photograph 9 x 12, mount 11.5 x 16.
ii) Carte de Visite: photograph 6 x 9, mount 6.5 x 10.5.
iii) Galerie Photographique: larger photographs, in various sizes.
iv) Musée Goupil: photograph 9 x 12, mount 31 x 43.
v) Photographies d'après les grands maîtres: photograph 18 x 24, mount 45 x 63.
vi) Album de Photographies: photograph 13 x 18, mount 30 x 43.
Some photographs were hand coloured. This listing was compiled by the Musée Goupil, Bordeaux.

2 No copy of the catalogue seems to have survived (the British Library's copy was destroyed during the Second World War). The *Art Journal* review (August 1875) describes the most important paintings and many of the works are also mentioned in the *Athenaeum* (22 May 1875).

3 For a more detailed discussion of Van Gogh's dismissal, see *Young Vincent,* pp. 66-7.

4 Six names are inexplicably omitted in the English translation of the letter: Antigna, Zamacois, De Tournemine, Pasini, Schreyer and Wahlberg. Details of the artists published by Goupil's in 1870-76 are taken from a listing of the holdings of the Bibliothèque Nationale, Paris, prepared by Joost Jonker for the Barbican Art Gallery. Some of Van Gogh's favourite artists were probably published before 1870.
It is also perhaps no coincidence that Van Gogh's favourite English painter, George Boughton, was one of the few English artists handled by Goupil's.

5 Little has been published on Goupil's in later years. The gallery was renamed Boussod, Valadon & Cie in 1884 and it went through several changes of ownership until its dissolution in c1917.
In London, Obach later had problems with Goupil's directors. [II 171] In c1884 he left to set up his own print company, Obach & Co, based at 20 Cockspur St (it merged with Colnaghi in 1911, which for three years was renamed P & D Colnaghi & Obach). Also in 1884 Goupil's acquired West End premises at 116-7 New Bond St (which moved to 5 Regent St in 1894). The West End branch was managed by David Croal Thomson from 1884 to 1898.
In the late 1890s the Covent Garden and West End companies split. The original

Bedford St branch operated until the dissolution of the Paris company in c1918. The Regent St 'Goupil Gallery', run by William Marchant, survived until the 1930s.
An important new source of material on Goupil's has recently become available. In November 1991 the Goupil Museum in Bordeaux was opened at 40-50 cours de Médoc. It was established with a collection of prints and documentation donated by Guy Imberti, whose father had purchased Goupil's stock after the First World War.

Fig.12 Charles Cope *The Council of the Royal Academy Selecting Pictures for the Exhibition*, 1875 (Royal Academy of Arts, London)

The Great Room of the Royal Academy, with a group portrait of the Selection Committee for the 1875 Summer Exhibition. Among those present are the President, Sir Francis Grant (toward left of painting, seated and wearing a black top hat and holding gavel), Cope himself (a small figure just behind Grant, to the right), John Everett Millais (seated prominently at front, his top hat on the floor), and Thomas Faed (just above green table, in a dark brown jacket and with his hand on his chin).

The catalogue entry for the painting explained: 'The selection is made by the council for the year; all works sent in are brought before them, and are accepted, rejected, or made doubtful, the decision in every case being determined by a majority of votes, the President having the casting vote.' In 1875, 4,638 works were entered for the Summer Exhibition, of which 561 were accepted, 995 'made doubtful' and 3,082 rejected.

The selection process was then, as it still is today, controversial. It was in 1875 that a painter called John Soden published a highly critical pamphlet, *A Rap at the RA*, which included these famous lines:

The toil of months, experience of years,
Before the dreaded Council now appears..
Scarce time for even faults to be detected,
The cross is chalked; 'tis flung aside "REJECTED".

In 1876 Cope's painting was hung in the Summer Exhibition, having been given pride of place in the Great Room. When it was donated to the Academy the *Art Journal*, August 1876, commented: 'This an odd present, as it strikes us now... but a century hence it will be an authentic piece of history.'

Paintings at the Royal Academy

Fig.13 *The Royal Academy of Arts, Burlington House*, a view from the courtyard off Piccadilly. Published in the *Illustrated London News*, 30 May 1874. The Royal Academy had moved here from Trafalgar Square in 1869.

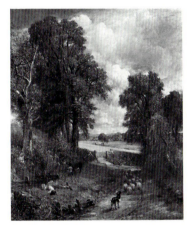

Fig.14 John Constable *Cornfield*, 1826 (National Gallery, London)

'I AM... CURIOUS TO SEE the English painters; we see so little of them because almost everything remains in England,' Van Gogh wrote to Theo a few weeks before he came to London. [I 4] With Goupil's specialising in Continental pictures, the young Dutchman hardly knew the artists working across the Channel.[1]

Two months after his arrival Van Gogh reported back to his brother:

At first English art did not appeal to me; one must get used to it. But there are clever painters here, among others, Millais, who has painted 'The Huguenot', 'Ophelia', etc, of which I think you know the engravings; his things are beautiful. Then there is Boughton, whose 'Puritans Going to Church' is in our Galerie Photographique; I have seen wonderful things by him. Among the old painters, Constable was a landscape painter who lived about thirty years ago; he is splendid – his work reminds me of Diaz and Daubigny. Then there are Reynolds and Gainsborough, whose forte was very beautiful ladies' portraits, and Turner, whose engravings you must have seen.[2] [I 10]

For the young Dutchman, who loved the countryside, Constable's landscape pictures had a special meaning. After a walk along the Thames near Isleworth he once described having seen a sky such as 'Constable would have painted.' [I 64] Nearly eight years later, when Theo was visiting London, Van Gogh urged him to go to the National Gallery. 'You must not forget a few very beautiful Constables there, including *Cornfield* (fig.14), nor that other one in South Kensington called *Valley Farm*.'[3] [II 300] Another English artist of the same era whom Van Gogh greatly admired was Richard Bonington. Also known for his landscapes, he had died in 1828 at the age of just twenty five. Van Gogh pasted a copy of Bonington's print *A Road* (fig.23) in a scrapbook of his favourite works.[4]

Despite Van Gogh's interest in the early nineteenth century landscape painters, he was also keen to discover contemporary English painters. He arrived in London at the best moment to do so, with the Royal Academy of Art's 105th Summer Exhibition having just opened. The RA's 'Exhibition of Works by Living Artists', as it was formally known, was the art event of the year. Over 300,000 visitors came annually to see the show (twice the number that it now attracts).

Four years before Van Gogh's arrival the Academy had moved to new premises in Piccadilly (fig.13). When he walked up the grand staircase of Burlington House into the galleries he would have found the walls densely packed with paintings, most of them in gilt frames and set against the rich red walls. Despite the large number of works on show, there was still tough competition to be accepted. The selection process, with paintings rapidly passing in front of the Academicians, is brought to life in Charles Cope's *The Council of the Royal Academy Selecting Pictures for the Exhibition* (fig.12). Those considered to be the best works were placed at eye level – unlike the pictures which were 'skied' – hung so high up that it was impossible to see them properly.

Van Gogh must have been struck by how different English art was from the pictures he knew from the Continent. As the *Illustrated London News* explained on 2 May 1874:

We have not at Burlington House, like our Gallic neighbours, scores of sprawling nudities, acres of battle-pieces, miracles of ingenious labour expended on boudoir trivialities and inanities, or the

costumes of galvanised historical dummies; we have not the specious dazzle of the latest Italian school; we have not a regiment of landscapes by painters, all, like the Germans, drilled to match; we have not the bourgeois insensibility to beauty and grace of much Belgian art: we certainly have a great deal of weak draughtsmanship and garish colouring; but the taste is not often irreclaimably artificial or dull, and scarcely ever indecent.

By the 1870s the walls of the Summer Exhibition were dominated by anecdotal genre paintings, depicting scenes of everyday life which epitomise what we now regard as the sentimental style of the Victorian period. Pre-Raphaelite works, which had been first shown a quarter of a century earlier, continued to be popular, although they were on the wane. Other artists, such as Frederic Leighton, worked in a Neo-classical style. Most controversial was a small group of radical artists who tackled Social Realist subjects. They concentrated on the 'darker' side of life, portraying poverty and death in Victorian Britain.

Van Gogh's first impression of the Royal Academy was negative. Writing to Theo on 13 September 1873, he said that the paintings were 'with a few exceptions very bad and uninteresting'. Two works he singled for special criticism. 'I saw one which represented a kind of fish or dragon, six yards long. It was awful. And then a little man, who came to kill the above-mentioned dragon. I think the whole represented "The Archangel Michael Killing Satan",' he explained. This was Edward Poynter's *Fight between More of More Hall and the Dragon of Wantley*, but Van Gogh's reference to the Archangel reveals that he had misunderstood its subject. The other painting he mockingly referred to as depicting 'about fifty black pigs and swine running helter-skelter down the mountain, and skipping over one another into the sea', a reference to Val Prinsep's *The Gadarene Swine*.[5] Van Gogh added that there was also 'a very clever picture by Prinsep', probably *Devonshire House* (cat.79). [I 14]

By the following summer, Van Gogh had a deeper understanding of the London art scene and his impressions were more positive. 'There are beautiful things in the Royal Academy this year. Tissot has three pictures there,' he told Theo in June 1874. [I 20]

Print of George Boughton's *The Heir*, 1873 (cat.60a)

THE HEIR PRESUMPTIVE.
(From the Picture by George Boughton, A.R.A., in the Corcoran Institution, New York.)

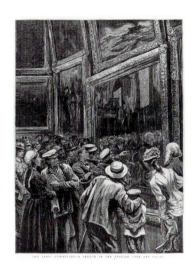

Charles Roberts *The Paris Exhibition – A Sketch in the English Fine Art Court.* Published in the *Graphic*, 29 June 1878 (cat.98)

The illustration shows a crowd looking at Hubert Herkomer's *The Last Muster*.

Fig.15 James Tissot *London Visitors*, 1874 (Toledo Museum of Art)

Van Gogh does not mention the next two Summer Exhibitions in his surviving letters. The 1875 show opened on 3 May, and although he left for Paris in late May it is difficult to believe that he would have missed what was the art event of the year. It is less clear whether Van Gogh visited the 1876 show. When it opened on 1 May, he was teaching in Ramsgate, but he had several opportunities to see it. In mid-June he passed through London on his way to visit his sister Anna in Welwyn. After he moved to Isleworth he made several trips to London before the exhibition closed on 7 August. It is therefore almost certain that he visited the 1875 exhibition and probable that he also saw the 1876 show.[6]

The artist whom Van Gogh saw at the Academy who had most impact on him was undoubtedly George Boughton. Born in Norwich in 1833, Boughton had spent his early years in America and France before settling in London in 1862. Known for his historical themes and atmospheric landscapes, he was among the few English artists handled by Goupil's. Today his paintings appear overly sentimental and his work is now largely forgotten.

Boughton's only painting at the 1873 exhibition was *The Heir* (cat.60a), depicting a woman in black walking with a young boy through an estate. Van Gogh was so excited by the picture that he made a little sketch of it for a friend in Holland. [III 345] The following summer it was again a Boughton painting, *God Speed!* (cat.59), which left the strongest memories. Two years after seeing this landscape with its procession of pilgrims he wrote a lyrical description of it and concluded, 'truly, it is not a picture but an inspiration.' [I 66] A few weeks later Van Gogh referred to the painting in his first sermon, using it to explain his view of life as 'a pilgrim's progress'. Boughton's works at the 1875 Summer Exhibition included *The Bearers of the Burden* (cat.60), depicting three women with bundles and a child, trudging along a path. The title must have impressed Van Gogh, who six years later used it on a drawing he made of coal-miners' wives in the Borinage (cat.15).

The only artist whom Van Gogh singled out by name from the 1874 exhibition was James Tissot. Born in France, Tissot had fled to London in 1871 at the time of the Paris Commune and eventually stayed for eleven years. During this period he became part of the English art scene, becoming known for his pictures of elegant women. Tissot's three paintings at the 1874 exhibition were *The Ball on Shipboard* (cat.81) *London Visitors* (fig.15) and *Waiting*.[7]

The third major artist at the Academy whom Van Gogh admired was John Everett Millais. Van Gogh had liked his early Pre-Raphaelite pictures,[8] as well as his bleak landscape, *Chill October* (cat.75). By the early 1870s Millais had adopted a more conventional style and was among the most successful English painters, dominating the Summer Exhibitions. His most important painting in the 1874 show was *The North-West Passage* (cat.77), portraying an elderly captain reminiscing to his daughter.

Boughton, Tissot and Millais were very much in the mainstream of Victorian art, evidence of Van Gogh's highly conventional taste. By contrast he was later to develop a passion for the Social Realists, who caused such a scandal in the 1870s. Among these artists were Luke Fildes, Frank Holl and Hubert Herkomer. Although Van Gogh only names these painters in his later letters, their pictures were to have a profound influence on his own work in the early 1880s. In particular, their subject matter was to encourage Van Gogh in his attempts to portray 'low life' in The Hague.

The Social Realist movement of the 1870s is epitomised by *Applicants for Admission to a Casual Ward*, exhibited in 1874 by Luke Fildes (fig.17, cat.63). A special railing had to be installed to hold back the crowds who wanted to see this sombre-coloured painting of a queue of homeless people outside an overnight shelter on a cold winter's night. Although the following

John Everett Millais *Winter Fuel*, 1873 (cat.76)

'*Bare ruined choirs, where once the sweet birds sang*' (*Sonnets*, 73) Quoted alongside the painting at the Royal Academy in 1873.

John Everett Millais *Chill October*, 1870 (cat.75)

'"*Chill October*" was painted from a backwater of the Tay just below Kinfauns near Perth. The scene, simple as it is, had impressed me for years before I painted it... I made no sketch of it, but painted every touch from Nature, on the canvas itself, under irritating trails of wind and rain.'

John Everett Millais, 18 May 1882

year Fildes showed *Betty* (cat.64), a conventional picture of a smiling milkmaid, in 1876 he bravely tackled the theme of death in *The Widower* (cat.65).

Frank Holl also made his name as a Social Realist, showing at the Royal Academy oil paintings of earlier Black-and-White images engraved for the *Graphic*. In 1873 he exhibited *Leaving Home,* depicting a forlorn young woman and a soldier waiting outside a third-class railway waiting room (cat.70). This probably inspired Van Gogh's own attempts to paint third-class waiting rooms after he returned to Holland. Holl exhibited *Deserted* (cat.71) in 1874 showing a poverty-stricken mother who had just abandoned her infant by the side of the Thames, and in 1876, *Her Firstborn* (cat.72), a touching scene of a child's funeral with the family in mourning.

Hubert Herkomer's most important work, *The Last Muster – Sunday at the Royal Hospital, Chelsea* (fig.16, cat.68), was shown at the Royal Academy in 1875. The scene is of a congregation of Chelsea Pensioners, with an elderly man feeling the pulse of a colleague who has just died. In 1883 Van Gogh explained how Herkomer had originally done a drawing of this subject for the *Graphic,* which almost rejected it. 'This is the origin of a picture which has since gained the wonder and admiration of the best, in Paris as well in London,' he explained. [l 533] In 1876 Herkomer showed *At Death's Door* (cat.69), in which a family in a mountain village await a priest coming to administer the last rites. Van Gogh had Herkomer's pictures of Chelsea Pensioners in mind when he later drew a series of veterans (cat.18).

The trio of Fildes, Holl and Herkomer were to strongly influence Van Gogh when he took up drawing in The Hague in the early 1880s. Their subject matter – abandoned women with babes, the homeless, the elderly and the bereaved – reflected his own social concerns during this period. Although it was engravings in the *Graphic* which inspired Van Gogh, these Black-

and-White reproductions must have brought back memories of the painted versions that he had once seen in London hanging at the Royal Academy.[9]

Although far less controversial, there were also two other Realist painters whom Van Gogh admired at the Summer Exhibitions in the 1870s. The Scottish painter Thomas Faed was known for his scenes of peasant life, particularly his cottage interiors. Among his works shown at the Academy were *A Lowland Lassie* (cat.61) in 1873 and *Forgiven* (cat.62) the following year. Alphonse Legros, a French-born artist who had settled in London, was another Realist. His works at the Academy in 1873 included *Blessing the Sea* (cat.74), a religious scene set on the Channel coast.

A very different view of the countryside is represented in the highly sentimental scenes of Myles Birket Foster, whose oil paintings at the Academy included *The Brook* (cat.66). Fred Walker, another of Van Gogh's favourite artists, showed *The Right of Way* in 1875, depicting a young child and mother walking through a field of sheep.[10] Van Gogh must also have noticed the work of the Paris-born illustrator and novelist George du Maurier, who was living in England and worked for *Punch*. In 1876 Du Maurier exhibited a drawing entitled *Souvenir de Dieppe*. Seven years later Van Gogh described a reproduction of it as the 'finest' Du Maurier in his collection.[11] [III 363]

Although the vast majority of the artists at the Summer Exhibition were based in Britain, there were also a few foreign exhibitors. These included the Hague School painter Jozef Israëls, who was later to have a great influence on Van Gogh's work, especially his paintings of peasants and fishermen in the early 1880s. In 1874 Israëls showed *Expectation*, depicting a fisherman's wife sewing (cat.73).[12] Van Gogh also liked the French artist Edouard Frère, who exhibited *Gathering Wood near Ecouen* in 1875.[13]

Van Gogh never forgot the paintings he had seen at the Royal Academy. Even in 1884, eight years after leaving England, he recalled some of his favourite pictures seen in London: paintings by Constable, *Chill October* by Millais, and drawings by Frederick Walker and George Pinwell. 'I for my part have always remembered some English pictures', he told Theo.[14] [II 300] Indeed, it was only after he had left Britain that the real impact of English art hit him, through the Black-and-White illustrators who worked for the *Illustrated London News* and the *Graphic*. Their work was to inspire him when he set out to become an artist, having a crucial impact on the development of both his choice of subject matter and style.

1 The term 'English' art is used here in a loose sense, to refer to artists who were working and exhibiting in England regardless of their nationality. The word 'English' (rather than British) is used, following Van Gogh's own usage.

2 *A Huguenot* (1852) is owned by Huntingdon Hartford College, New York. *Ophelia* (1852) is at the Tate Gallery. Other references in Van Gogh's letters to English 'Old Masters' include: John Crome (1768-1821) [I 23, 506], Thomas Gainsborough (1727-88) [II 441], Sir Joshua Reynolds (1723-92) [I 23] and George Romney (1738-1802) [I 23].

3 *Valley Farm* (1835) was originally in the collection of the National Gallery (not South Kensington) and was transferred to the Tate Gallery in 1919.

4 The print after Bonington was by Jules Laurens (1851). The painting it depicts is now titled *Near Boulogne* (1823-4, Tate Gallery).

Van Gogh hung the print in his bedroom in June 1875 [I 29] and later stuck it in a scrapbook of prints (Rijksmuseum Vincent van Gogh). Bonington continued to be one of Van Gogh's favourite English painters. [I 17, 33, 34, 168, 395]

5 *The Gaderene Swine* remains unlocated. It does, however, appear as a very rough illustration in a cartoon by Charles Keene (1823-91) which was published in *Punch* (21 June 1873). Keene, like Van Gogh, mocks the Prinsep painting. The original cartoon was exhibited by the Chris Beetles Gallery in November-December 1991 and is reproduced in their catalogue, *The Illustrators*, pp. 16-7.

6 Pickvance argues that Van Gogh did not see the 1876 exhibition (*English Influences*, pp. 47-8).

7 *Waiting* is now lost. It was described by the *Graphic* as 'a young lady seated in a pleasure-boat: the first, probably, of a pair of lovers to arrive at a place of assignation' (16

May 1874). It should not be confused with *Waiting for the Train*, also dating from c1874 (Dunedin Public Art Gallery, New Zealand). *London Visitors* is in the collection of the Toledo Museum of Art and a replica is at Milwaukee Art Gallery.

8 Including *A Huguenot*, *Ophelia* and *The Widow's Mite* (1870, Birmingham City Art Gallery). [I 10, 96, 129, III 463]

9 Pickvance argues that the Social Realist pictures at the RA 'escaped his attention altogether' (*English Influences*, p. 24). Although they may not have greatly interested him at the time, he cannot have missed them. They were controversial, generating considerable press attention and large crowds at the exhibitions. Van Gogh, who had an excellent memory for images, must have remembered many of the paintings when he later saw the Black-and-White engraved versions.

10 *The Right of Way* is at the National Gallery of Victoria, Melbourne.

11 *Souvenir de Dieppe* was published in *L'Art*, volume 6 (1876). Van Gogh's own copy of this print is at the Van Gogh Museum in Amsterdam.

12 Other Dutch artists who exhibited at the RA included Jacob Maris (*A Canal in Holland*, 1874) and Hendrik Mesdag (*On the Coast, Scheveningen*, 1874).

13 Reproduced in the *ILN* (22 January 1876). In 1883 Van Gogh had an English print which he called *Woodgathers*, probably the *ILN* illustration [III 355].

14 Other contemporary English painters referred to by Van Gogh are William Holman Hunt (1827-1910) [I 98, III 229, 463], Sir Edwin Landseer (1803-73) [I 149, 151], Dante Gabriel Rossetti (1828-82) [III 229] and the Anglo-American artist, James McNeill Whistler (1864-1903) [I 554, II 351, 492, III 165, 355, 358, 464].

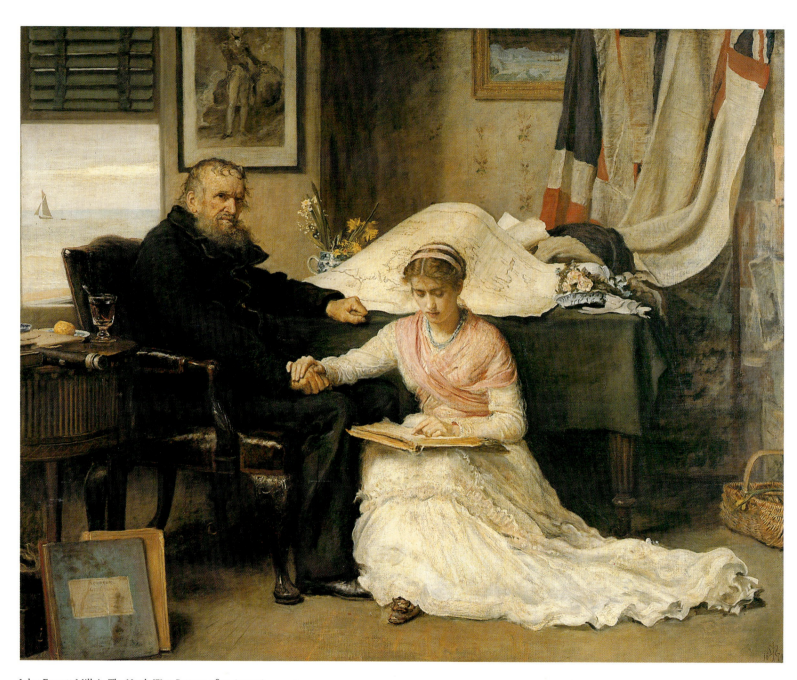

John Everett Millais *The North-West Passage*, 1874 (cat.77)

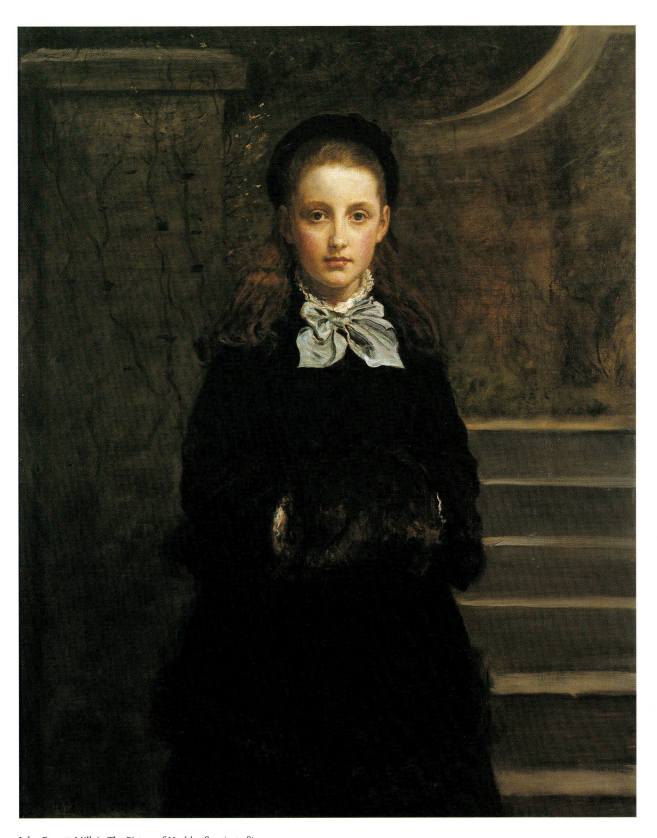

John Everett Millais *The Picture of Health*, 1874 (cat.78)

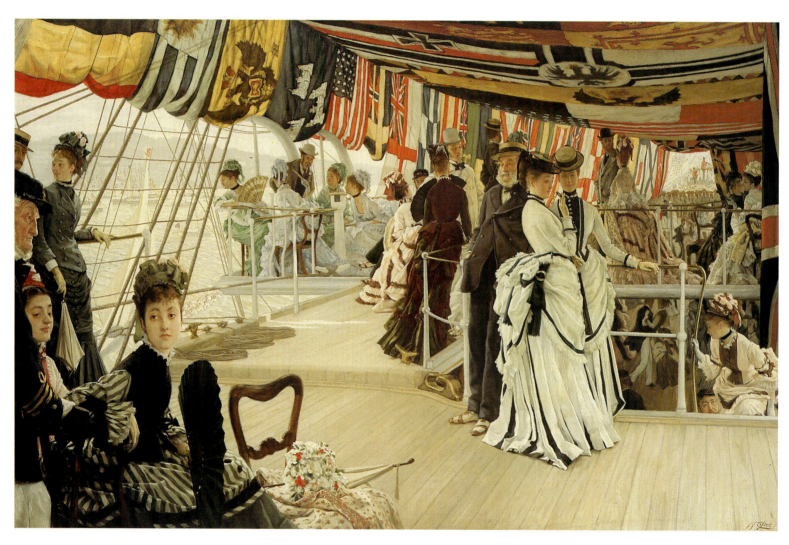

James Tissot *The Ball on Shipboard*, 1874 (cat.81)

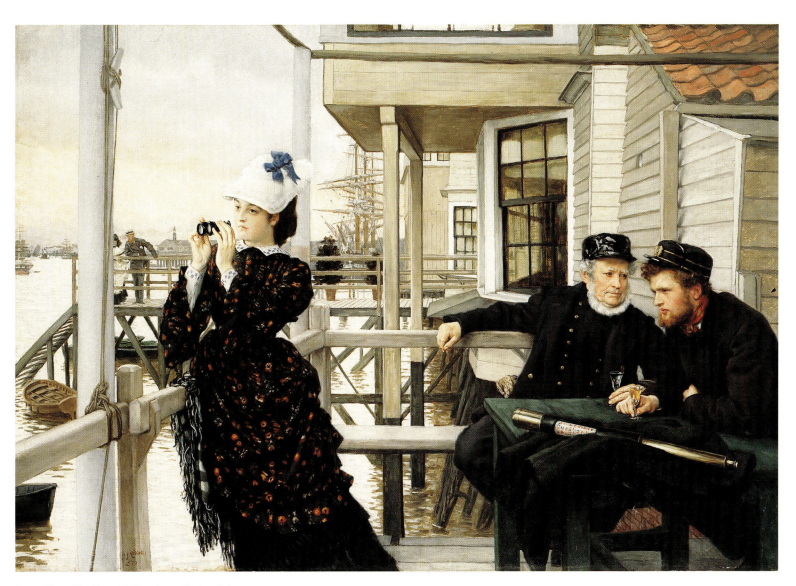

James Tissot *The Captain's Daughter*, 1873 (cat.80)

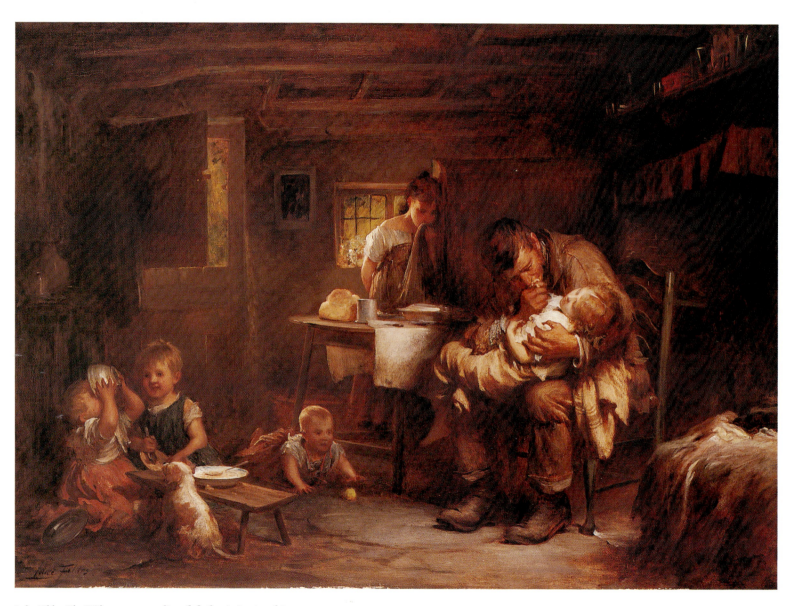

Luke Fildes *The Widower*, 1902 replica of 1876 painting (cat.65)

Thomas Faed *A Lowland Lassie*, 1873 (cat.61)

'It took a long time before I could admire Thomas Faed's work, but now I do not hesitate about it any more.'

Van Gogh to Theo, 5 November 1882 [I 482]

Thomas Faed *Forgiven*, 1874 (cat.62)

*'God be praised! Mary's come hame, she slipped in last
Thursday. I nearly fainted... He treated her, she says, fair
enough for a while while they were married, but the black
scum floated at last... She has suffered for her disobedience
poor lassie – but she's hame now.'*

Quoted by Faed alongside his painting at the Royal
Academy in 1874.

Myles Birket Foster *The Brook*, 1874 (cat.66)

Hubert Herkomer *After the Toil of the Day*, 1873 (cat.67)

Fig.16 Hubert Herkomer *The Last Muster – Sunday at the Royal Hospital, Chelsea*, 1874

Frank Holl *Deserted,* 1874 (cat.71)

Frank Holl *Leaving Home*, 1873 (cat.70)

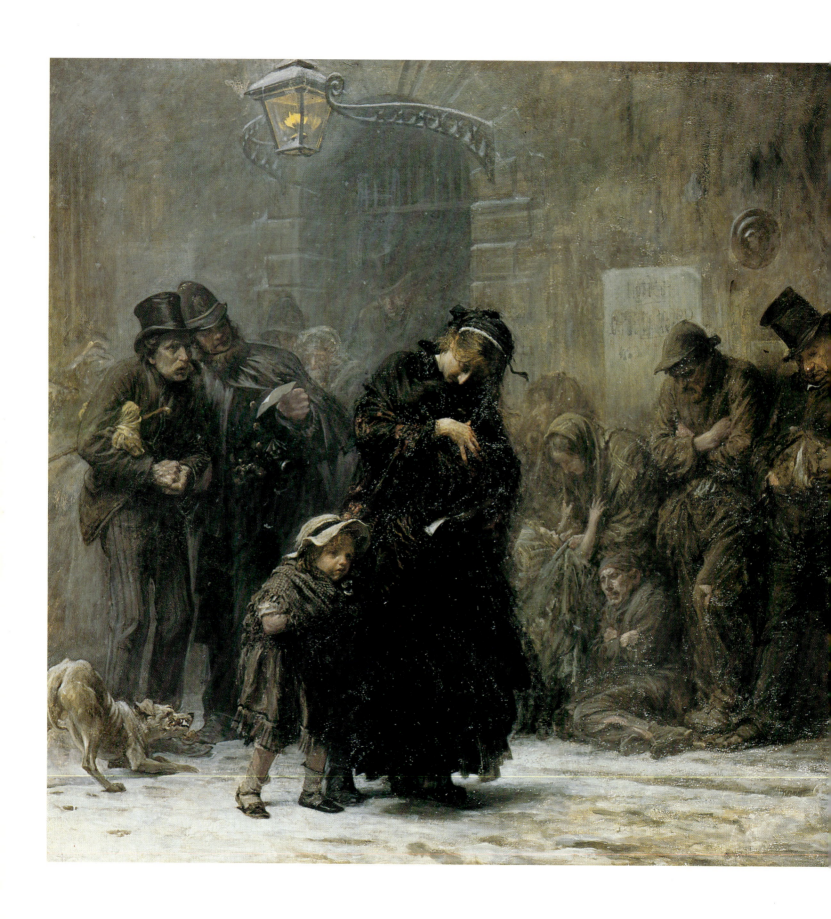

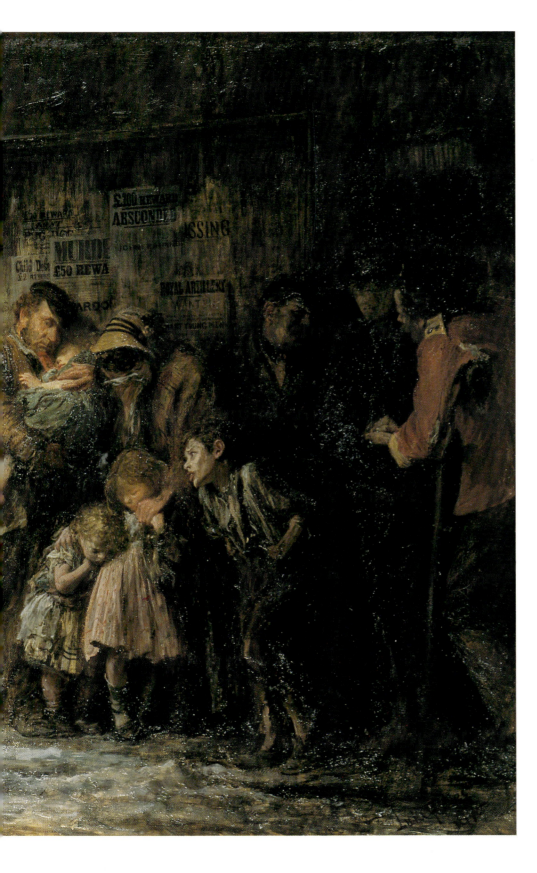

Fig.17 Luke Fildes *Applicants for Admission to a Casual Ward*, 1874 (original version belonging to Royal Holloway and Bedford New College)

'Dumb, wet, silent horrors! Sphinxes set up against that dead wall and none likely to be at the pains of solving them until the general overthrow.'

An extract from a letter by Charles Dickens after a visit to a Whitechapel workhouse, quoted by Fildes alongside his painting at the Royal Academy in 1874.

Hubert Herkomer *At Death's Door*, 1876 (cat.69)

Frank Holl *Her Firstborn*, 1876 (cat.72)

Jozef Israëls *Expectation*, 1874 (cat.73)

Alphonse Legros *Blessing the Sea*, 1873 (cat.74)

George Boughton *God Speed!*, 1874 (cat.59)

'The landscape through which the road winds is so beautiful – brown heath, and occasional birches and pine trees and patches of yellow sand, and the mountain far in the distance, against the sun. Truly, it is not a picture but an inspiration.'

Van Gogh to Theo, 26 August 1876 [I 66]

A Pilgrim's Progress

The English painting which undoubtedly had the greatest impact on Van Gogh was *God Speed!* (cat.59), which he saw the Royal Academy in June 1874. The themes of the painting became bound up with his own spiritual quest and were to inspire his first sermon (see p.116), delivered at the end of his stay in England.

Van Gogh's religious commitment developed in the spring of 1875, following a bleak winter of depression. Writing to Theo on 8 May, on the eve of his transfer to Paris, there was a hint of his new vision. He ended his letter with a quotation from *Jésus*, by the French writer Ernest Renan:

To act well in this world one must sacrifice all personal desires. The people who become the missionary of a religious thought have no other fatherland than this thought. Man is not on this earth merely to be happy, nor even to be simply honest. He is there to realize great things for humanity. [I 26]

That summer Van Gogh's letters to Theo begin to be peppered with biblical exhortations. His dismissal from Goupil's forced him to consider his future, and his first thought was to seek a post with the Church. That proved impracticable, partly because of his youth and lack of qualifications, but as a teacher in Isleworth he began to help in the local Congregational and Methodist churches.

On 29 October 1876 Van Gogh delivered his first sermon at Richmond Methodist Church (fig.18).[1] He described the occasion to Theo in great excitement:

Theo, your brother has preached for the first time, last Sunday, in God's dwelling, of which it is written 'In this place, I will give peace.'

Fig.18 Extract from Van Gogh's sermon, delivered at Richmond Methodist Church on 29 October 1876. (Rijksmuseum Vincent van Gogh [Vincent van Gogh Foundation], Amsterdam)

CHRIST RÉMUNÉRATEUR

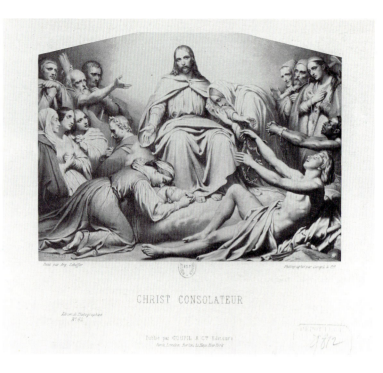

CHRIST CONSOLATEUR

Goupil print: Ary Scheffer *Christus Rémunérateur*, 1848 (cat.54)

Van Gogh hung these two religious prints by Scheffer on his bedroom wall in Isleworth.

Goupil print: Ary Scheffer *Christ Consolateur* 1837 (cat.53)

'The words that are written over "Christ Consolateur"– "he has come to proclaim liberty to the captives" – are true to this day.'
Van Gogh to Theo, 8 July 1876 [I 63]

> *It was a clear autumn day and a beautiful walk from here to Richmond along the Thames, in which the great chestnut trees with their load of yellow leaves and the clear blue sky were mirrored. Through the tops of the trees one could see that part of Richmond which lies on the hill: the houses with their red roofs, uncurtained windows and green gardens; and the grey spire high above them; and below, the long grey bridge with the tall poplars on either side, over which the people passed like little black figures.* [I 73]

When he stepped up to the pulpit, Van Gogh took as his text Psalm 119, Verse 19 and introduced the theme of his sermon:

> *'I am a stranger in the earth, hide not Thy commandments from me.' It is an old faith and it is a good faith that our life is a pilgrim's progress – that we are strangers in the earth, but that though this be so, yet we are not alone for our Father is with us. We are pilgrims, our life is a long walk or journey from earth to heaven... The end of our pilgrimage is the entering in Our Father's House.*

He went on to stress that 'sorrow' is part of life, and can be a blessing in disguise. 'Sorrow is better than joy – and even in mirth the heart is sad – and it is better to go to the house of mourning than to the house of feasts, for by the sadness of the countenance the heart is made better,' he told the congregation. He then quoted St Paul's Second Epistle to the Corinthians (6:10): 'As being sorrowful yet always rejoicing.' He continued with a plea that even death should not be feared:

> *Slowly but surely the face that once had the early dew of morning, gets its wrinkles, and the eyes that once beamed with youth and gladness speak of a sincere deep and earnest sadness... The hair turns grey or we loose it – ah – indeed we only pass through the earth, we only pass through life – we are strangers and pilgrims in the earth...*
> *Our life, we might compare it to a journey, we go from the place where we were born to a far*

Illustration by Henry Selous from John Bunyan's *The Pilgrim's Progress*, 1874-75 (cat.120)

off haven... Has any of us forgotten the golden hours of our early days at home, and since we left that home – for many of us have had to leave that home and to earn their living and to make their way in the world?

It was towards the end of the sermon, that for us the most interesting passage occurred. Van Gogh described Boughton's *God Speed!*, explaining:

Our life is a pilgrim's progress. I once saw a very beautiful picture, it was a landscape at evening. In the distance on the right-hand side a row of hills appearing blue in the evening mist. Above those hills the splendour of the sunset, the grey clouds with their linings of silver and gold and purple. The landscape is a plain or heath covered with grass and heather, here and there the white stem of a birch tree and its yellow leaves, for it was in autumn. Through the landscape a road leads to a high mountain far, far away. On the top of that mountain is a city whereon the setting sun casts a glory.

On the road walks a pilgrim, staff in hand. He has been walking for a good long while already and he is very tired. And now he meets a woman, a figure in black that makes one think of St Paul's words: 'As being sorrowful yet always always rejoicing.' That Angel of God has been placed there to encourage the pilgrims and to answer their questions.

He then quoted his favourite poem by Christina Rossetti, sister of painter and poet Dante Rossetti.[2]

Charles Haddon Spurgeon *The Metropolitan Tabernacle: Its History and Work*, 1876 (cat.130)

right: Fig.19 Gustave Doré *Scripture Reader in a Night Refuge* from *London – A Pilgrimage*, 1872 (cat.127)

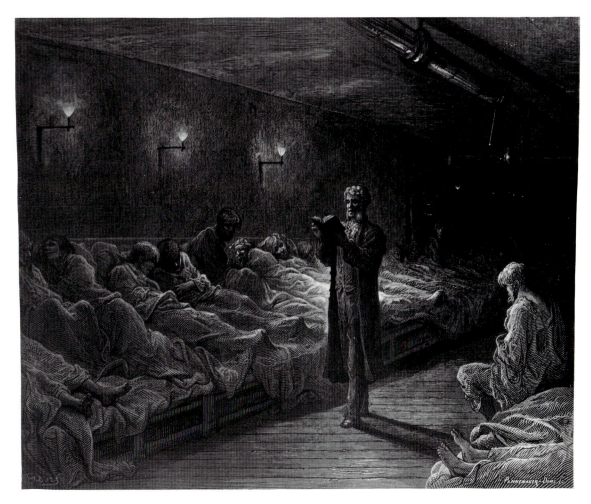

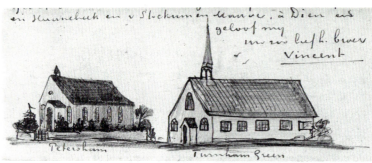

Fig.20 Vincent van Gogh: sketch of Petersham and Turnham Green churches included at the end of a letter to Theo, 25 November 1876 [I 77] (Rijksmuseum Vincent van Gogh [Vincent van Gogh Foundation], Amsterdam)

Collecting card for Turnham Green Church, 1875 (cat.107)

Does the road go uphill all the way?
Yes to the very end.
And the journey takes all day long?
From morn till night my friend.

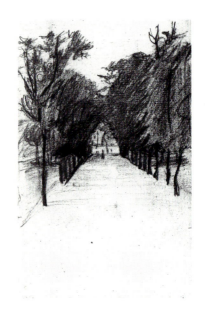

Fig.21 Vincent van Gogh: two drawings from the *Third Sketchbook for Betsy Tersteeg*, July 1874 (Rijksmuseum Vincent van Gogh [Vincent van Gogh Foundation], Amsterdam)

Van Gogh concluded: 'The pilgrim goes on sorrowful yet always rejoicing, sorrowful because it is so far off and the road so long. Hopeful as he looks up to the eternal city far away, resplendent in the evening glow.'

Van Gogh, in his letter to Theo, explained with pride: 'Your brother was indeed deeply moved when he stood at the foot of the pulpit and bowed his head and prayed.' [I 73-4] Although the congregation may have found Van Gogh's Dutch accent and his somewhat rambling style rather difficult to follow, there can have been little doubt about the conviction of the 'stranger' who had come to preach in their midst.

The worshippers may also have been mystified by the painting which Van Gogh described. He did not identify the artist or the title, presumably because it was the 'ideas' in it which were important. From earlier comments which Van Gogh had made to Theo, it is clear that the painting was by Boughton, although he had then called it *The Pilgrim's Progress*. [I 78] To add to the confusion, Van Gogh's description of the painting is slightly different from the actual work which was exhibited at the Academy in 1874. Nevertheless a careful analysis of all the evidence makes it clear that the painting which inspired Van Gogh's sermon must indeed have been *God Speed!*.

Van Gogh transformed *God Speed!* into a vivid metaphor of life's journey. Boughton had inspired Van Gogh, who in turn 'painted' his own vision of *God Speed!*, altering its theme and titling it to reflect his own beliefs. Van Gogh called the painting *The Pilgrim's Progress,* after John Bunyan's allegorical book, first published in 1678 (cat.119 and 120). Bunyan's journey from 'this World to that which is to come' tells the story of Christian, who flees from the City of Destruction, passing through the Slough of Despond, the Valley of the Shadow of Death and the Delectable Mountains, before reaching the Celestial City. *The Pilgrim's Progress* provided Van Gogh with a view of man's role on earth. The book proved to be among the most important he discovered in England, and Christian's journey reflected his own view of life as a pilgrimage or 'a long walk from earth to heaven.'

After telling Theo about his first sermon, Van Gogh added: 'It is a delightful thought that in the future wherever I go, I shall preach the Gospel.' [I 73] Just eleven days later he announced

that he would 'work more at Turnham Green', where the Revd. Slade-Jones ran his Congregational church. Soon after he was formally accepted as a 'co-worker' at its Sunday school. [I 74]

Van Gogh also continued to attend the Methodist church at Richmond and the chapel at Petersham. His spiritual quest was now truely ecumenical. He had told Theo about how he had passed a Catholic church on one of his walks from Turnham Green on 6 October. 'I entered and found it to be a very beautiful little Catholic church where a few women were praying,' he explained. Later that same evening he reached the Anglican church in Isleworth, 'the church with the ivy, and the churchyard with the weeping willows on the banks of the Thames.' [I 70]

Van Gogh had also attended Baptist services, when living in Kennington. He visited the nearby Metropolitan Tabernacle (cat.130), at Elephant and Castle, run by the charismatic preacher Charles Spurgeon. According to Paulus Görlitz, who knew Van Gogh in early 1877, Spurgeon was then 'one of his favourite authors'. [I 113] Görlitz even claimed that Spurgeon's *Little Gems* (cat.131) was the 'only' book he read, along with the Bible. [III 596]

Van Gogh once explained why he worshipped in such a wide variety of churches: 'In every church I see God, and it's all the same to me whether a Protestant pastor or a Roman Catholic priest preaches. It is not really a matter of dogma, but of the spirit of the Gospel, and I find this spirit in all churches.' [III 596-7] Van Gogh kept up his links with the English Church after his return to Holland, regularly attending the English Reformed Church in Amsterdam's Beginjhof. [I 144, 152, 160, 162] He also helped at Zion's Chapel, a Sunday school in Amsterdam run by the British Society for the Propagation of the Gospel Among the Jews. [I 162, 167] In July 1878, when he gave up his studies in Amsterdam, it was his old friend the Revd. Slade-Jones who helped him get a place at a mission training school at Laeken, near Brussels. [I 172-4]

Fig.22 Meindert Hobemma *The Avenue at Middelharnis*, 1689 (National Gallery, London)

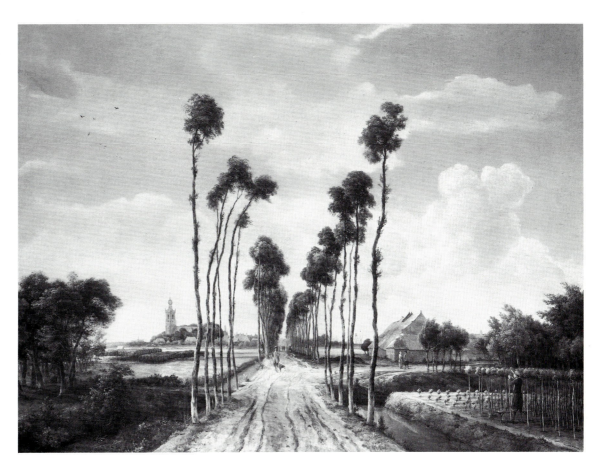

Although Van Gogh failed to qualify at the end of his three-month course at Laeken, this did little to dampen his enthusiasm. In January 1879 he was assigned as an evangelist to the village of Wasmes, in the Borinage. However, after only six months he was dismissed, as his selfless life of abject poverty was regarded as inappropriate for a churchman. He moved to the nearby town of Cuesmes, where he served as an evangelist without the backing of the Church.

Van Gogh himself admitted that the miners of the Borinage ignored him and in the end he accepted that he was unable to communicate the faith that he had first discovered in England. 'There may be a great fire in our soul, yet no one ever comes to warm himself at it, and the passers-by see only a wisp of smoke coming through the chimney, and go along their way,' he wrote to Theo in July 1880. [I 197] Two months later Van Gogh made his fateful decision: 'In spite of everything I shall rise again: I will take up my pencil... and I will go on with my drawing. From that moment everything has seemed transformed for me.' [I 206] By the following year he had rejected the Church.

Even then, however, Van Gogh continued to see his life in terms of a journey. Always travelling, he rarely stayed anywhere for more than a matter of months. 'I always feel I am a traveller, going somewhere and to some destination' he admitted to Theo in August 1888. [III 2]

Van Gogh's view of life as a journey, a theme he developed in England and believed in for the rest of his days, is reflected in a poem which he had copied out for Theo from Isleworth in 1876. The poem, by George Eliot, tells the story of how a man and woman fall in love, marry, have children, bring them up, see them leave home, and finally in old age think back on their past. Eliot titled it *Two Lovers*, but revealingly Van Gogh re-titled it, calling it *The Journey of Life.*[3]

This idea of life as a journey emerges as a fundamental theme in Van Gogh's art. Throughout his life he drew and painted the motif of a path or road stretching out into the distance. Usually it is lined with a row of trees, intensifying the sense of perspective and emphasizing the distance of the way ahead. Often a lone figure makes his way along the route. In Van Gogh's work, these 'tree-lined paths' acquire a metaphorical dimension, suggesting the

Print of Jacobus van der Maaten's
Burial in a Cornfield, 1863, with inscriptions by Van Gogh (cat.105)

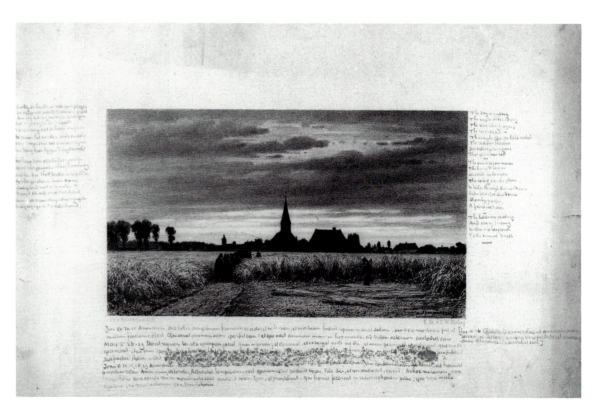

Fig.23 Van Gogh's own copy of Richard Bonington's *Une Route* (A Road), 1823-4 (Rijksmuseum Vincent van Gogh [Vincent van Gogh Foundation], Amsterdam)

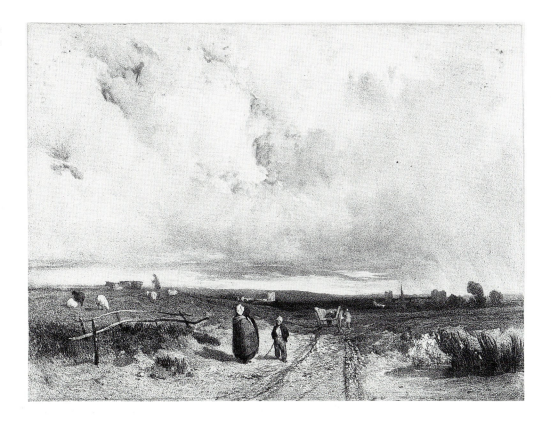

idea of a journey. This motif can be seen as a visual expression of the philosophy that he preached in his first sermon in Richmond.

The motif of the tree-lined path had already occured in Van Gogh's early drawings. It can be seen clearly in the avenue of trees which he drew in the third sketchbook for Betsy Tersteeg (figs.21). There are also echoes of this theme in the three landscapes which he did in Holland early in 1873, *A Ditch, A Canal* and *A Lane* (cat.1, 2 and 3) . It is also revealing that many of the paintings by other artists which Van Gogh appreciated during his period in England were of tree-lined paths or roads. It appears most starkly in Meindert Hobemma's *The Avenue at Middelharnis* (fig.22), which Van Gogh saw at the National Gallery. [II 300] Constable's *Cornfield* (fig.14), also at the National Gallery, had a similar theme. [II 300] One of his favourite Bonington works was a work he entitled *Une Route* (fig.23), although the painting is now more prosaically called *Near Boulogne*. [I 29] When Van Gogh copied *Westminster* by De Nittis (fig.3) he exaggerated the height of the trees along the Thames Embankment, emphasising the grand avenue leading to the Houses of Parliament.

This theme of the figure on a lonely road or path was one which Van Gogh came back to throughout his life. *Lane of Poplars in Autumn* (cat.24) and *Lane of Poplars at Sunset* (cat.30), painted in Nuenen in 1884 and 1885, are among his early works in oil and their style is strongly influenced by the artists of the Hague School. In these two pictures Van Gogh depicts a lone figure on a pathway. This theme recurs in a number of his later paintings, including works dating from his periods in Paris, Arles, St-Rémy and Auvers.

As he had preached in his first sermon, Van Gogh saw life as a journey, its purpose – to quote Renan – was 'to realize great things for humanity'. Initially Van Gogh saw this in religious terms, as a search for the light of God. When he finally left the Church and became a painter, his goal changed. Van Gogh's quest became a highly personal and passionate search for artistic expression.

1 Internal evidence in the letters has been intepreted to suggest that the sermon must have been delivered on either 29 October or 5 November 1876. However, Van Gogh's description of moonlit walk in the letter he enclosed his sermon (omitted from English edition) proves that the date was 29 October, since the full moon was on 1 November. Although Van Gogh's sermon is reprinted in the English edition of Van Gogh's letters [I 87-91], there are some minor transcription errors. The last page of the sermon containing the hymn 'Tossed with rough winds and feint with fear' was omitted, along with a short note by Van Gogh in Dutch. These are included in the Dutch edition of the letters (*De Brieven*, pp. 176-81). The sermon is reproduced here on pp.116-7

2 Van Gogh also quoted this poem in his letters of 5 October 1875 [I 38, 41], 26 August 1876 [I 66] and 30 October 1877 [I 146].

3 The poem copied out in Van Gogh's letter of 25 November 1876 is omitted from the English edition.

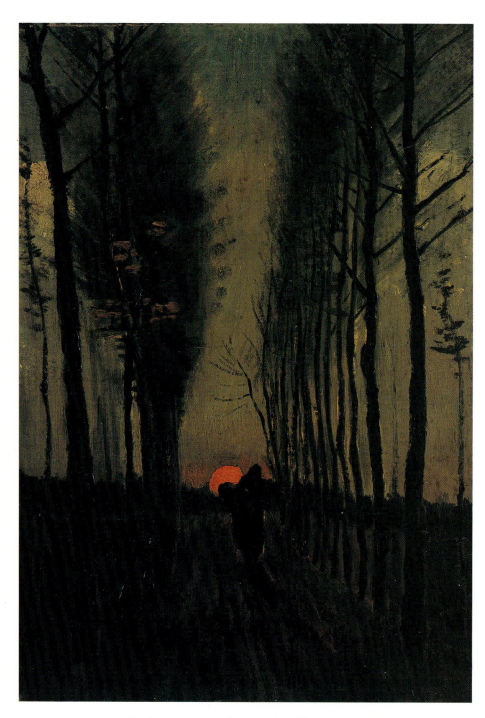

Vincent van Gogh *Lane of Poplars at Sunset*, October-November 1885 (cat.30)

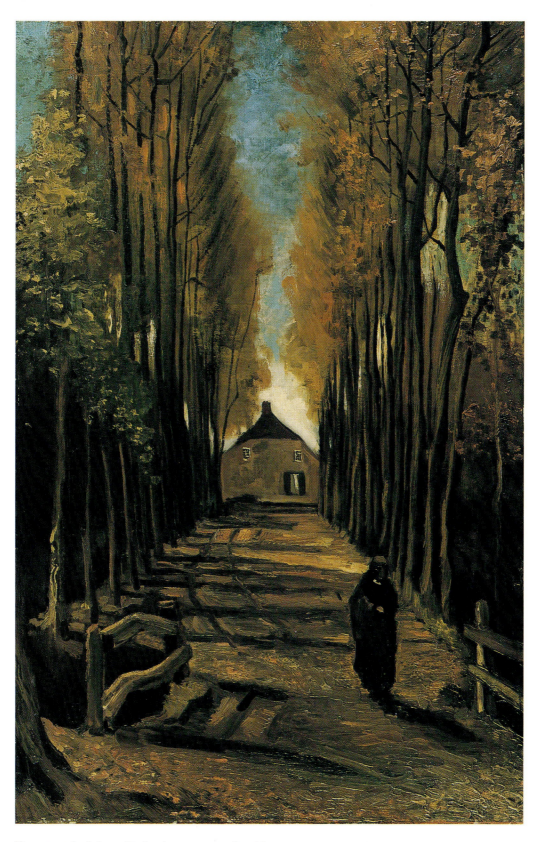

Vincent van Gogh *Lane of Poplars in Autumn*, October 1884 (cat.24)

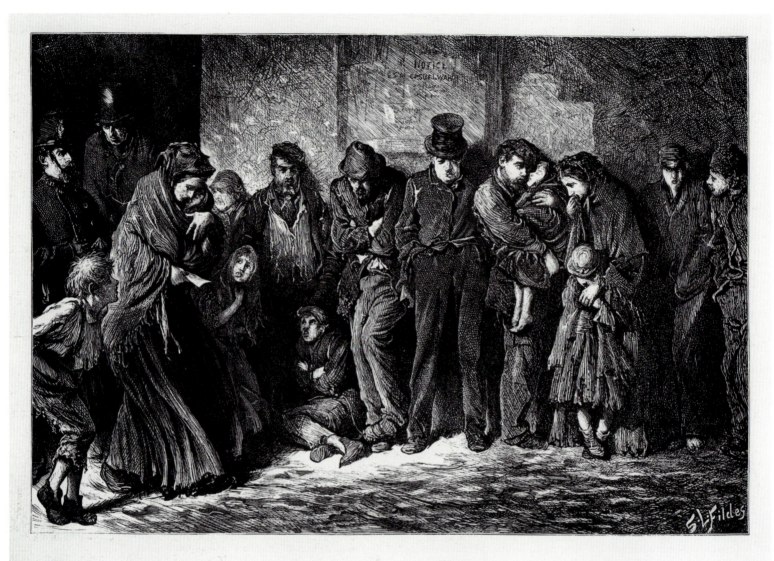

HOUSELESS AND HUNGRY.

DRAWN BY S. L. FILDES.

Luke Fildes, *Houseless and Hungry*, 1869 (cat.84)

'It is by virtue of that [Houseless Poor] Act that the group before us will obtain food and shelter tonight... they present themselves at a police station and ask for a ticket for admission to the casual ward of a workhouse.'

From the *Graphic*, 4 December 1869

The Black-and-White Illustrators

\mathbf{V}AN GOGH FIRST DISCOVERED the English Black-and-White illustrators in London. 'As I lived in England for fully three years, I learned much about them and their work by seeing a lot of what they did. Without having been in England for a long time it is hardly possible to appreciate them to the full,' he told his friend Anthon van Rappard in September 1882. [III 330] Five months later he added: 'More than ten years ago, when I was in London, I used to go every week to the show windows of the *Graphic* and the *[Illustrated] London News* to see the new issues. The impressions I got on the spot were so strong that, notwithstanding all that has happened to me since, the drawings are clear in my mind. Sometimes it seems to me that there is no stretch of time between those days and now – at least my enthusiasm for those things is rather stronger than it was even then.'[1] [III 346-7] By this time Van Rappard, whom Van Gogh had met at the Art Academy in Brussels in 1880, had become an equally enthusiastic follower of the English illustrators.

The *Illustrated London News*, founded in 1842, was the first of the weekly magazines to make extensive use of illustrations for news events. Its main rival, the *Graphic*, was founded in 1869 and the two publications immediately became rivals. Both journals were at the height of their popularity during Van Gogh's period in England. Densely packed with text, they were aimed at a well-educated readership, but they were distinguished by their dramatic use of illustrations. The printing technique involved an artist drawing directly onto a woodblock with an engraver then cutting away the surface to leave the picture in relief, ready for printing.

The first sign of Van Gogh's 'rediscovery' of the English illustrators came in January 1881, in Brussels. He explained to Theo: 'I have finished at least a dozen drawings, or rather sketches in pencil and in pen and ink, which seem to me to be something better. They vaguely resemble

below left: Theodore Wirgman *Some 'Graphic' Artists*, 1881

'I enclose a copy of the "Graphic", Christmas 1882. Read it carefully, it is worthwhile. What a colossal institution, isn't it, what an enormous circulation... Look at that group of great artists, and think of foggy London and the bustle in that small workshop.'
Van Gogh to Theo, c 11 December 1882 [I 508-9]

below centre and right: *Illustrated Journalism*, published in the *Illustrated London News*, 30 August 1879 (cat.115)

The illustrations show the printing and publishing process at their premises at 198 Strand, London.

Frank Holl *London Sketches – The Foundling* , published in the *Graphic*, 26 April 1873 (cat.93)

right: Vincent van Gogh *Sorrow*, November 1882 (cat.16)

far right: Vincent van Gogh *Orphan Man Drinking Coffee*, November 1882 (cat.17)

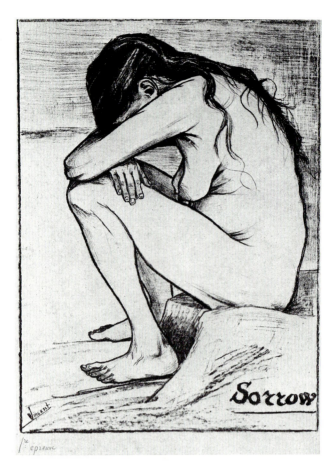

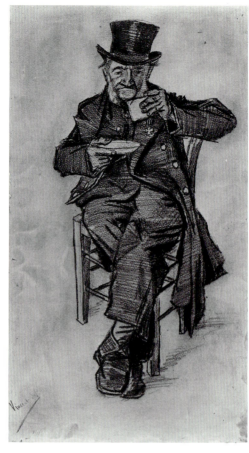

Hubert Herkomer *Sunday at Chelsea Hospital*, published in the *Graphic*, 18 February 1871 (cat.89)

certain drawings by Lançon, or certain English wood engravings.'[2] [I 213] A few weeks later Van Gogh told his parents that he was 'collecting wood engravings again', adding that it was possible that he would 'work from wood engravings sometime.' [I 217]

By the time Van Gogh arrived at The Hague in November 1881 he had already started collecting back-issues of the English weeklies. It was the following January when he made a major acquisition, a set of the *Graphic* of 1875-76 as well as an album of the best illustrations from the magazine, the *Graphic Portfolio* of 1877 (cat.88). 'I bought very cheaply some beautiful wood engravings from the *Graphic*... Just what I have been wanting for years, drawings by Herkomer, Frank Holl, Walker and others. I bought them from Blok, the Jewish book dealer, and for 5 guilders I chose the best from an enormous pile of *Graphics* and *London News*. There are things among them that are superb,' he wrote with great enthusiasm. [I 302]

By June 1882 Van Gogh told Theo that he now had 'about a thousand sheets'. [I 381] Considering how little money he had, and that he had only started buying them a few months earlier, it was an astonishingly large collection. Although some of the illustrations came from Continental and American periodicals, his main interest was in those from England. The following month Van Gogh explained: 'For me one of the highest and noblest expressions of art is always that of the English, for instance, Millais and Herkomer and Frank Holl.' [I 417]

The engravings in the two English weeklies covered a wide range of subjects, including news events, features and reproductions of art works. The *Graphic* occasionally published illustrations depicting the deprivation of Victorian Britain, and it was these Social Realist images of working-class life which had the strongest appeal for Van Gogh. 'An artist needn't be a clergyman or a churchwarden, but he certainly must have a warm heart for his fellow men. I think it

Fig.24 Vincent van Gogh *The Great Lady*, April 1882 (H128/I 334) (Rijksmuseum Vincent van Gogh [Vincent van Gogh Foundation], Amsterdam)

very noble, for instance, that no winter passed without the *Graphic* doing something to arouse sympathy for the poor,' he said. [I 477]

In January 1883 Van Gogh made his most important purchase, an almost complete run of the *Graphic* from the start of publication in 1869 to 1880 which he bought very cheaply at auction in The Hague. He wrote in great excitement to Van Rappard:

> The 'Graphics' are now in my possession. I have been looking them over until far into the night... While I was looking them over, all my memories of London ten years ago came back to me – when I saw them for the first time; they moved me so deeply that I have been thinking about them ever since, for instance Holl's 'The Foundling' and Herkomer's 'Old Women'... There is something stimulating and invigorating like old wine about those striking, powerful and virile drawings.'[3] [III 355-6]

Van Gogh went on to ask his friend whether he should break up the twenty-one bound volumes. 'If I cut out the sheets and mount them, they will show up better and I can arrange them according to the artists who did them. But then I mutilate the text... I'd also have to spend a lot on mounting board,' he wrote. [III 359] In the end, Van Gogh split up the volumes and pasted the most important prints on dark grey or brown paper. 'I have finished cutting out and mounting the wood-engravings from the *Graphic*. Now that they are arranged in an orderly manner, they show up ever so much better,' he reported. [III 368] Most of these mounted sheets still survive and are in the Van Gogh Museum in Amsterdam (cat.82, 83, 84, 86, 87, 89, 90, 91, 94, 96, 97, 99, 100, 101, 102).

As Van Gogh looked through the volumes of the *Graphic* he found many of the Social Realist images which he had seen on the walls of the Royal Academy many years earlier. There was *Houseless and Hungry* (cat.84) by Fildes, *At a Railway Station – A Study* (cat.92) and *Deserted – A Foundling* (cat.93) by Holl, and *Sunday at Chelsea Hospital* (cat.89), *The Last Muster* (see cat.89) and *At Death's Door* (cat.69) by Herkomer. Van Gogh also found many other artists in the pages of these magazines, including Fred Barnard, Charles Green, Arthur Boyd Houghton, Percy Macquoid, George du Maurier, George Pinwell, Félix Régamey, Matthew Ridley, William Small and Fred Walker.

Van Gogh described his collection as 'a kind of Bible to an artist, in which he reads from time to time to get in a devotional mood.' [III 361] The English illustrators proved to be a vital source of inspiration. 'Every time I feel a little out of sorts, I find in my collection of wood engravings a stimulus to set to work with renewed zest. In all these fellows I see an energy, a determination and a free, healthy, cheerful spirit that animates me. And in their work there is something lofty and dignified – even when they draw a dunghill,' he told Van Rappard. [III 340] Van Gogh admired the freshness and directness of the English illustrators, particularly the 'bold contour' of their drawing. [III 386]

In June 1883 Van Gogh told Theo that it had taken time to appreciate the work of the English Black-and-White artists. 'At first I didn't like them at all, and just like most people here [in Holland], thought that the English were quite wrong; but that did not last, and I have learned to look at things from a different angle,' he said. [II 64]

Van Gogh's love for the illustrators is reflected in his decision to give English titles to some of his own drawings and watercolours. The first surviving drawing which Van Gogh titled in English dates from April 1881, *The Bearers of the Burden* (cat.15). At the same time he drew its lost pendent, *The Lampbearers,* which presumably depicted miners of the Borinage. Van Gogh also did two other drawings entitled *Winter Tale* and *Shadows Passing*.[4] In September-October 1881 he painted two watercolours of an old man sitting with his head in his hands, both entitled *Worn Out*.[5]

Fig.25 Vincent van Gogh *The State Lottery Office*, September 1882 (Rijksmuseum Vincent van Gogh [Vincent van Gogh Foundation], Amsterdam)

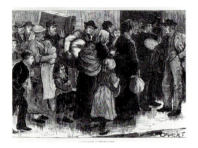

William Small *A Queue in Paris*, published in the *Graphic*, 11 March 1871 (cat.99)

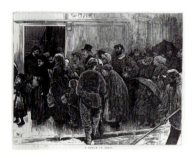

Michael Fitzgerald *Pawn Office at Merthyr Tydfil*, published in the *Graphic*, 20 February 1875 (cat.86)

William Bazett Murray *L'industrie du jute: Le tissage des nattes en Angleterre* (The Jute Industry: Mat Weaving in England), published in *l'Univers Illustré*, c 1881 (cat.95)

The next batch of drawings with English titles date from the following spring. *The Dustman,* depicting a man with a cart, has been lost, although it is known from a photograph.[6] Soon afterwards, Van Gogh drew *The Great Lady* (fig.24), based on Thomas Hood's poem 'The Lady's Dream'. Van Gogh summarised it as 'telling of a rich lady who cannot sleep at night because when she went out to buy a dress during the day, she saw the poor seamstress – pale, consumptive, emaciated'. [I 336] The model was his lover Sien, who had herself been a seamstress before turning to prostitution. *Sorrow,* a nude study of Sien whilst pregnant with her head in her hand dates from only a few days later. Saying it was among his best works, he told Theo that 'I'm very fond of the English drawings done in this style, so no wonder I tried it.' [I 337]

In November 1882 Van Gogh decided to make lithographs of some of his drawings. He told Theo: 'No result of my work could please me better than that ordinary working people would hang such prints in their room or workshop. I think what Herkomer said, "For you, the public it is really done", is true.'[7] [I 489] Two of the six lithographs which Van Gogh produced had English titles, *Sorrow* (cat.16) and *At Eternity's Gate* (cat.18). The latter shows an old man whose pose is remarkably similar to an illustration by Arthur Boyd Houghton for Dickens' *Hard Times* (cat.121).

Van Gogh only occasionally titled his pictures, usually those works he considered to be finished versions rather than studies. Yet from April 1881 to the end of 1882, all his surviving titled drawings and watercolours have English titles. Van Gogh was paying homage to the illustrators who had inspired his own work. He may have also intended to send these works to the *Graphic* and the *Illustrated London News*, hoping that their titles might help make them more attractive to English editors.

For the next few years the influence of the English illustrators still shines through in much of his work. One of Van Gogh's earliest oil paintings, *Girl in White in a Wood* of August 1882, is partly based on an illustration in the *Graphic*. The girl's dress and and the tree trunks are similar to an engraving in the *Illustrated London News* by Percy Macquoid, entitled *Reflections*.[8] The English influence can also be seen in *The State Lottery Office* of September 1882 (fig.25). Whilst painting it he told Theo that he felt 'greatly attracted by the figures either of the English draughtsmen or of the English authors because of their Monday-morning-like soberness and studied simplicity and solemnity and keen analysis.' [I 468] His powerful watercolour has parallels with Michael Fitzgerald's *A Pawn-Office at Merthyr-Tydfil* (cat.86) and William Small's *A Queue in Paris* (cat.99).

Links with the English illustrators can be seen in Van Gogh's series of 'orphan men' (cat.17), also dating from the autumn of 1882. These were clearly inspired by Herkomer's Pensioners in *Sunday at Chelsea Hospital* and *The Last Muster*. Evidence for this is Van Gogh's use of the distinctive Dutch word 'weesmannen' to describe both Herkomer's pensioners and the old men in his own drawings. Van Gogh's *Woman Weeping* of February 1883 (cat.20), is very similar to the figure in the foreground of a print he had described as excellent, Edward Dalziel's *Waiting for the Public House to Open* (cat.83). [III 368]

The spirit of English illustrators and writers is evident in Van Gogh's series of weavers, painted in Nuenen from December 1883 to July 1884 (cat.22 and 23). The difficult life of weavers was a popular literary theme, in such books as George Eliot's *Silas Marner: The Weaver of Raveloe* which Van Gogh had read and greatly enjoyed.

Van Gogh's debt to the English illustrators can be clearly seen in his 'heads of the people', the title the *Graphic* had given to a series of vivid portraits it ran from 1875. Among Van Gogh's favourite 'heads' was Herkomer's *The Coastguardsman* (cat.91), which in part inspired his own

Van Gogh *Interior with Weaver*, July 1884 (cat.22)

'In the days when the spinning-wheels hummed busily in the farmhouses – and even great ladies, clothed in silk and thread lace, had their toy spinning-wheels of polished oak – there might be seen in districts far away among the lanes , or deep in the bosom of the hills, certain pallid undersized men, who, by the side of the brawny country-folk, looked like the remnants of a disinherited race... It came to pass that those scattered linen-weavers – emigrants from the town into the country – were to the last regarded as aliens by their rustic neighbours, and usually contracted the eccentric habits which belong to a state of loneliness.'

From George Eliot's *Silas Marner: The Weaver of Raveloe*, 1861. Van Gogh read *Silas Marner* in 1876.

'The passengers on the box could see that this was the district of protuberant optimists, sure that old England was the best of all possible countries... the district of clean little market-towns without manufactures, of fat livings, an aristocratic clergy, and low poor-rates. But as the day wore on the scene would change; the land would begin to be blackened by coal-pits, the rattle of handlooms to be heard in hamlets and villages. Here were powerful men walking queerly with knees bent outward from squatting in the mine, going home to throw themselves down in their blackened flannel and sleep through the daylight, then rise and spend much of their high wages at the ale-house with their fellows of the Benefit Club; here the pale, eager faces of handloom weavers, men and women haggard from sitting up late... Everywhere the cottages and the small children were dirty, for their languid mothers gave their strength to the loom...The gables of Dissenting chapels now made a visible sign of religion... The breath of the manufacturing town, which made a cloudy day and a red gloom by night on the horizon, diffused itself over all the surrounding country, filling the air with eager unrest. Here was a population not convinced that old England was as good as possible... Yet there were the grey steeples too, and the churchyards, with their grassy mounds and venerable headstones, and fine old woods covering a rising ground... The busy scenes of the shuttle and wheel, of the roaring furnace, of the shaft and pulley, seemed to make but crowded nests in the midst of the large-spaced, slow moving life of homesteads... it was easy for the traveller to conceive that town and country had no pulse in common, except where the handlooms made a far-reaching straggling fringe about the centres of manufacture...'

From George Eliot's Introduction to *Felix Holt-The Radical*, 1866. This was Van Gogh's favourite English novel, which he first read in 1876 and re-read in 1884 in Nuenen.

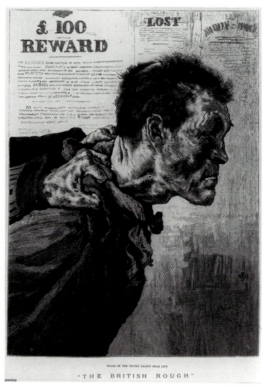

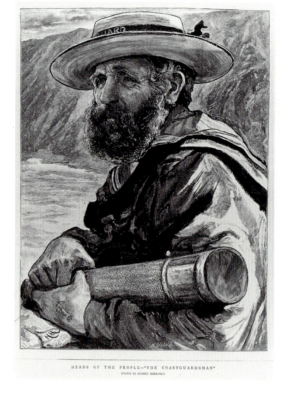

William Small
*Heads of the People I:
The British Rough,*
published in the
Graphic, 26 June
1878 (cat.100)

Hubert Herkomer
*Heads of the People:
The Coastguardsman,*
published in the
Graphic, 20
September 1879
(cat.91)

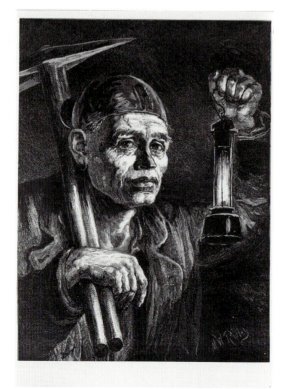

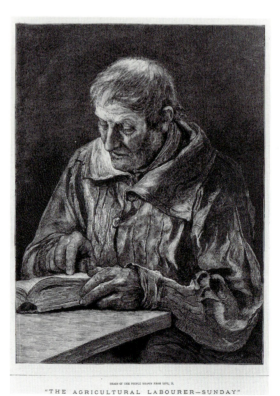

Mathew Ridley
*Heads of the People
VI: The Miner,*
published in the
Graphic, 15 April
1876 (cat.97)

*'He works laboriously
by the pale, dim light
of a lamp, in a
narrow tunnel, his
body bent double...
when he goes down
into the shaft, wear-
ing on his hat a little
lamp to guide him in
the darkness, he
entrusts himself to
God.'*
Van Gogh to Theo,
15 November 1878
[I 179]

Hubert Herkomer,
*Heads of the People:
The Agricultural
Labourer – Sunday*
(cat.90)

*'No more worthy men
are to be found in the
world than some of
our farm labourers...
If, however, such a
patriarch as is here
represented can read,
we may be pretty sure
that he spends some
of his well-earned
leisure over the well-
worn pages of the
family Bible.'*
From the *Graphic,* 9
October 1875

Edward Dalziel, *London Sketches –
Sunday Afternoon, 1pm: Waiting for the
Public House to Open*, 1874 (cat.83)

'A good many of them are decent people
enough, hard-working mothers of families,
who have been busy tidying the children
and preparing for the Sunday dinner, and
who come, jug in hand... Intermingled
with these are a less respectable class of
customers, persons of both sexes, unaccus-
tomed to frequent places of worship, on
whose hands the Sunday morning hangs
heavily, and who very possibly have
imbibed more than is good for them on the
Saturday night.'
From the *Graphic*, 10 January 1874

right: Vincent van Gogh *Woman
Weeping*, February 1883 (cat.20)

far right: Vincent van Gogh *Fisherman
in Sou'wester*, January 1883 (cat.19)

Fisherman with Sou'wester (cat.19) of January 1883. That same month he told Van Rappard: 'I hope to learn a few more things about the forces of black and white from these *Graphics*... What I have been working at especially of late is heads – Heads of the people – fishermen's heads with sou'westers, among other things.'[9] [III 354] Several years later Van Gogh returned to the same theme. Between December 1884 and May 1885 he produced over forty portraits of peasants at Nuenen, which he again called 'heads of the people' (cat.25, 26, 27, and 29).

Van Gogh's experience in working on peasant heads was to lay the foundations for his first masterpiece, *The Potato Eaters* (fig.36, cat.28). In writing about this work, which he finished in April 1885, Van Gogh explained:

> Though the ultimate picture will have been painted in a relatively short time and for the greater part from memory, it has taken a whole winter of painting studies of heads and hands. All winter long I have had the threads of this tissue in my hands, and have searched for the ultimate pattern; though it has become a tissue of rough, course aspect, nevertheless the threads have been chosen carefully and according to certain rules. [II 369-70]

The weaving analogy came from the preface of *Little Dorrit*, where Dickens talks about holding the 'various threads' of his story and asks the reader to look at the cloth 'in its complete state, and with the pattern finished.' [III 384]

Another indication of Van Gogh's fervent interest in the Black-and-White illustrators was his plan to return to London to work for the *Graphic* or the *Illustrated London News*. Back in December 1882 he had told Theo: 'If I went... to England, if I made every effort, I should certainly have a chance of finding a job... Of course, I love to do my best on my drawings, but

Vincent van Gogh *Head of a Young Peasant*, May 1885 (cat.29)

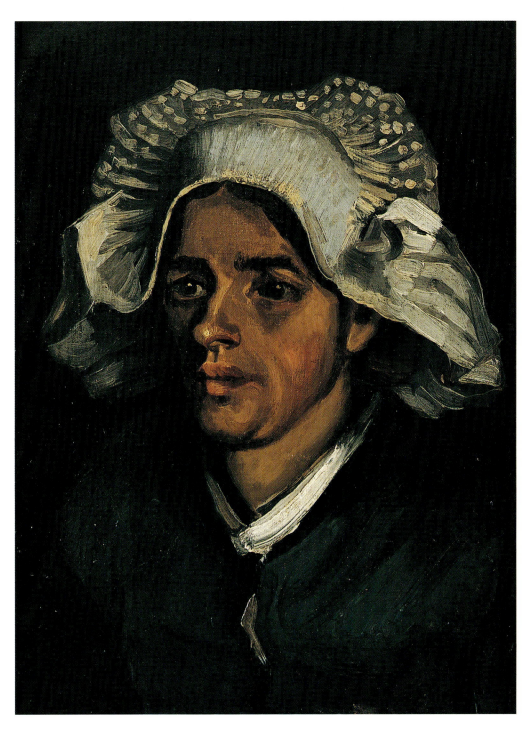

Vincent van Gogh *Head of a Peasant Woman*, April 1885 (cat.27)

to present myself at all those publishers' office – oh, I hate the thought of it!' [I 510] By the following June, he was talking more confidently. 'I should like to get into contact with the *Graphic* or *London News*... I should think it advisable to go to London myself with studies and drawings and to visit the managers of the various establishments or, better still, the artists Herkomer, Green, Boughton... I don't think it's every day that the managers of magazines find somebody who considers making illustrations his speciality,' he explained to his brother. [II 43-4]

The following month he returned to the idea: 'There would be more chance of selling my work, and I also think that I could learn a great deal if I came into contact with some artists there... What beautiful things one could make at those dockyards on the Thames!' he wrote. [II 75] Soon afterwards he asked Theo 'whether you think it would be better to go and see people like Herkomer, Green or Small *now*, or to *wait*.' [II 108] Theo suggested waiting, fearing that his brother's tattered clothes would give a bad impression. A year later Van Gogh had still not given up the idea of seeking work with the English magazines, and he had a series of photographs of his paintings taken to send to them.[10] In the end, however, he did not return to London and his work was never published in the English publications.

Van Gogh did not slavishly copy the English Black-and-White illustrators, but their work provided encouragement at a critical time. As Van Gogh explained: 'I adopted the manner of some English artists, without thinking of imitating them, but probably because I am attracted by the same kinds of things in nature.' [II 59]

Vincent van Gogh *The Potato Eaters*, April 1885 (cat.28)

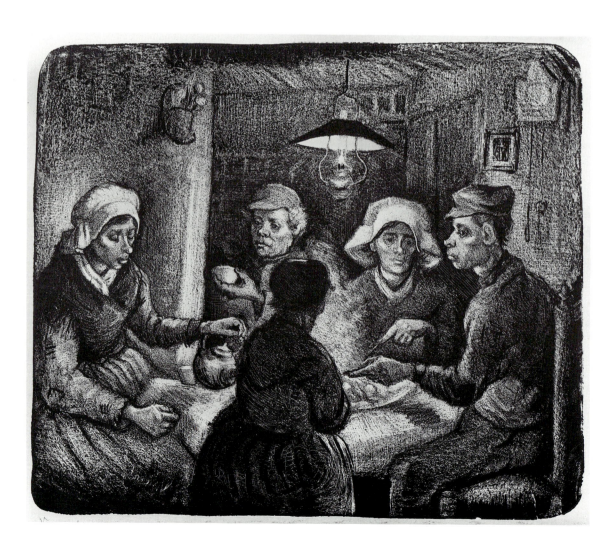

Anonymous *Life in Russia: Drosky or Sledge Drivers in a Tea House – A Hint for our Cabmen,* published in the *Graphic,* 14 February 1874 (cat.82)

LIFE IN RUSSIA: DROSKY OR SLEDGE DRIVERS IN A TEA HOUSE—A HINT FOR OUR CABMEN
FROM A SKETCH BY OUR SPECIAL ARTIST

1 The earliest reference to the Black-and-White illustrators is in Van Gogh's letter of 30 October 1877, in which he told Theo about the studio of the engraver Joseph Swain. [I 148]

2 Auguste Lançon (1836-87) was a leading French illustrator.

3 'Old Women' is presumably *Old Age – A Study at the Westminster Union* in the *Graphic,* 7 April 1877.

4 On c 30 May 1883 Van Gogh wrote to Theo: 'Do you remember that in the very beginning I sent you some sketches, *Winter Tale, Shadows Passing,* etc?' [II 37] The first drawing could have been related to Shakespeare's *The Winter's Tale.* The second drawing probably depicted miners, because of an earlier reference to 'passing shadows'. On 20 August 1880 Van Gogh wrote: 'I have sketched a drawing representing miners, men and women, going to the shaft in the morning through the snow, by a path along a thorn hedge: passing shadows, dimly visible in the twilight.' [I 200] Enclosed with his next letter of 7 September was a sketch of this drawing. [I 202/F831]

5 There are two watercolour versions of *Worn Out,* dating from September 1881 (F863/H34) [I 239, 491] and October 1881 (F864/H51) [III 305]. Two British works may have inspired Van Gogh's title for this composition, although both are of different subjects. Faed painted *Worn Out* in 1868, depicting an exhausted father at his ill son's bedside (Forbes Collection, London; reproduced in *Hard Times,* plate II). In November 1882 Van Gogh referred to the Faed painting with admiration. [I 482] There is also an illustration by William Thomas (1830-1900)

entitled *Worn Out* in the *Graphic* (18 December 1869), which depicts an exhausted young girl asleep in a doorway. Van Gogh had this print in his collection.

6 F1078a/H127. Van Gogh refers to depicting dustmen in October 1882 [III 365] and June 1883 [II 47, 56].

7 Van Gogh also knew Thomas Hood's poem *The Song of the Shirt.* [III 307] He must have been aware that it was a favourite subject with British artists, including Holl (1875, Royal Albert Memorial Museum, Exeter). Van Gogh drew and painted a number of works of seamstresses, some of whom are sewing a shirt (eg. F1221/H70).

7 Van Gogh's quotation from Herkomer was written in English.

8 The *Graphic* illustration of *Innocent: A Tale of Modern Life* was by Helen Paterson (1848-1926) and published on 11 January 1873. The girl's dress is similar to Macquoid's *Reflections,* published in the *ILN,* Christmas 1874 (both illustrations are reproduced in *English Influences,* p.41). On 20 August 1882 Van Gogh wrote to Theo about an oil study he had done in a wood of 'some large green beech trunks on a stretch of ground covered with dry sticks, and the little figure of a girl in white' (F8/H182). [I 442] Then on c 12-14 September he referred to the Macquoid illustration as 'the girl in white leaning against a tree.' [III 327] The linkage is suggested because in both cases he used the same Dutch expression 'meisje in 't wit' (girl in white).

9 Van Gogh wrote 'Heads of the people' in English.

10 In September 1884 Van Gogh told Theo that he intended to order some photographs 'to send them to some illustrated papers, to try to get some work.' [II 314] He sent two photographs to Theo on 22 October [II 319] and 'a few' more at the end of the month [II 319, 320]. There is no evidence that he actually sent the photographs to the English magazines. Six 'carte de visite' photographs survive at the Van Gogh Museum. These are of paintings which date from May-September 1884: *Weaver Facing Front* (F30/H479), *Weaver Standing in Front of the Loom* (F33/H489), *Plowman and Potato Reaper* (F172/H514), *Shepherd with Flock of Sheep* (F42/H517), a copy of Millet's *Sower* (lost) and *Woman Spinning* (lost).

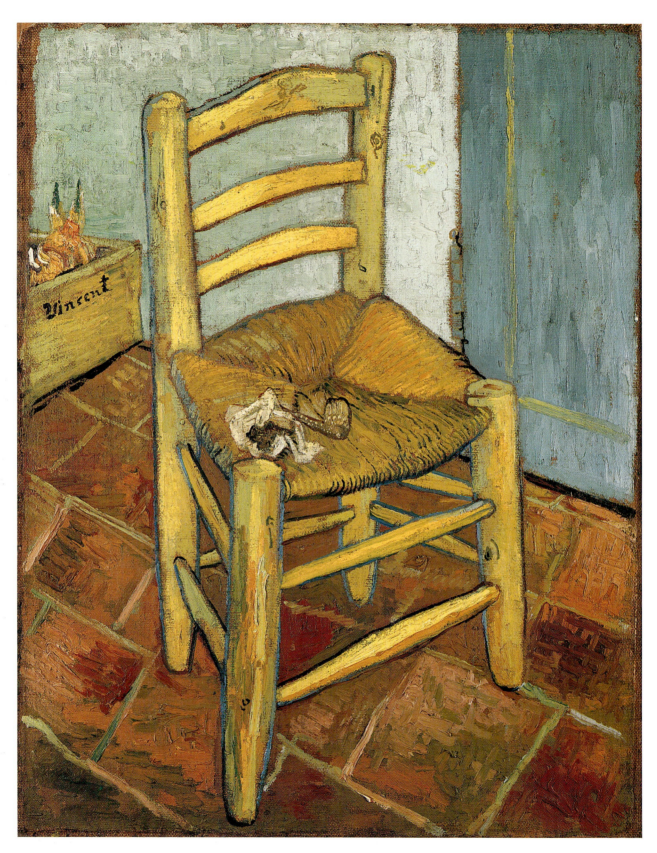

Vincent van Gogh *Van Gogh's Chair* (*The Chair and the Pipe*), November 1888 (cat.32)

The Empty Chair

'FOR ME THE ENGLISH BLACK-AND-WHITE ARTISTS are to art what Dickens is to literature. They have exactly the same sentiment, noble and healthy, and one always returns to them... I am organising my whole life so as to do the things of everyday life that Dickens describes and the artists I've mentioned draw,' Van Gogh told Van Rappard in September 1882. [III 330-1] Van Gogh, who saw close links between art and literature, frequently compared the qualities of painters and writers. He was an avid reader in four languages: Dutch, English, French and German. In his letters, he mentions over fifty English titles, many of which he read after he returned to Holland.

Van Gogh's favourite book from his time in England was *Felix Holt, The Radical*, by George Eliot. It was not a surprising choice, for the book, published in 1866, tells the story of an idealistic young man who has chosen the simple life of an artisan. In January 1876 Van Gogh sent Theo a copy of *Felix Holt,* suggesting he read it and then pass it on to their parents. 'It is a book that impressed me very much,' he reported with enthusiasm. [I 46] Typically, Van Gogh re-read the book several times in his life. In March 1884 he explained to Van Rappard: 'There are certain conceptions of life in it that I think are excellent – deep things, said in a guilelessly humorous way; the book is written with great vigour, and various scenes are described in the same way Frank Holl or someone would draw them. The conception and the outlook are similar.' [III 400]

Felix Holt continued to be a touchstone for Van Gogh. He refers to it in relation to *The Soup Kitchen* of March 1883 (cat.21), which depicts Sien's family. He wrote to Theo, explaining 'when you see this group of people together, can you understand that I feel at home with them? Some time ago I read the following words in Eliot's *Felix Holt*':

> *The people I live among have the same follies and vices as the rich – only they have their own forms of folly and vice – and they are not what are called the refinements of the rich to make their faults more bearable. It does not matter to me – I am not fond of those refinements but some people are and find it difficult to feel at home with such persons as have them not.*[1] [II 2]

Six years later, Van Gogh again drew a parallel between *Felix Holt* and his own work. Writing to his sister Wil about his painting, *Bedroom in the Yellow House,* he justified his choice of colours:

> *You will probably think the interior of the empty bedroom with a wooden bedstead and two chairs the most unbeautiful thing of all – and notwithstanding this I have painted it twice, on a large scale. I wanted to achieve an effect of simplicity of the sort such as one finds described in 'Felix Holt'. After being told this you may quickly understand this picture, but it will probably remain ridiculous in the eyes of others who have not been warned.*[2] [III 460]

Van Gogh also enjoyed Shakespeare throughout his life, evidence of his mastery of the English language.[3] In July 1880 he wrote to Theo: 'My God, how beautiful Shakespeare is! Who is mysterious like him? His language and style can indeed be compared to an artist's brush, quivering with fever and emotion.' [I 196] Nine years later, in the asylum at St-Rémy, Shakespeare comforted him in his time of misery. After being sent *Measure for Measure* and

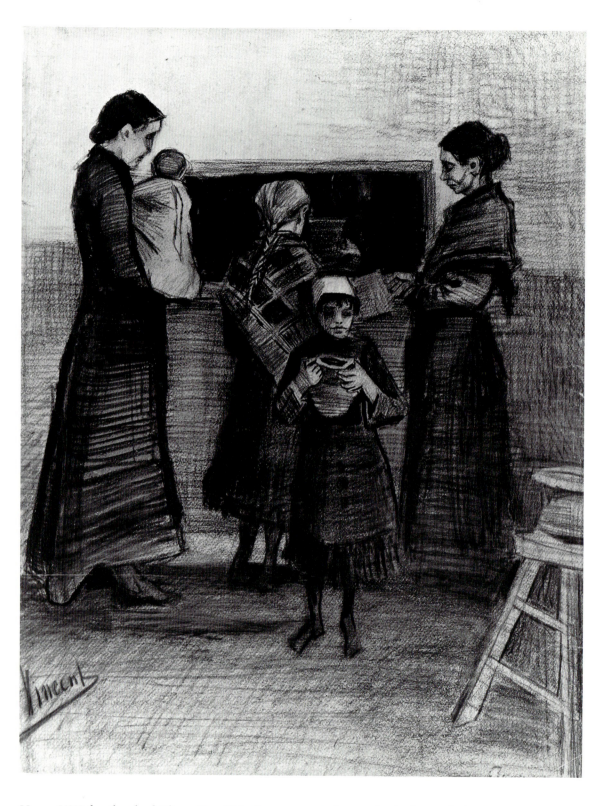

Henry VIII, he thanked Theo: 'It will help me not to forget the little English I know, but above all it is so fine... What touches me, as in some novelists of our day, is that the voices of these people, which in Shakespeare's case reach us from a distance of several centuries, do not seem unfamiliar to us.' [III 187]

Thomas Carlyle was another British writer whom Van Gogh admired and continued to read long after he left England.[4] Other English novelists he enjoyed included Daniel Defoe, Charlotte Brontë, Edward Bulwer-Lytton, Mrs Craik and Elizabeth Wetherell, as well as the

poetry of Thomas Campbell, Thomas Hood, John Keats, Christina Rossetti and Alfred Tennyson. Van Gogh also read the American writers Harriet Beecher Stowe, Henry Longfellow, Washington Irving, Edgar Allan Poe and Walt Whitman.

Van Gogh's favourite English writer, however, was the highly popular Charles Dickens. There are no Dutch authors to whom he refers as often in his letters, and only Michelet and Zola among French writers recur slightly more frequently. During his life Van Gogh read nearly all of Dickens' books, most of them several times.

Even after he left England, Van Gogh's letters are peppered with references to Dickens. On moving to Dordrecht in January 1877 he described how his lodgings overlooked houses covered with ivy. 'A strange old plant is the ivy green,' he quoted from *Pickwick Papers*. [I 92] A few months later he talked of ivy as the plant 'which stealeth on though he wears no wings.'[5] [I 116] In August 1877 he told Theo he had breakfasted on a piece of dry bread and a glass of beer. 'That is what Dickens advises for those who are on the point of committing suicide, as being a good way to keep them, at least for some time, from their purpose,' he joked.[6] [I 135]

Whilst living in the coal mining area of the Borinage, Van Gogh read *Hard Times*. Set in 'Coketown', Van Gogh may have seen a parallel with his own situation. On 5 August 1879 he explained to Theo: 'It is excellent; in it the character of Stephen Blackpool, a working man, is most striking and sympathetic.' [I 190] When he visited his parents a fortnight later in August 1879, his mother commented that 'he reads Dickens all day and speaks only when he is spoken to.' [I xxix] Among other works Van Gogh read during this period were Dickens' *A Child's History of England* and *A Tale of Two Cities*. Later he suggested that *A Tale of Two Cities* was an inspiration to sketch: 'One can get such splendid subjects for drawing out of that revolutionary period... incidents of everyday life and the appearance of things as they used to be'. [III 385-6]

In The Hague, where Van Gogh bought new editions of *A Christmas Carol* and *The*

James Mahoney, frontispiece and illustration to Charles Dickens' *Little Dorrit*, 1873 (cat.124)

Fred Barnard, frontispiece and illustration to Charles Dickens' *The Life and Adventures of Martin Chuzzlewit*, 1872 (cat.123)

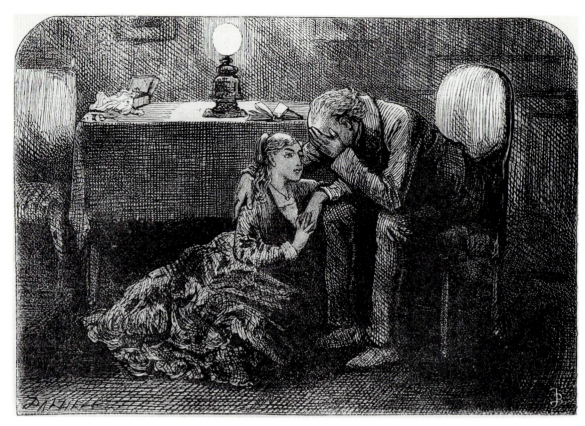

Haunted Man, he told Van Rappard: 'I have re-read these two "children's tales" nearly every year since I was a boy, and they are new to me again every time... There is no writer, in my opinion, who is *so* much a painter and a Black-and-White artist as Dickens.' [III 374] When discussing *Little Dorrit,* he pointed out that the preface to the book helped to explain his own artistic problems. Dickens, he said, expresses 'what goes on the mind of a figure painter while he is working on a composition.' [III 383] It was during his stay in The Hague that he also read another two of Dickens' works, *Oliver Twist* and *Martin Chuzzlewit.*

Five years later, in Arles, Van Gogh was still enjoying the novelist. In November 1888, he used an analogy from Dickens to describe his painting *Memory of the Garden at Etten.* He told his sister Wil that he had depicted her walking in the garden, looking like she was a character out of a Dickens novel. [III 447-8]

Not only did Van Gogh find resonances of characters from Dickens in his paintings, but he made a more direct reference by including a copy of one of his books in a portrait of the Arlesienne. In the four versions he did in February 1890 he placed *Christmas Stories* (cat.126), along with the American writer Harriet Beecher Stowe's *Uncle Tom's Cabin,* on the table in front of Madame Ginoux.

Van Gogh's interest in Dickens was heightened by the excellent illustrations to his novels. Dickens attracted the very best illustrators, particularly for the Household Edition, which was published in the 1870s and avidly collected by Van Gogh.[7] *Christmas Stories,* the book Van Gogh featured with his Arlesienne, was illustrated by Edward Dalziel (cat.126). It included a picture of a sailor with a sou'wester, which must have interested Van Gogh because of the fisherman he had drawn at Schveningen. *Little Dorrit* had illustrations by James Mahoney, which he described as 'very beautiful'. [III 336] *Martin Chuzzlewit* (cat.123) was illustrated by Fred Barnard and his *Brother and Sister* echoes Van Gogh's images of a man with his head in

his hands. Other illustrators included Charles Green, Luke Fildes, Arthur Boyd Houghton, John Leech, and George Cruickshank.

It is *Van Gogh's Chair* (cat.32), and the companion painting, *Gauguin's Chair* (fig.26), which epitomises Van Gogh's interest in Dickens and his illustrators. Dating from November 1888, just before the crisis with Gauguin, these two paintings were inspired by a series of links between Dickens, Millais and Fildes. Van Gogh had learnt about the connection nearly seven years earlier, when he had acquired the *Graphic Portfolio*. The portfolio described how Millais had encouraged Dickens to commission Fildes to illustrate *Edwin Drood*. It told how Dickens had been so impressed by *Houseless and Hungry* (cat.84) that he 'engaged Mr Fildes to illustrate *The Mystery of Edwin Drood* (cat.122), the work he was engaged upon at the time of his death'. Later that year Van Gogh discovered more about the commission from reading John Foster's biography, *The Life of Charles Dickens*.

With great excitement Van Gogh recounted the story to Theo:

> *I see Millais running to Charles Dickens with the first issue of the 'Graphic'. Dickens was then in the evening of his life, he had a paralysed foot and walked with a kind of crutch. Millais says that while showing him Luke Fildes' drawing 'Homeless and Hungry', of people and tramps in front of a free overnight shelter, Millais said to Dickens, 'Give him your "Edwin Drood" to illustrate,' and Dickens said, 'Very well.' 'Edwin Drood' was Dickens' last work, and Luke Fildes, brought into contact with Dickens through those small illustrations, entered his room on the day of his death, and saw his empty chair; and so it happened that one of the old numbers of the 'Graphic' contained that touching drawing, 'The Empty Chair'.* [I 509]

This illustration of Dickens' study, with his empty chair (cat.85), was to remain one of the most memorable images published by the *Graphic*.

For Van Gogh, the story of this commission had a special significance. In 1873, when he had arrived in London, he had immediately named Millais as one of the best English artists.

right: Edward Dalziel, frontispiece and illustration to Charles Dickens' *Christmas Stories*, 1879 (cat.126)

below: Arthur Boyd Houghton, frontispiece to Charles Dickens' *Hard Times*, 1866 (cat.121)

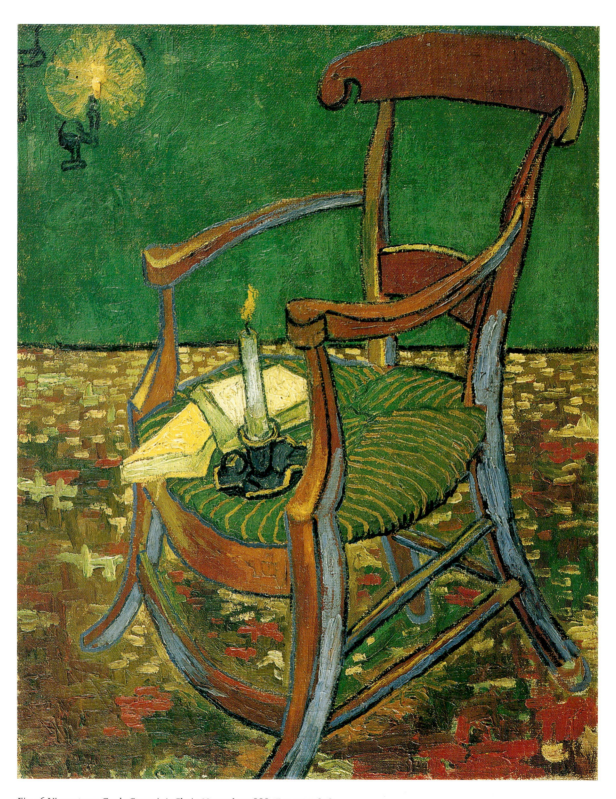

Fig.26 Vincent van Gogh *Gauguin's Chair*, November 1888 (F499/H1636)
(Rijksmuseum Vincent van Gogh [Vincent van Gogh Foundation], Amsterdam)

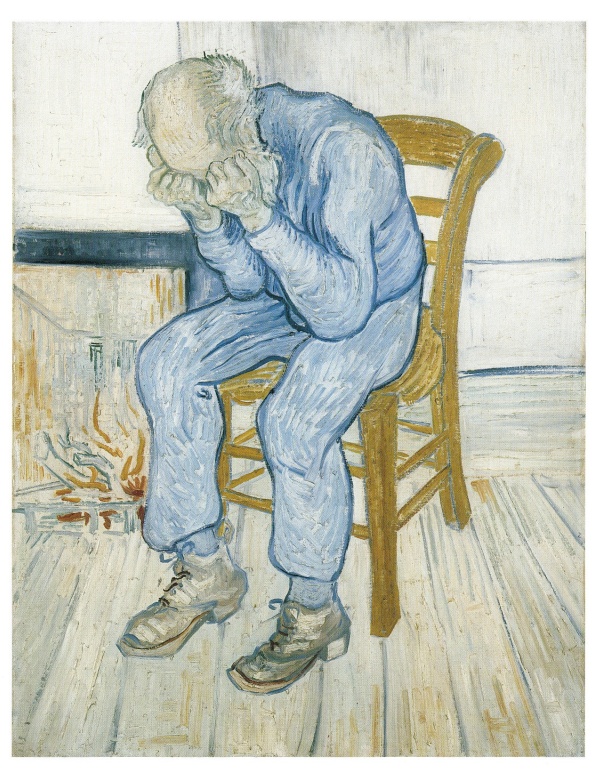

Vincent van Gogh *At Eternity's Gate*, May 1890 (cat.33)

Later on in The Hague, Fildes became one of his best loved Black-and-White illustrators. Dickens, of course, was Van Gogh's favourite English writer.

Van Gogh had read *Edwin Drood* in June 1882, when he was suffering from gonorrhoea. Writing from his hospital bed, he told Theo: 'I have... a few volumes of Dickens, including *Edwin Drood*... Good God, what an artist! There's no one like him.' [I 387] As soon as he was out of hospital Van Gogh bought a copy of the Fildes print of Dickens' empty chair. 'I am also very anxious to show you the wood engravings. I have a splendid new one, a drawing by Fildes, *The Empty Chair* of Dickens from the *Graphic* of 1870,' he told Theo. [I 424] In December 1882, when he related the story of the Fildes commission to Theo, he went on to discuss the mortality of his favourite English artists. 'Sooner or later there will be nothing but empty chairs in place of Herkomer, Luke Fildes, Frank Holl, William Small, etc.' he explained. [I 509]

Characteristically, the story of the 'empty chair' acted as a trigger to Van Gogh's own personal vision. Two paintings resulted, one representing his own chair, the other his friend Gauguin's. Each can be read as a kind of portrait. Although the figures of the two men are missing, Van Gogh's simple straw chair and the elegant armchair of Gauguin tell us much about how he saw himself and his companion. So too do the room settings, his own chair in daylight and Gauguin's at night, as well as the handful of objects he selected for each picture.

Painted toward the end of his life, less than two years before his suicide, the 'empty chairs' also reflect the importance that Van Gogh placed on English culture, especially Millais, Fildes and Dickens – that great trio of Englishmen – artist, illustrator and writer. The paintings, in a sense, pay homage to these important sources of inspiration.

Finally, the two 'empty chairs' are a symbol of the mortality of an artist; all he can leave behind is his work. When Van Gogh completed these two paintings he had already given up hope of selling his pictures. He gave both the 'chair' paintings to his brother, not daring to believe that they would ever be appreciated by a wider audience than a few friends. Van Gogh

Luke Fildes *Sleeping it off* from Charles Dickens' *Edwin Drood*, 1870 (cat.122)

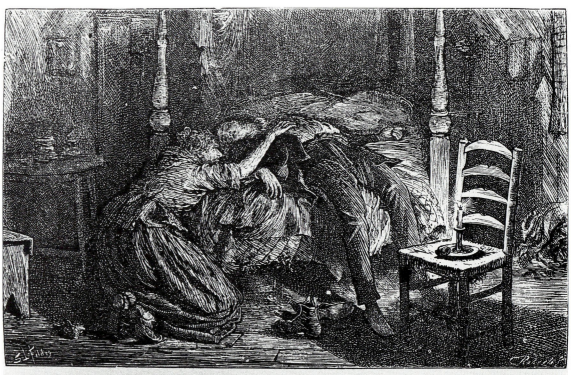

Sleeping it off
(p. 269)

THE EMPTY CHAIR, GAD'S HILL—NINTH OF JUNE 1870

Luke Fildes *The Empty Chair, Gad's Hill – Ninth of June 1870* (cat.85), published in the *Graphic*, Christmas 1870.

can hardly have imagined that one of them, his own 'empty chair' would in 1924 become one of the first of his works to enter a public collection in Britain. It belongs to the National Gallery in Trafalgar Square, just a few minutes walk away from the street where Van Gogh once worked as an art dealer.

1 Van Gogh wrote out the quotation in English, with a few minor mistakes. The extract is from the last chapter (51) of *Felix Holt*, where Felix is asking Esther Lyon to marry him. Van Gogh's other favourite Eliot books were *Scenes of Clerical Life* [I 48, 66, 92, 164, III 400], *Adam Bede* [I 23, 34, 92, 93, 163, III 400], *Middlemarch* [I 544], *Romola* [I 163-4]and *Silas Marner* [L66, I 163 and reference in letter of early August 1878].

2 Van Gogh made frequent references to *Felix Holt* in his letters. Van Gogh's father wrote to Theo that he had received a letter dated 11 March 1876 (lost) from him, 'about *Felix Holt*'. His father added that he was reading Eliot's book 'with interest' (Hulsker, *Simiolus*, p. 249). Van Gogh also refers to *Felix Holt* in further letters [I 80, 183, II 25, and references omitted from English edition in his letter of 18 August 1876 and at the end of his sermon letter]. Van Gogh did three versions of *Bedroom in the Yellow House*, the

first in October 1888 (F482/H1608) and two copies in September 1889 (F483-4, H1771 and 1793).

3 Van Gogh read *Hamlet, Henry IV, Henry V, Henry VI, Henry VIII, King Lear, Macbeth, Measure for Measure, The Merchant of Venice, Richard II* and *The Taming of the Shrew*. [I 195, 196, 249, II 148, 217, 219, III 187-8, 192, 456, 546]

4 Van Gogh read *History of the French Revolution* [I 146, 325], *Oliver Cromwell's Letters and Speeches* [I 125, 325, II 194-5], *On Heroes, Hero-Worship and the Heroic in History* [II 170, III 16] and *Sartor Resartus* [II 62, III 374].

5 These two extracts, which are slightly misquoted, are from the poem 'The Ivy Green', recited by the clergyman of Dingley Dell in chapter VI of *Pickwick Papers*.

6 Van Gogh repeated the same comment in

April 1889, a year before he took his own life. [III 452]

7 For Van Gogh's references to Dickens' illustrators see his comments on Barnard [I 382, 524, III 374], Leech [III 375], Cruikshank [III 375], Fildes [I 382, 509] and Mahoney [I 450, III 336-7].

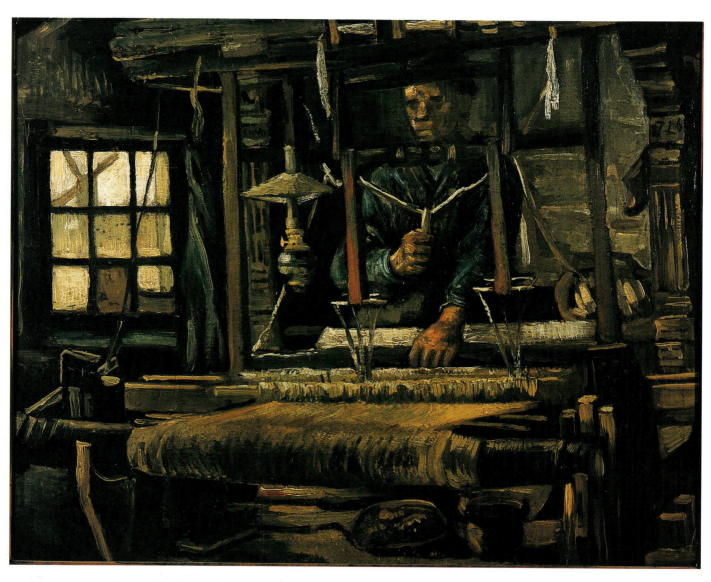

Van Gogh *Interior with Weaver*, July 1884 (cat.23)

'The miners and the weavers still constitute a race apart from other labourers and artisans, and I feel a great sympathy for them. I should be very happy if someday I could draw them so that those unknown or little known types could be brought before the people. The man from the depth of the abyss – de profundis – that is the miner; the other with his dreamy air, somewhat absent minded, the somnambulist, that is the weaver.'

Van Gogh to Theo, 24 September 1880 [I 206]

'But what I wanted to express by it was just this: "When that monstrous black thing of grimed oak with all those sticks is seen in sharp contrast to the greyish atmosphere in which it stands, then there in the centre sits a black ape or goblin or spook that clatters with those sticks from early morning to late at night. And I indicated that spot by putting in some sort of apparition of weaver."'

Van Gogh to Van Rappard, late March 1884 [III 402]

Pilgrim's Progress and Vincent van Gogh's Métier [1]

by Debora Silverman

Fig.27 Vincent van Gogh *Weaver, Facing Right,* February 1884. (F1122/H454) (Rijksmuseum Vincent van Gogh [Vincent van Gogh Foundation], Amsterdam)

Fig.28 Vincent van Gogh *Weaver, Facing Front,* May 1884. (F30/H479) (Rijksmuseum Kröller-Müller, Otterlo)

Fig.29 Vincent van Gogh: perspective frame, included in letter of 5-6 August 1882. [I 433]

IN 1884 VINCENT VAN GOGH became a devoted observer of the labour activities of the weavers of Nuenen, while he considered the progress of his own artistic apprenticeship. At this time Van Gogh construed his work as an artist as a painstaking and rigorous craft, what he called his 'métier', a product of methodical and arduous exertion rather than a sudden release of exalted vision. In executing the weaver series, Van Gogh articulated an equivalence between his artistic work, his métier, and the work of the weaver at his loom – 'le canut à son métier'. He expressed this equivalence by signing his own name on the wheel where the thread was released to the loom shuttle, and by presenting the weaver 'drawing threads' in a position strikingly similar to that of an artist directing his pen across the surface of the paper (fig.27). Van Gogh deepened the identification between the two craft activities by comparing the artist's mechanical tool, a perspective frame of his own construction, to the rugged frame of the weaving loom. In his frontal weaver of 1884 Van Gogh incorporates the component parts of his perspective frame onto the frame of the loom itself (fig.28). The threads of the weaving frame are suspended in the pattern echoing that of the perspective device, while the wooden stakes supporting the loom's oblong frame are marked by a series of notches. These notches replicate the functional holes on Van Gogh's perspective tool, where they served as similar adjustable points for the fixing of the wooden frame to the two upright poles. By highlighting the resemblance of the perspective frame and the frame of the loom, Van Gogh visibly likened himself to the weaver and his craft.

Van Gogh's association between the skilled artisan situated at the métier and the artist engaged in his métier comprises more than linguistic similitudes and intriguing visually-rendered analogies. For the coupling of artist and artisan, art and craft, is deeper and more explicit in Van Gogh's life and work, and provides a key to his self-definition and his conception of the nature and function of his art. Throughout his career Van Gogh was committed to the depiction of labour, the active strain and effort of pre-industrial workers, particularly peasants and craftsmen. He not only represented workers but expressed a deep personal identification with them, attempting to reproduce the activity of pre-industrial labour in his own pictorial forms.

How can we explain Van Gogh's sense of the powerful interdependence between art and work? His consistent drive to live among, depict and emulate labour represents a highly elaborated religious project of justification, with a specific intellectual history. Its origins emerge from a consideration of Van Gogh's early career between 1869 and 1880, which encompassed a deep religious crisis concerning the nature and value of his own work and worthiness. A crucial period of self-definition preceded Van Gogh's decision to become a painter at the age of 27. The central problem of this period was precisely the conflicting claims of different definitions and functions of work, embodied in Van Gogh's attempt to choose what he called a 'profession' or 'vocation' between 1869 and 1880. The first seven years of this period witnessed Van Gogh's immersion in the professional working world of business. Yet he rejected the security of earning a living as an art dealer in favour of the impractical, but sacred worthiness of a religious vocation, first as a Methodist lay preacher in England, and then as an evangelist in the mines of the Belgian Borinage. This choice of a spiritual calling, however, did not silence the

inner voices and outer expectations that demanded daily earnings. When Van Gogh chose to become an artist in 1880, he attached this new calling to his own ongoing struggle with the ambiguous Calvinist meanings of justification: justification by faith alone, which elevated spiritual integrity over worldly achievement; and justification by works, which necessitated worldly recognition as a sign, if not the key to salvation and election. In applying this conflict to painting, Van Gogh placed recurrent pressure on the image to be both a sign of regular, productive work – what he termed 'earning my bread' – and a conveyor of spiritual transcendence -what he called 'deserving God's grace'. This dual imperative that visual art act simultaneously as tangible craft product and immaterial sacred presence structured stylistic choices as it transposed religious conflict into image-making, whilst illuminating some of the distinctive historical texture of Van Gogh's psychological being.

The terms of Van Gogh's protracted struggle over the meaning of work and worthiness were set by a number of competing religious legacies within Calvinism that Van Gogh absorbed in the Netherlands and in England. These included his minister father's Romantic theology of the Groningen School,[2] English Methodism, and Dutch modernism, a widely debated religious movement of the 1860s which celebrated art as a special vehicle of divinity. This article focuses on one important source of Van Gogh's religious mentality of work – the evangelical populism he encountered in John Bunyan's *Pilgrim's Progress* during the period he spent in England as a teacher and lay preacher.

The Bunyan text has been mentioned as one of a succession of books that Van Gogh read in his early period, but it plays a more important role than has been hitherto acknowledged. The themes of the book corresponded to Van Gogh's personal predicament of material and religious crisis of 1875-76, and provided him with the critical and intellectual tools with which to redirect his 'craving for sanctity' from inner purity to social engagement. Moreover, the text offered him lasting attitudes towards the visual that are expressed in his artistic practices.[3]

John Bunyan's 'Pilgrim's Progress': Visuality as Social and Literary Inversion

First published in 1678 John Bunyan's *Pilgrim's Progress* was a landmark in the development of English Protestant dissent. Bunyan's choice of subjects and vernacular style posed a striking challenge to the conventions of elite literary and religious culture, and the book made available to scores of readers of plain English theological debates hitherto confined to learned initiates in Latin and Greek.[4] While some elements of Bunyan's biography remain ambiguous, we do know that he was born in Bedford in 1628 to a family of 'humble origins', that his father was a brazier, equipped with a shop and forge, and that Bunyan practiced the trade of the tinker, a mender of metal pots and pans. After a spiritual crisis in early adulthood, Bunyan experienced a personal conversion and began to engage in popular preaching, exhorting crowds assembled in open fields, makeshift pulpits and finally in a small Baptist church in Bedford to open their hearts to Christ. As a craftsman and lay preacher, Bunyan was not unusual in the English countryside of the 1650s – the upper ranks of Nonconformity were filled with artisans such as mechanics, cobblers, weavers, and cheesemongers who took to the fields and hamlets to preach the Word. Like many of them Bunyan suffered repression under the restored monarchy and was imprisoned in 1660 for unlicensed preaching. During the twelve years he spent in jail Bunyan supported his family by learning a new trade, tagging laces, and wrote the first part of his masterpiece of anti-institutional religious piety, *Pilgrim's Progress*. In the first fifteen years

Fig.30 (top) and 31 Illustrations to John Bunyan's *The Pilgrim's Progress* from a popular 19th century edition published by the Book Society for Promoting Religious Knowledge Among the Poor, 1867

after its publication, the book was printed in over twenty editions in England, and was translated into numerous Dutch editions, due to the efforts of publisher Johannes Boekholt, who had commissioned the first illustrations to accompany Bunyan's text.[5] Its influence proved extraordinarily far-reaching after Bunyan's death – by the 19th century *Pilgrim's Progress* was one of the most widely read books in England, which, along with Robinson Crusoe and the Bible, formed the map of what historian E. P. Thompson has called the 'inner spiritual landscape of the lower classes'. The book provided one of the foundations of 19th century English Methodism, and influenced many other European Protestant evangelical movements, including those in the Netherlands, the social composition of which continued to reflect the inclusiveness that originally drew segments of the popular classes to its message of spiritual egalitarianism and the religion of the heart.[6]

The full title of Bunyan's book is *The Pilgrim's Progress from this World to that Which is to Come: Delivered under the Similitude of a Dream*, which captures the story and the author's invention. The narrative presents the journey of Christian from the city of destruction to the celestial city. Distressed by the weight of his sins which he carries as a burden on his back, Christian relinquishes his family, home and possessions, and sets out on his journey. He is directed by an evangelist to the light emanating from the distant celestial city, and he recognises his destination. Christian loses his burden when he sees a vision of Christ on the cross, and he replaces his fear of divine punishment with his identification with Christ's unconditional love (fig.30). The journey proceeds as Christian joins up with fellow pilgrims like Faithful and Hopeful as they endure multiple trials and battles with the forces of evil poised to deter them from their path to salvation. In each case, Christian and his fellow pilgrims endure the ordeals and dispense with their foes, ultimately reaching their destination; they arrive at the gate and are granted entry to the splendid celestial city of eternal life.[7]

Embedded in the story of the pilgrims' protracted struggle to their final redemption was a new theme, the sanctification of the poor, which transposed some traditional strains of Calvinist piety into the new key of social criticism. Bunyan's point of departure is the devaluation of the temporal world, and the cultivation of spiritual purity through renunciation. Earthly existence is seen as a series of obstacles to be overcome; the route to the Kingdom of heaven was to be through self-denial, humility, and total surrender to Christ's selfless love. Worldly success and earthly recognition provided no credit in this economy of salvation, for justification was only realised by faith alone, unconnected to the signs of election in visible worldly achievement. Provision for the life eternal, called by the pilgrim his 'inheritance incorruptible', was made only by accumulating the inner spiritual treasures of the heart in unconditional submission to God's disposition, by enduring suffering as a necessary test of faith, and by embracing the source of piety in feeling, unimpeded by rational abstraction or institutional authority.

Bunyan's radical invention was that he, reviving an older subversive theme within Christianity, attached these requisites of salvation to a specific social location – the poor and the lower classes. Material deprivation gave the lower social orders a natural spiritual advantage in this theology of self-denial, humility, and worldly renunciation. Bunyan presents Christ as a labourer – 'he who has worked' and gives away the fruits of his labour to the poor. Bunyan renders Christ's rebuke as the revulsion of members of polite society against the sordidness of Christ's outer appearance; they chase him away 'like a common stone' instead of realising that they were in the presence of 'a precious stone covered over with a homely crust'.[8] The pilgrims, who emulate Christ, are strangers and outcasts, divested of material possessions and social status (fig.31). Their indigent outer appearance provokes maltreatment from other men; but

their hearts are full with love of Christ and unquestioning faith, and they are rewarded with splendour and bounty in the life to come.[9]

Accompanying Bunyan's celebration of poverty and purity was his indictment of worldly position and material success, for he affirms the inverse proportion between spiritual wealth and material achievement. The pages of *Pilgrim's Progress* are filled with personifications of evil, invested with social specificity. Bunyan constructs enemies for the godly pilgrims with identifiable class positions, and moves them through their journey by encounters with a whole range of vices situated in the upper reaches of the social scale. These include such aristocratic representatives as Lord Hate-Good, Lord Luxurious and Lord Lechery, and the bourgeois devotees of legal, commercial, and intellectual culture, such as Legality, Mr. Money-Love, Mr. Self-Will and the Professor. In their victories over all these social superiors, the pilgrims learn that the source of salvation lies only in the inner treasures of the heart, and that the temporal distinctions of splendid clothing, elegant speech, and high birth are obliterated by the divine imperatives for humility, faith, and love. In the final scenes this inversion is complete as the poor pilgrims are transformed into the aristocrats in the kingdom of heaven, regaled with beautiful clothes and jewels, bounteous feasts, and joyous music.

At the heart of Bunyan's text is what I will call 'visual piety', which structures both the form and content of his innovative work. In rejecting reason and celebrating the religion of feeling, Bunyan accorded a privileged place to seeing, both as an attribute of divinity and as the vehicle for the pilgrim's redemption. *Pilgrim's Progress* de-emphasised the role of God as Judge and elevated Him as a source of light and love; He is a surveyor whose dominion is expressed in penetrating sight. The God in Bunyan's text is characterised as the 'God who sets light by the world'; 'who looks down from heaven to encompass all in His eyesight'; 'who sees through to our hearts, for our inmost thoughts are always open to His eyes'.[10] The goal of the pilgrims is conceived by Bunyan as a visual deliverance – their salvation is realised in seeing Christ directly in the kingdom of heaven: 'In that place, they enjoy the perpetual sight and vision of Him and see him as he is; they look their redeemer in the face with joy'.[11] This direct beholding obliterates the need for all other senses; in the celestial city, the pilgrims exclaim at their journey's end, that they 'can now live by sight alone', in the company of Christ.[12]

Before they achieve their redemption in seeing Christ close up, the pilgrims are granted only a distant, vague, and mediated view of their redeemer and His city. Indeed, Bunyan presents their entire journey as a series of illuminations, mappings, and sightings; the progress of the pilgrim is measured by the progressive clarity and fixity of Christian's vision.

After losing his burden, Christian is guided by the Shining Ones, radiant emissaries from heaven. They provide him with a topographical view, directing him to look over and across a very wide field to a distant mountainous wicket-gate and shining light. At this point, Christian can only see a vaguely glowing light; the wicket-gate is too far away, and obscured to his sight. The rest of his journey unfolds as Christian responds to the visual instructions of the Shining Ones that he 'keep that light in his eye and follow it', and, in moving toward it, that he 'get the City itself in view'.[13]

A series of other guides appear to help the pilgrims, equipped with candles, pictures, maps, and mirrors that facilitate their visual deliverance to the celestial city. Some of these offerings – such as that which results in the pilgrim looking in the mirror and seeing Christ's face – have biblical precedent, and Bunyan refers the reader to their Old or New Testament referents. Other visual facilitators do not have such explicit theological sources, and emerge from a world of craft devising. On a number of occasions, the pilgrims rely on optical instruments to help

focus their sighting of the divine centre. In the culminating scene of part one, four shepherds offer Christian and Hopeful their 'perspective glass' – an early name for a spy glass or telescope – to bring the city gates into sharp view. But the shepherds wonder 'whether the pilgrims have the skill to look through' the device, as at this stage, the pilgrims are indeed unable to rivet their eye to its point of focus on the gates. Their hands shake, and the instrument moves unsteadily on the eye, yielding a blurred image. This blurred vision is removed entirely upon the pilgrims entry to the celestial city, where they experience the fullness of light and acuity of focus in the face of Christ himself.[14]

The theme of salvation through the visual and the mediations of craft are enacted by the pilgrim in Bunyan's book. But visual redemption and its craft facilitators also capture the essence of Bunyan's own literary strategies, which he articulates quite explicitly. Bunyan is very self-conscious about his role as image-maker and craftsman of his text. He offers a remarkable account of his visual style as a new literary form, whose discovery transforms the writer himself into an instrument of revelation.

Bunyan conceived his work as a visual allegory, whose forms and functions he discussed in a provocative preface that he entitled the 'Author's Apology for the Book'. In an imaginary dialogue with his detractors, Bunyan anticipates that the critics will not only condemn his humble heroes as unworthy of literary representation, but will impugn his vernacular style as a grating departure from classical symmetries. The 'carpers', as he calls them, will dismiss his language as base and inelegant, his metaphors as obscure, dark, insubstantial, and valueless. Bunyan responds by legitimising the form of his words in the same way he elevates the pilgrim in the story. Like the pilgrim, whose visible indigence belies inner spiritual purity, Bunyan claims his words only appear rough, crude, and dark; and he warns the reader not to confuse their outer form with their inner worth. He defends his choice of style as deliberate, and redemptive; he rejects formal elegance as hollow and faithless, like the mellifluous cadences of the irredeemable Talkative in the story. Bunyan asserts that his rough and humble words, divested of surface finery, are containers of spiritual substance, carriers of essential truth beneath their apparently grimy wrappers: 'My dark and cloudy words, they do but hold the truth, as cabinets enclose the gold'; 'words as dark as mine make truth to spangle and its rays shine'.[15]

In this defence of his allegorical style, Bunyan constructs an exact literary analogue to the religious inversion described in the story. The social inversion of religious redemption is restated in the literary inversion of artistic value. Like the pilgrim, whose worldly debasement entitled him to the greatest measure of divine attention, Bunyan's vernacular style elevates humble words as agents of revelation. Bunyan characterises this formal revelation visually, in terms of illumination – his words are dark forms enclosing golden rays; and as sharply focused sight – the words appear unclear, shrouded in cloudy obscurity, but at the same time conceal a deeper and sparkling acuity. Thus the reader, in the act of reading the text, will experience the same cycle of visual redemption assigned to the pilgrim in the story; as the pilgrim progresses to salvation by moving from darkness to light, from blurred vision to keenly focused eyesight, the reader moves from concealment to revelation, slowly recognising the glowing truth and keen insight contained in Bunyan's unconventional literary forms. In attributing such sacred power to the very forms of his language, Bunyan promotes the craft skill of the writer as the mediator of revelation. In the end of the apology Bunyan compares the artist's pen to the peasant's plough, as equally guided by God's designs, and as humble vehicles of transcendence. The craft I use he says, simple and awkward as it may be, 'still pleases God'; it 'makes base

things usher in the divine'.[16] The base ushering in the divine unites both form and content in Bunyan's *Pilgrim's Progress*; the social message of the sanctification of the poor is wedded to a low literary style that transmits deliverance through popular allegory.

A Pilgrim and a Stranger: Vincent van Gogh in England, 1876

Pilgrim's Progress had a special correspondence to Van Gogh's personal predicament of 1875-76 and contributed in significant ways to his self-definition and visual assumptions. Soon after being transferred from the London to Paris branch of the Goupil art dealers in May 1875, Van Gogh entered a period of intense religious brooding, and by January of 1876 his remoteness from the daily responsibilities of his job led to his dismissal from the firm. He decided to return to England and took up a post as an assistant teacher. After spending a short time in a working class boarding school in Ramsgate, he founded a position in Isleworth, near London, in a religious boys school run by the Reverend Slade-Jones, where he acted as a kind of assistant evangelist. He complemented this religious work in the school by delivering sermons in the Methodist Churches in nearby Richmond and Petersham, taking turns with other lay preachers in sharing their thoughts on Christ's atoning love.[17]

It is during this year of career change and Methodist practice that Van Gogh refers to *Pilgrim's Progress* explicitly as a favoured book, one he is 'exceedingly fond of'.[18] Bunyan's story responded to powerful personal needs in this period of dislocation. In terminating his position at Goupil's Van Gogh ended a seven year preparation towards career consolidation and financial security. He experienced the humilation of dismissal and endured the shock and disappointment of his parents, who had invested great expectations in their eldest son's professional advancement and were themselves beset by financial anxieties. While Van Gogh embraced his new direction as the choice of a sacred vocation over a predictable profession, he absorbed familial pressures and voiced some regrets at relinquishing a regular salary and expressed deep doubts about his future.[19] In this context of material and familial disruption, the themes of *Pilgrim's Progress* enabled him to project his situation of personal uncertainty into an exalted drama of redemption through suffering and material deprivation.

Van Gogh considers himself a pilgrim in 1876; he positions himself in a journey and sees himself on a road that leads from departure to destination. Like Christian and Valiant in the Bunyan book, he has cut himself off from his family and his country to seek a place of God's choosing. Casting himself as a pilgrim grants Van Gogh the reassurance that his road, like theirs, will have a structure, indeed a progress that will unfold through predictable stages and trials towards the arrival promised by the cycle of the story. Van Gogh's God in Isleworth, like the God of Bunyan's pilgrims, is a guide along the 'right path', and he views his new situation in terms of spatial and topographic distances from a heavenly father. He sees himself 'standing from afar', 'separated from his father and those in heaven by the same stretch of space that separates' his real father from himself.[20] This preoccupation with distance and proximity across a stretch of road is repeated in his selection of one of his texts for a Richmond Methodist sermon: 'But when he was a great way off, his father saw him, and had compassion'.[21] Van Gogh is drawn to these conceptualisations of convergence across divine distance partly because of his longings for home and real sense of paternal loss were so intense.[22] This is the time when he recounts to his brother Theo the devastating early memory of being deposited by his parents at Mr. Provily's boarding school at the age of eleven and of watching the carriage

diminish as it moved further and further away through the open meadows. Bunyan's narrative reverses this image of growing remoteness with the momentum of increasing nearness. The topography of salvation mapped out for Bunyan's pilgrim corresponded with Van Gogh's experience of desolation, and enabled him to shift the site of his longing from his real father, separated by physical distance, to his heavenly father, initially distant but bound inexorably to come into closer and closer contact with the steadfast and faithful pilgrim.[23]

If *Pilgrim's Progress* thus provided Van Gogh with powerful forms of consolation in a year of personal transition, the book also added a new dimension to his theology of self-surrender, faith and feeling. Van Gogh brought to his reading of Bunyan a set of religious attitudes already in place from other, specifically Dutch traditions, which the Bunyan book confirmed and extended. Indeed, his receptivity to Bunyan was itself shaped by the striking correspondences between Bunyan's religious system and the two major strains of Van Gogh's early Dutch religious legacy: his father's Groningen School evangelical pietism, and the anti-materialist asceticism of Thomas à Kempis. While some elements of *Pilgrim's Progress* thus reinforced pre-existing components of Van Gogh's Dutch religious formation, its distinctive contribution in the critical years of 1875-76, was to crystallise for Van Gogh the particular social location of salvation, consolidating his deep identification with what he called 'Christian workman' as the source of divinity. Bunyan's inversion of religious redemption facilitated Van Gogh's shift from the cultivation of inner purity to pursuit of social connection among those deemed as the most worthy and deserving of God's grace: lowly labourers and the poor. During the period from 1875-76, we find a slow and discernable reorientation in Van Gogh's forms of identification. The disciple of Thomas Kempis's *The Imitation of Christ*, scaling the heights towards mystic fusion with Christ in ascetic isolation, cedes its priority to the pilgrim of Bunyan's rendering, grounded in a community of earthly drudgery towards an eventual spiritual bounty.

We can trace this new dimension in the shift from psychological to social sources of Van Gogh's faith expressed in his letters of 1875-76. In the spring and autumn of 1875, Van Gogh describes his developing religious fervour in the language of ascetic isolation, invoking Kempis's *The Imitation of Christ* and celebrating the primacy of 'the kingdom within'.[24] In Kempisian fashion Van Gogh associates the charge of self-abasement in emulation of Christ with the rejection of intellectual mastery and the deference to the simple purity of the heart. He construes this in 1875 as an internal psychological stance, cast as that of the levelling of cognitive power to the lowly state of meekness and simplicity – to follow after Christ is to be 'gentle, long-suffering, and lowly of *heart*'.[25] Bunyan also indicts cognitive scrutiny as a form of egoism and celebrates the simple piety of the heart, but invests these desired spiritual qualities of lowliness with social specificity. As Van Gogh assimilates the Bunyan text, he also transposes the psychological stance of subordinating the head to the heart into its social equivalent; he attaches the individual qualities of inner spiritual purity to the bottom of the social scale where they are presumed to be embodied. Van Gogh thus adapts his Kempisian ideal of redemption through psychological inversion to Bunyan's social inversion of redemption, imagining, like Bunyan, that material deprivation gave the lower social orders a natural spiritual advantage in a theology of humility, self-denial, and worldly renunciation. In his return to England in 1876, Van Gogh amplifies this tendency into a full-fledged sanctification of the poor, and he expresses it as theological construct, ego ideal, and evangelical practice. Now Van Gogh sees himself as a preacher of the Gospel to the poor, a 'Christian labourer', and aspires to absorb, by association, the special entitlement to divinity vested in the socially disinherited.[26] He tries to

become one of those he exalts, in Bunyan fashion, for their spiritual worthiness and material dispossession. What Van Gogh describes in 1876 as the 'higher life, higher feelings', is now distinctively embedded in the lower classes, a theme that will reappear in 1878, as Bunyan is reinforced by other texts, in his equation of what he calls the 'homme intérieur et spirituel' – he who shows the signs of the higher life – with the humble labourer.[27]

The themes of *Pilgrim's Progress* converge in the sermon Van Gogh delivered in English in the Methodist church at Richmond in October, 1876.[28] The sermon provides the most explicit rendering of Van Gogh's reliance on Bunyan. The text is organised around the image of the pilgrim, that 'our life is a pilgrim's progress... a long walk or journey from earth to Heaven... we have come from afar and we are going far'.[29] This topography of salvation restates the Bunyan cycles of departure and destination, and the consoling exchange of the real for the heavenly Father noted earlier. Van Gogh evokes the pilgrim's pain at leaving home and becoming a stranger, only to be greeted by the 'arms of our Father in heaven' at his journey's end.[30] Within this organising structure, Van Gogh reaffirms all the themes of the social and emotional theology of *Pilgrim's Progress*, from the glorification of the lowly 'Christian workman', to the redemptive value and necessity of suffering and tribulation, to the unquestioning submission to God's disposition, poised no matter what with a heart full of love and acceptance.[31]

Another striking link with Bunyan's text in Van Gogh's sermon is his reliance on the visual as both the source and strategy of salvation. Van Gogh appeals to a God who is a guiding 'eye on the road from earth to Heaven', and he also presents an image of the celestial city.[32] At the sermon's end, Van Gogh compares the pilgrim's progress to a painting he once saw, a painting of a pilgrim on the road, staff in hand. He describes a landscape leading to a high mountain, 'far, far, away', and a city on the top of that distant mountain wrapped in a resplendent glow of the sun.[33] We know from art historians Ronald Pickvance and Hope Werness that the painting Van Gogh refers to was George Boughton's *God Speed! Pilgrims Setting out for Canterbury, Time of Chaucer* (cat.59) which was exhibited at the Royal Academy Summer Exhibition of 1874, which Van Gogh had visited. Werness notes the many discrepancies between the Boughton painting and Van Gogh's description.[34] Werness does not comment upon the way Van Gogh disremembers the painting almost as though it were refracted through the prisms of Bunyan's text: Van Gogh's portrayal of the city on the distant hill is closer to Bunyan's representation of the celestial city in *Pilgrim's Progress*, sighted through landscapes to distant mountains in enveloping sunlit radiance, rather than to the painting's quite indistinct rendering of this topography and illumination.

The most intriguing element of Van Gogh's sermon's visual theology is his statement defining the way to salvation through the focusing and fixity of the eye. In 1874 and 1875, Van Gogh's letters begin to register a theological ideal of approaching God in terms of developing what he calls an open eye, a simple and single eye, an eye without beams in it.[35] The Bunyan text enhanced this theology of optical singularity, and gave it a vivid turn. Bunyan presented the journey of the pilgrim as a succession of sightings, during which the pilgrim's progress is measured by the clarity and fixity of his vision, occasionally aided by optical tools. In the sermon, Van Gogh construes the movement towards the heavenly father in similar terms of approach through a single eye directed to its point of focus; he asserts, 'may the experience of life make our eye single and fix it on Thee'.[36]

Bunyan's Resonances in Van Gogh's Art

Vincent van Gogh did not remain the passive pilgrim, determined to fix his eye on God. In turning from religion to art he redirected his vision from the heavens to earth, exchanging what he termed a 'system of resignation' for active production. Yet Van Gogh transferred to painting a pre-existing core of values that had been forged during his ten year struggle for self-definition and self-justification. One element of continuity in the mentality that Van Gogh brought to painting was provided by the legacy of Bunyan, which offered him lasting attitudes toward the visual that are expressed in his artistic practices. I would suggest that these resonances and transformations of Bunyan's legacy are evident in the 1881 drawing of *The Bearers of the Burden*; the construction and reliance on the perspective frame; and the 1885 painting of *The Potato Eaters*. Taken together, these examples transpose into new forms the three levels of meaning made available to Van Gogh by *Pilgrim's Progress*: the social inversion of religious redemption; deliverance through sight and craft tools; and the stylistics of revelation through the union of lowly subject and awkward form.

The Bearers of the Burden (cat.15) reconnects Van Gogh to Bunyan's sanctification of lowly labour. This is one of his earliest drawings, sketched in Brussels in April of 1881 in the period just after Van Gogh decided to become a painter.[37] The image of the mining women is nourished by Van Gogh's experience of being a lay missionary among the wretched mining communities of the Borinage, and by the protracted period of personal crisis concerning his own work and worthiness that followed his dismissal from that post in July of 1879. The choice of subject and an English title for the drawing, along with those of *The Lampbearers* and *At Eternity's Gate* (cat.18) of that same year, returned Van Gogh to the world of Bunyan and the drudgery of the encumbered pilgrim. At the same time this immersion in the imaging of humble labour fulfilled a personal function of identification similar to that which he expressed during his years of evangelism in England and Belgium: the quest for salvation by association. Now Van Gogh transforms this ideal of attaching himself to the social source of grace through Gospel teaching among the lower classes to that of the visual project of representing those he still considered to be the most worthy, honest, and deserving in God's eyes.

In his evangelical work in Belgium, Van Gogh had deepened his commitment to the social inversion of religious redemption heightened by Bunyan and Methodism. He believed that he had located in the miners the purest embodiment of this inversion, claiming that these labourers of the underground, who crawled in the dark recesses of the centre of the earth, were the most receptive and deserving of God's transfiguring light.[38] The drawing, *The Bearers of the Burden*, casts this inversion in visual form, and renders the Borinage women as modern pilgrims. Its subject and composition re-fashion the organising image of *Pilgrim's Progress* – bearing the burden of earthly suffering consoled by Christ's atoning love. Van Gogh presents a procession of women bearing sacks of coal on their backs. The weight of the sacks lowers them almost to the ground; eyes cast down and absorbed in their exertion, they move through the stark landscape in silent passage. A witness surveys 'the bearers of the burden'; Christ on the cross, visible in a small open wooden box attached to the tree at the right edge of the picture plane. In his sermons to the Borinage miners, Van Gogh had stressed the Bunyan theme of Christ as a labourer, lacking outer splendour but graced with a precious inner soul; a companion in their misery and a model of humility to be emulated.[39] The drawing reunites Christ with his fellow labourers whose spiritual resignation is expressed in their physical encumbrance, and whose endurance of grinding drudgery assures them, like the pilgrims, of the joy of the

Vincent van Gogh *The Bearers of the Burden*, April 1881 (cat.15)

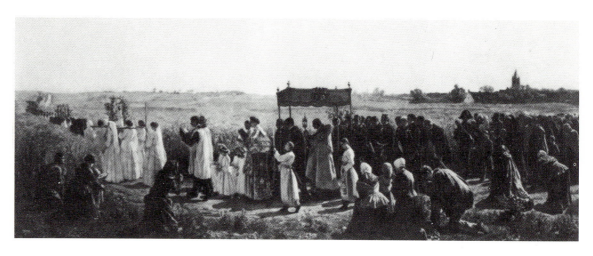

end of all toil in the life to come. The special connection of Christ and lowly labour is realised not only in their common disposition in the foreground of the picture plane, but in their distance from the church in the background. An accelerated perspectival recession dramatises the spatial separation of the women from the church, and this same recession operates to exaggerate the distance between the church and the small wooden box on the tree bearing Christ on the crucifix. These visual polarities suggest pictorial equivalents to the Bunyan theme of the opposition between the evangelical religion of the poor and the institutions of the church. Consoled by Christ and guided, like the pilgrims, by a lampbearing lead figure, the burdened women too will pass, through darkness, to light.

The power of Bunyan's evangelical populism in relation to *The Bearers of the Burden* deepens when it is compared to two other images by artists Van Gogh admired. The procession of burdened women recalls, while it reverses, both visually and substantively, an mage of a male procession entitled *The Blind Leading the Blind* by Peter Breughel the Elder, one of Van Gogh's favoured Netherlandish painters. The group of men moving off to the right in Breughel's image are crippled by their faithlessness, and proceed to fall into a ditch, the marker of their spiritual blindness and sin. Van Gogh's women file across the picture plane to the left, weighted down by their work, and destined for the underground coal pit. Yet their eyes gaze forward aided by lighted lamps, as well as the witness of Christ, who will assume their burden and relieve their suffering. In contrast, a vision of agrarian bounty is found in Jules Breton's moumental, *The Blessing of the Corn, Artois*, 1857 (fig.32). Breton's image of Catholic clerical authority is another depiction of a religious procession that was studied and praised by Van Gogh. At the centre of the canvas a priest, protected by a velvet canopy, holds the monstrance and moves through the field to bless the crop of corn, aided by other clerics in their official robes. The abundance of the harvest is marked by the visibility of stacked, thick sheaves, and the foreground is dominated by peasants kneeling as the holy pageant approaches. This scene of a rural Catholic commmunity contrasts sharply with Van Gogh's destitute Protestant mining women. Where Breton presents the splendid richness of the land, Van Gogh depicts a barren landscape, empty and intractable. Breton's peasants are at rest, beholding the fruits of their labour and bowing down to the church leaders, whose own material luxury is evident in the thickly painted robes, canopy and jewelled monstrance. Van Gogh's labourers move across the plane in a contorted exertion, hunched down under the weight of their sacks, unrelieved by any sign of temporal sustenance or physical comfort. This procession has no host, and no mediating clergy, only the very distant spire of the church and the consoling compensatory presence of the crucified Christ. Van Gogh's immersion in the ideas and practices of Bunyan's theology

Fig.33 Van Gogh with his perspective frame on the beach at Scheveningen, August 1882. [I 431]

and Methodism solidified this depiction of redemption through suffering and lowly labour; while he revered Breton, the Frenchman's radiant visions of corporate community and Catholic immanence, what Breton called 'la communion des âmes et des choses', had no natural foundations in Van Gogh's mental or visual system.[40] *The Bearers of the Burden* offers us an example of the Bunyan legacy through its content and evocation of the themes of salvation through suffering and the sanctification of humble labour. However, there is another dimension of continuity between Bunyan's religion and Van Gogh's art which lies outside the confines of explicit subject matter and emerges from what I have called Bunyan's visual piety. For Van Gogh transported to his pictorial practice not only the iconography of religious aspiration, but the cognitive style and visual skills consolidated by the Calvinist theology and literature that he had assimilated. The Bunyan theme of redemption through sight, of visual deliverance to a divine centre, was part of a mutually reinforcing pattern of religious ideas that Van Gogh invoked from a variety of other sources in the period before he became a painter. His selections from the New Testament, along with his reading of Kempis, Bunyan, Longfellow, Spurgeon, Carlyle, and Laurillard, all intersected in their common affirmation of salvation expressed as a particular kind of sight. Godly vision here emerges in the images of looking straight and ever forward, of eyes riveted to its single point of focus, of a vision driven to unobstructed linear convergence. These expressions concentrate, in theological form, the major features of the art of single point perspective. Bunyan's place within this pattern of religious attitudes of the visual was distinctive in that he presented the pilgrims in the actual process of sighting the divine centre, and had them rely on optical devices operated in landscapes of topographical specificity. During his evangelical period Van Gogh has affirmed the theology of visual singularity in his conceptions of the eye without beams, of the single eye fixed on God. When Van Gogh turned from religion to art, he converted the theology of optical singularity into a visual practice, facilitated by a craft tool bearing a striking affinity to the perspective glass relied on by Bunyan's pilgrims – his perspective frame.

Van Gogh first builds the oblong frame with the aid of a carpenter and blacksmith in The Hague in the winter of 1882. He perfects it during that summer by attaching the frame to adjustable grooves on two wooden poles that could be staked in the ground for outdoor sightings (fig.33).[41] Van Gogh constructs this perspective device as part of a rigorous programme of self-education toward mastery of the skill of drawing. Looking through it like a window, the artist is trained to compare the proportion of objects nearby with those on a more distant plane, while the intersection of the threads pressed the eye to its point of convergence. Van Gogh's frame, although unique, was based on similar perspective instruments he studied in books by Albrecht Dürer and by Armand Cassagne.[42]

Its uniqueness comprised additional diagonal threads which acted to intensify the point of convergence, both within the frame as a nodal point and as sightings through the frame to a distant goal on the landscape. Van Gogh records his delight in using the instrument, comparing it to a spyhole he could turn on the fields, sea, or sky; in another instance he describes the lines 'shooting into the distance like arrows from a bow'.[43] Both the deepening of the visual pressure towards convergence in the modified frame, and the notion of the spy hole evoke Van Gogh's earlier theology of the single eye fixed on God, and the particular sightings of Bunyan's pilgrims. The pilgrims progressed in their journey as they kept their eyes riveted to the celestial city, and they used the shepherds' perspective glass – a spy glass or telescope – to sharpen their focus. Van Gogh's frame as a spy hole works also like a small telescope, accelerating the movement of the eye toward a distant central point. A crucial difference now separates Van Gogh

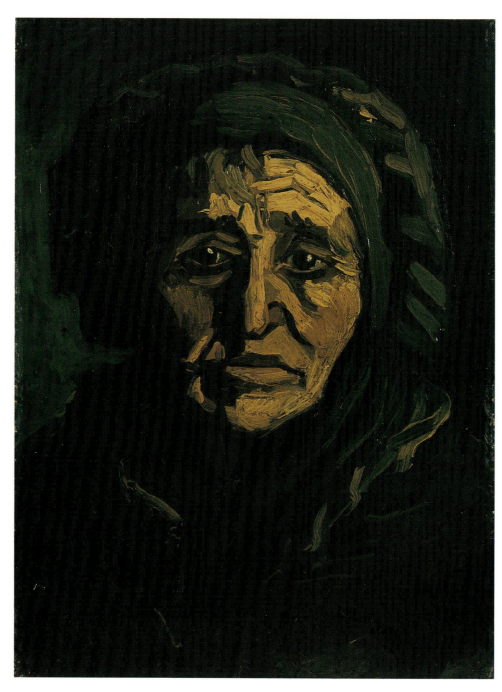

Vincent van Gogh *Head of an Elderly Peasant Woman*, February/March 1885 (cat.26)

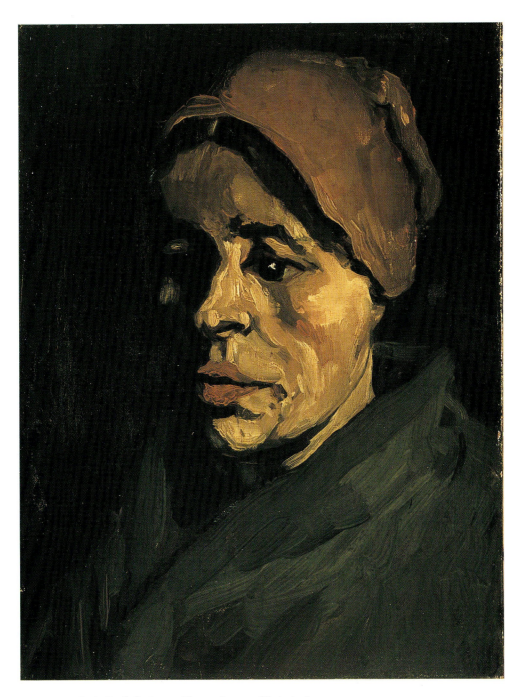

Vincent van Gogh *Head of a Peasant Woman*, January 1885 (cat.25)

Fig.34 Vincent van Gogh *Two Hands with Tongs*, April 1885 (F1166/H751) (Rijksmuseum Vincent van Gogh [Vincent van Gogh Foundation], Amsterdam)

right: Fig.35 Vincent van Gogh *Two Hands*, April 1885 (F1153/H741) (Rijksmuseum Vincent van Gogh [Vincent van Gogh Foundation], Amsterdam)

both from the pilgrims and his own earlier visual piety. The pilgrim's lack skill and are unable to use their perspective glass correctly; their hands shake and their vision remains blurred. For in Bunyan's set of religious assumptions, clear sight is only attainable in the celestial city, in the deliverance from earthly existence. In 1882, Van Gogh believes that visual progress is possible through practised dexterity and painstaking effort; his craft tool is a guide to a slow and incremental mastery of the skill of representation. But there remains a theological undercurrent, located in specific sources of his early period, to Van Gogh's continued preoccupation with riveting the eye to a single centre, and to his construction of a perspective frame distinctively suited to exaggerate thrusts to a point of convergence.[44]

The Nuenen *Potato Eaters* of 1885 (fig.36) reaffirms Bunyan's evangelical ideal of the blessedness of lowly labour and Van Gogh's continued drive to link himself to those he considered to be the social carriers of redemption. But the painting also captures a new direction in Van Gogh's artistic development, which transposes his religious project of identification with labour into the new key of pictorial form. It is in the long process of preparing the *Potato Eaters* that Van Gogh first consolidates visual techniques that reproduce the humble labour he associated with sanctification, transferring to the art forms themselves the special worthiness embodied in lowly labour. And in legitimising his new found equivalence between pictorial forms and labour drudgery, Van Gogh expressed striking correspondences to Bunyan's defense of his new style in *Pilgrim's Progress*, where the union of lowly subject and awkward form combine to elevate art as an instrument of revelation.

Van Gogh refracted the subjects of *The Potato Eaters* through the religious screens of the social inversion of redemption. Here are the counterparts to the 'bearers of the burden', whose earthly resignation to unpleasant labour assures them of the greatest quotient of God's transfiguring light. The appearance and positioning of the figures in *The Potato Eaters* resonate with the organising dualisms of Van Gogh's earlier evangelical populism. In Amsterdam in 1877, Van Gogh expressed how he associated dark objects and the colour black with their sacred opposite; crusts of black bread, muddy boots, or wet black clothes, he wrote, immediately evoked for him the passage of the righteous into the blazing eternal brightness of the light in the kingdom of heaven.[45] *The Potato Eaters* is structured by this visually powerful

theology of inversion. Cramped together around the table in their heavy dark work clothes, the peasants are framed by the central beacon of the lamp. Their brightly lit faces, intensified by contrast with their cave-like surround and dark garments, suggests Van Gogh's earlier imperative of the light rising in the darkness as what he called the foundation of the whole Gospel and Bible, and of the lowly labourers, adapted and humbled to the earth below, as the most receptive to divine illumination. The physical appearance of the figures suggests Bunyan's central contrast of outer indigence and inner treasures, of precious inwardness wrapped in homely crusts. The faces of the peasants, in preparatory images (cat.25, 26, 27, and 29) and the final composition, are streaked with jagged line and crevices, reminiscent of Van Gogh's Bunyanesque charge to the miners of the Borinage that they emulate Christ, whom he describes as a 'labourer and a working man whose life is hard, and who bears the lines of sorrow, suffering and fatigue in his face – without splendour or glamour, but with an immortal soul'.[46] The hands of the peasants, in studies (fig.34 and 35) and final image are gnarled, bony, and swollen, the result of digging in the earth and also exemplars of what Van Gogh defined earlier as essential 'signs of spirituality'; outer deformation was the external mark of spiritual riches accrued through earthly grief and distress.[47] In 1878, Van Gogh had celebrated painters like Josef Israëls in terms of these religious dualisms of inversion. He admired Israëls, he wrote, for evoking the riches of the inner souls of his subjects through their physical imperfections, homeliness, and their rough hands that show they have worked.[48] In his own *Potato Eaters* of 1885, partly modeled at that time on an actual painting by Israëls, Van Gogh returned to these fundamental dualisms of his earlier evangelical populism and realised them in his own distinctive visual presentation of his subjects.[49]

In choosing to depict the world of humble labour, Van Gogh associated himself with those he still considered the true servants of God, whose earthly production and sacred worthiness surpassed those of a self-taught painter struggling with the inner and outer pressures for justification. Yet during the Nuenen period, Van Gogh not only represented labourers and expressed a deep personal identification with them, but he discovered pictorial forms to emulate their redemptive activities, elaborating visual equivalents to the pre-industrial work processes he admired.

Significantly, Van Gogh did not consider *The Potato Eaters* as an image of rest and repast but as a visual statement of the labour process *preceding* the meal, which he had depicted in extensive studies for the final composition. He explained that 'I want to make it clear how these people, eating their potatoes in the lamplight, have dug the earth with the very hands they put in the dish, and so it speaks of *manual labour*, and how they have honestly earned their food'.[50] Van Gogh achieves this message pictorially by loading the pigment in rough-hewn, brick-like applications, and in the deep earth tones and mud-like colouring which permeates the canvas as a whole. Calling his own activity 'keeping my hand to the plough as I cut my furrow steadily', Van Gogh realised a painted surface of rough physicality, which linked his arduous visual effort to the worthy communion assembled at the table.[51] His labours, linked to theirs in the execution of painting as worked earth, signalled that he too had 'honestly earned' and merited grace.[52]

While Van Gogh considered his *Potato Eaters* a master work, he found it necessary to defend his dark coarse canvas to his brother Theo. Stung by his friend and fellow painter Anthon van Rappard's criticism of the awkward figural compositions, Van Gogh explained that his departures from the smooth polish and physical charm of conventional picturing were deliberate vehicles in the service of truth. The awkward lumpiness of the figures, the visible

signs of smoke, steam, and smells of the table, and the coarse physicality of the loaded paint surface were indivisible elements of truth, the form and content of what he called 'a real peasant picture'.[53] Anticipating that others too would criticise the painting for the characteristics that he described as 'nasty, coarse, dirty and stinking', Van Gogh responded that these very attributes of the image rendered it 'real and honest', ' a serious thing that will teach something' and that 'will rouse serious thoughts in those who think seriously about art and about life'.[54]

In this presentation of the truth revealed in humble labour and unpolished form, Van Gogh expressed certain affinities with John Bunyan's defense of *Pilgrim's Progress*. While critics might only see only vapor, darkness and ugliness, Bunyan claimed, his dark and cloudy words held the truth, like cabinets enclosed gold; the craft skill of the writer prefigures for the reader the passage to divine deliverance eventually accorded the pilgrim – through the pen, the base ushers in the divine. Van Gogh's *Potato Eaters* is not an allegory, like Bunyan's, but neither is it a straightforward visual description; it embodies what I would call sacred realism, charged with revelatory functions as 'a serious thing that teaches something', 'that rouses serious thoughts'. The contours of this revelation correspond to Bunyan's evangelical linkage of the redemptive qualities of humble subjects and the divine agency of awkward form. Bunyan had compared the artist's pen to the peasant's plough, celebrating both as humble vehicles of transcendence. Van Gogh strove to transform his brush into a plough, working the canvas into lumps of painted earth. The craft he used, like Bunyan's – simple, uneven, and grimy as it may be – acted as a mediator of eternal truth, as the connector of the material and the spiritual domains.

Van Gogh insisted to Theo that the *Potato Eaters* be framed in deep gold, off-setting its darkened greyness with an intense brightness.[55] The contrast of golden frame and muddy image recalls Bunyan's notion of his dark and cloudy words yielding through the text to the sparkling radiance and clarity of exposed truth, like opening dark cabinets enclosing gold. Van Gogh's golden frame initiated visually the passage from darkness to light assured the subjects redeemed by their work. Their deliverance from homely outer crust to precious inner treasure is anticipated in the forms themselves, by the heightened visual contrast of darkness and light both within the picture plane, and between the tenebrous picture as a whole and its incandescent frame.

1 Portions of this article derive from my longer and expanded analysis of the multiple stylistic consequences of Van Gogh's identification with labour in the Dutch and French periods, *Sighting God and Weaving Paintings: Religious Origins and Visual Forms of Vincent van Gogh's Métier*, in Michael S. Roth, ed., *Continuity and Change in Culture and History*, Princeton, N.J., Princeton University Press, in press. I would like to thank Director, Ronald de Leeuw and Curator, Louis van Tilborgh of the Rijksmuseum Vincent van Gogh in Amsterdam for giving me the opportunity to present some of my ideas to the Vincent van Gogh Centenary Symposium held at the museum in May 1990, and to Documentation Specialist, Fieke Pabst for countless acts of assistance. My thanks as well to Jane Alison, Joyce Appleby, Martin Bailey, Rudy Bekkers, Edward Berenson, Ruth Bloch, Carlo Ginzburg, Lynn Hunt, N. Gregory Kendrick, Arno Mayer, Jeffrey Prager, Virginia Reinberg, Simon Schama, Carl Schorske, Gary and Loekie Schwartz, Aaron Segal, Paul van Seters, Richard Thompson, Norton Wise, and Carol Zemel.

2 The Groningen School of Theology in the Netherlands, also known as the 'Evangelicals' emerged in the 1820s to challenge the 'rational supernaturalism' of the Dutch Reformed Church in the name of a renewed emotional piety. Unlike another contemporary anti-rational religious reform movement, the orthodox Netherlandish *Réveil*, the Groningeners remained bound to Dutch humanist legacies while rediscovering Thomas à Kempis, celebrating his *Imitation of Christ*, and not the teachings of John Calvin, as the basis for a revitalised national Reformed religion. Adapting their revival of Kempis to an admiration of the German theologian Friedrich Schleiermacher, the Groningeners emphasised selflessness and emulation of Christ through love, humility, and social service. Vincent van Gogh's father, Theodorus van Gogh, was a member of the first generation of divinity students trained in the Groningen Theology. See, on the Groningeners' challenge, Albert Réville, 'Les Controverses et les écoles religieuses du Hollande', *Revue des deux-mondes*, ser, 8, vol. 27, May-June, 1860, pp. 935-952; Eldred C. Vanderlaan, *Religious Thought in Holland*,

London, Oxford University Press, 1911, pp. 14-19; and D. Chantepie de la Saussaye, *La crise religieuse en Hollande*, Leyden, De Breuk & Smits, 1860, pp. 70-73. For Theodorus van Gogh and the Groningen School see M.E. Traulbaut, *Vincent van Gogh*, New York, Chartwell Books, 1969, p.12; and Frank Kools, *Vincent van Gogh en zijn geboorteplaats*, Zutphen, De Walburg Pers, 1990, pp. 9-14.

3 In another setting I explore how the three competing religious legacies interacted in Van Gogh's formative years, and how they shaped his identification with labour and his attitude toward the visual. Each offered distinctive resources, while also generating abiding tensions, particularly regarding the status of self, the value of image, and the meaning of the visible world. Highlighting Van Gogh's response to Bunyan provides the richness and specificity of a single case, while comprising only one element of the three different traditions that together form the building blocks of Van Gogh's identity.

4 My discussion of Bunyan's biography and social context is based on E.P. Thompson, *The Making of the English Working Class*, New

York, Vintage, 1963, ch.2; Christopher Hill, *A Tinker and a Poor Man, John Bunyan and His Church, 1628-1688*, New York, Knopf, 1989; and N.H. Keeble, *The Literary Culture of Nonconformity in Later Seventeenth-Century England*, Athens, Ga., University of Georgia Press, 1987.

5 J.B.H. Alblas, *Johannes Boekholt (1656-1693): The First Dutch Publisher of John Bunyan and Other English Authors*, Nieuwkoop, De Graa, 1987, esp. pp. 9-97.

6 For Bunyan and English Nonconformity, see Thompson, *Working Class,* Parts II and III, Hill, *Tinker,* chs. 27-29, and Kenneth Scott Latourette, *Christianity in a Revolutionary Age, The Nineteenth Century in Europe, The Protestant and Eastern Churches* New York, Harper, 1959, chs. XXVII-XXIX. For Bunyan and Pan-European Protestant Evangelical movements, including those in the Netherlands, see Latourette, *Christianity,* esp. ch. XXV, and F.E. Stoffler, *The Rise of Evangelical Pietism* , Leiden, 1965. The roots of Bunyan's influence in 19th century Dutch religion were struck in an earlier movement called the 'Nadere Reformatie' ('the further reformation'), when Bunyan's theology was incorporated into native pietistic strains of Dutch Reformed Calvinism.

7 All page references from the text will refer to the following popular 19th century illustrated edition: John Bunyan, *The Pilgrim's Progress from This World to That Which is To Come, Delivered Under the Similitude of A Dream* , London, the Book Society for Promoting Religious Knowledge Among the Poor, 1867.

8 Bunyan, *Pilgrim's Progress,* pp. 398; 508-509.

9 Thus the pilgrim's theme song, 'here little, afterwards bliss', and their praise for the man who gave away his earthly goods – 'the more he cast away, the more he had,' for 'the poor man who loves Christ is richer than the greatest man in the world who hates him' (*ibid.,* pp. 452, 503-504, 138). For the social specificity and class resonance of Bunyan's subversive theology see also Hill, *Tinker,* esp. chs. 12 and 18.

10 Bunyan, *Pilgrim's Progress,* pp. 281, 383, 462.

11 *Ibid.,* pp. 307-308.

12 *Ibid.,* pp. 594, 601.

13 *Ibid.,* pp. 15, 309.

14 *Ibid.,* pp. 232-235. It is difficult to trace the source of Bunyan's use of optical tools in *Pilgrim's Progress.* Contemporary emblem books offer one possibility. Francis Quarles's *Emblems and Hieroglyphics,* for example (1632), illustrated the contrast between temporal vanity and spiritual regeneration in the absorption of two figures in different kinds of beholding, aided by distinctive visual devices. The transience of earthly pleasure was signalled by a seated woman gazing downward at the play of coloured sunlight through a glass prism; the promise of salvation was represented in a standing figure looking upward through a telescope into the distance. In another of Quarles's emblems in the same collection, a text about walking through the maze of life toward redemption is illustrated in another image of monocular vision: a man looks through the eye of a giant

needle across the chasm of a complex maze to an angel looking back at him from the other side. The man's view point at the eye of the needle is physically linked to the angel's by a line of taut thread suspended through the needle across the maze, concretising the straight passage from worldly trial to eternal life. See Francis Quarles, *Emblems and Hieroglyphics of the Life of Man,* London, 1773 edition, pp. 94-95, 100-101. Quarles's emblem books were widely known, and would have been available to Bunyan. They were part of a general percolation and reintroduction of the image in Counter Reformation English Anglicanism, which tempered its earlier 'iconophobia' with resourceful attempts, through depiction, to respond to the Catholic challenge. This is discussed by Karl Josef Höltgen, *Aspects of the Emblem: Studies in the English Emblem Tradition and the European Context,* Kassel, Edition Reichenberger, 1986, pp. 23-65.

15 Bunyan, 'The Author's Apology for his Book', *Pilgrim's Progress,* pp. vi-viii.

16 *Ibid.,* p. ix.

17 Documentation of Van Gogh's transition from the art business to teacher and lay evangelist in England may be found in Vincent van Gogh, *Collected Letters,* Boston, N.Y. Graphic Society, 1978, [I 7-91]; A Verkade-Bruining, 'Vincent's Plans to Become a Clergyman,' *Vincent, Bulletin of the Rijksmuseum Vincent van Gogh,* V. 3, no. 4, 1974, pp. 14-17; and Martin Bailey, *Young Vincent: The Story of Van Gogh's Years in England,* London, Allison & Busby, 1990, Part I.

18 Van Gogh, *Letters,* [I 78].

19 *Ibid.,* [I 59-61].

20 *Ibid.,* [I 62, 64, 82].

21 *Ibid.,* [I 74].

22 *Ibid.,* [I 68, 70, 73, 78].

23 *Ibid.,* [I 78].

24 Van Gogh, *Letters,* [I 37]. Van Gogh also copies out passages from Renan's *Vie de Jésus* affirming self-sacrifice and the dissolution of the ego as the essence of faith, [I 26].

25 *Ibid.,* [I 38, 49].

26 *Ibid.,* [I 71, 76, 90].

27 *Ibid.,* [I 64, 164-165].

28 The Methodist context of Van Gogh's evocation of Bunyan was highly appropriate. In associating himself with Methodism, Van Gogh selected that part of the spectrum of English religious dissent where the theology of Bunyan had its strongest impact. Methodism was the social and spiritual heir to Bunyan's anti-institutional religion of feeling and social inclusion. An interesting indication of the widespread popularity of Bunyan during the 1870s was the preparation and unveiling of a 'colossal' bronze statue of John Bunyan in the author's native town of Bedford in 1874. The ten foot high figure was raised on a seven foot high pedestal, 'and ornamented with four bas-reliefs of subjects from *Pilgrim's Progress'.* See the *Illustrated London News,* 21 February 1874, p.174; 13 June 1874, p.569; and 20 June 1874, p.585.

29 Van Gogh, *Letters,* [I 87].

30 *Ibid.,* [I 87, 90].

31 *Ibid.,* [I 87, 89, 90, 91].

32 *Ibid.,* [I 88].

33 *Ibid.,* [I 91].

34 Ronald Pickvance, *English Influences on Vincent van Gogh,* Nottingham, England, 1975 p. 19; Hope B. Werness, 'Vincent van Gogh and a Lost Painting by G. H. Boughton,' *Gazette des Beaux-Arts,* V. 127 (1985), pp. 71-75.

35 Van Gogh, *Letters* [I 22, 36].

36 *Ibid.,* [I 89].

37 The National Museum of Western Art, Tokyo, *Vincent van Gogh Exhibition, 12 October-8 December 1985,* Chubu-Nippon Broad, 1985, p.40.

38 Van Gogh, *Letters* [I 177-178].

39 *Ibid.,* [I 184].

40 On Van Gogh and Breton, and more on *The Blessing of the Corn, Artois, 1857,* see Hollister Sturges, *Jules Breton and the French Rural Tradition,* Omaha, Nebraska, Joslyn Art Museum, 1982, pp.68-69, 130-131. Van Gogh was a long-term admirer not only of Breton's paintings, but his poetry as well, which he copied out in his earliest letters and albums and which remained a constant source of reference throughout his later career.

41 Van Gogh describes the construction and operation of the frame in *Letters,* [I 383,430, 432, 433].

42 See the discussion by Van Gogh himself and also Anne Stiles Wylie, 'An Investigation of the Vocabulary of Line in Vincent van Gogh's Expression of Space', *Oud-Holland,* 85, no 4, 1970, pp.210-222, and Anne H Murray, 'Strange and Subtle Perspective...' Van Gogh, the Hague School and the Dutch Landscape tradition', *Art History,* V3, no.4, December, 1980, pp.410-424. Dürer's woodcuts for *The Art of Measurement* include a frame , divided into a network of miniature squares; Cassange's popular 19th century manual on perspective suggests the use of a rectangular frame, divided by two lengths of thread into four equal sections. Van Gogh's oblong frame adds two diagonal threads to Cassagne's prescription, rendering it uniquely his own invention.

43 Van Gogh, *Letters,* [I 421, 433]. It is significant that Van Gogh shows the operation of the frame staked in the sand at the seashore at Scheveningen, adjacent to boats and fishermen. Van Gogh associated fishermen with independence and intense piety, which he had indicated by copying out long passages on these characteristics of the Scheveningen fishermen from a book by Henri Alphonse Esquiros. Among the passages copied out was also one describing the fishermen as uniquely turned with their heads up and their eyes towards the heavens as their natural posture, qualities Bunyan ascribed to the pilgrims. The excerpts from Esquiros's *La Néerlande et la vie hollandaise,* Paris, 1859, selected and transcribed by Van Gogh are published in *Vincent van Gogh's Poetry Albums,* edited by Fieke Pabst, Zwolle, Uitgeverij Waanders, and Amsterdam, Rijksmuseum Vincent van Gogh, 1988, pp. 76-82.

44 Particularly important here are the texts that Van Gogh read immediately after Bunyan's *Pilgrim's Progress* by a 19th century admirer of Bunyan – the popular English Baptist preacher and writer Charles Hadding Spurgeon. Spurgeon's *Gems* (1858), a book that Van Gogh read closely in 1877 (cat.130), affirms that the path to redemption 'consists of a word with four letters – Look, look, look to Christ', and emphasises the primacy of beholding as the main characteristic of a loving God and as the vehicle of salvation. Like Bunyan, Spurgeon construes redemption in terms of clarity and singularity of sight, and directs the eye 'fixed' on Christ to a range of optical tools, including telescopes. In one passage, Spurgeon describes spiritual beholders with a telescope, who, exactly like Bunyan's pilgrims, are unable to focus a clear image because they are unsteady. Spurgeon extends the range of Bunyan's optical piety to "Christ as a telescope of love," and to modern day microscopes, mirrors, shades, and a refracting device – he compares Christ to an instrument that filters out the rays of light too intense for the human eye to absorb, softening them into a mellow brightness. See C.H. Spurgeon, *Spurgeon's Gems, Being Brilliant Passages From the Discourses of the Reverand C.H. Spurgeon,* New York, Sheldon, Blackman, and Co., 1858, esp. pp. 31, 46, 66, 71, 77, 79-80, 87, 234-237, 244, 293, 344.

45 Van Gogh, *Letters* [I 147].

46 *Ibid.,* [I 184].

47 *Ibid.,* [I 160].

48 *Ibid.,* [I 160]

49 On Israëls as a source for the composition, see Albert Boime, "A Source for Van Gogh's Potato Eaters', *Gazette des Beaux-Arts* VI, 67, 1966, pp. 249-253.

50 Van Gogh, *Letters* [I 370, also 372].

51 *Ibid.,* [I 56]. The issue of 'earning one's food' was particularly charged for Van Gogh, whose own patient, rigorous, and painstaking work had not yielded any possibility for self-sufficiency. During the Nuenen period, the problem of saleability was particularly acute, and the gap between Van Gogh's inability to 'honestly earn' and the sustenance yielded by the peasants' exertion informed both his choice of subject and his intense formal efforts to link the arduousness of his own visual labour with the dredging and digging that had produced the meal depicted.

52 A second set of stylistic elements shaping *The Potato Eaters'* emergent language of labour derived from Van Gogh's attempt to replicate in paint the craft techniques and patterns of the Nuenen weavers, which I discuss at length in my 'Sighting God and Weaving Paintings', *op cit.,* Footnote 1.

53 Van Gogh, *Letters* [II 369-70].

54 *Ibid.,* [II 369-70]

55 *Ibid.,* [II 369-70]

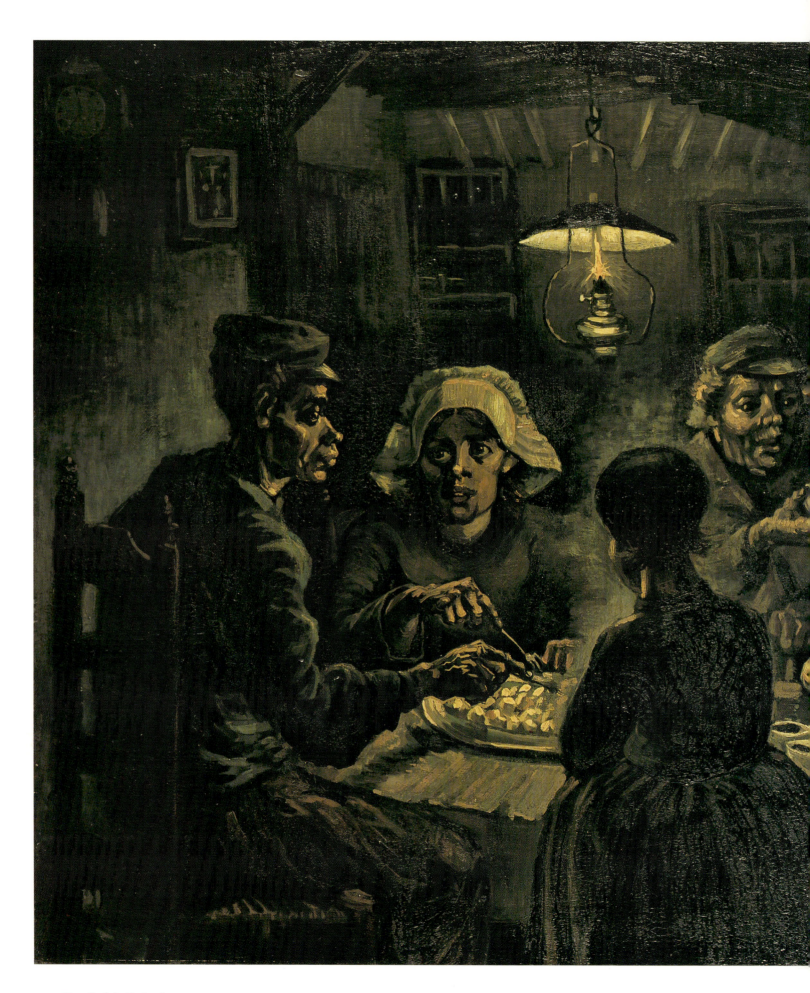

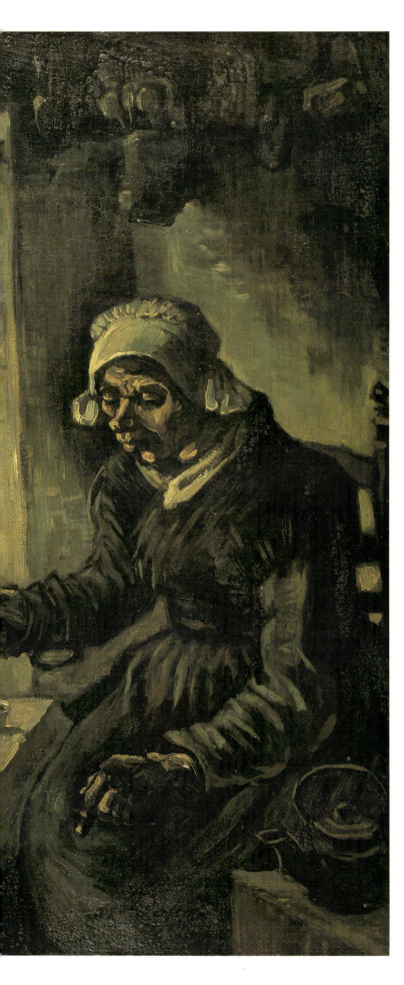

Fig.36 Vincent van Gogh *The Potato Eaters*, April 1885
(Rijksmuseum Vincent van Gogh [Vincent van Gogh
Foundation], Amsterdam)

*'I have tried to emphasise that those people, eating their
potatoes in the lamplight, have dug the earth with those
very hands they put in the dish, and so it speaks of manual
labour, and how they have honestly earned their food... I
am personally convinced that I get better results by paint-
ing them in their roughness than by giving them a
conventional charm... If a peasant picture smells of bacon,
smoke, potato steam – all right, that's not unhealthy.'*

Van Gogh to Van Rappard, *c*30 April 1885 [II 370]

Van Gogh's Sermon

Psalm 119:19. 'I am a stranger in the earth, hide not Thy commandments from me'

It is an old faith, and it is a good faith that our life is a pilgrim's progress – that we are strangers in the earth, but that though this be so, yet we are not alone for our Father is with us. We are pilgrims, our life is a long walk or journey from earth to heaven.

The beginning of this life is this. There is one who remembereth no more Her sorrow and Her anguish for joy that a man is born into the world. She is our Mother. The end of our pilgrimage is the entering in Our Father's house where are many mansions, where He has gone before us to prepare a place for us. The end of this life is what we call death, it is an hour in which words are spoken, things are seen and felt that are kept in the secret chambers of the hearts of those who stand by, – it is so that all of us have such things in our hearts or forebodings of such things.

There is sorrow in the hour when a man is born into the world, but also joy – deep and unspeakable – thankfulness so great that it reacheth the highest Heavens. Yes the Angels of God they smile, they hope and they rejoice when a man is born in the world. There is sorrow in the hour of death – but there too joy unspeakable when it is the hour of death of one who has fought a good fight. There is One who has said, I am the resurrection and the life, if any man believe in Me, though he were dead yet shall he live. There was an Apostle who heard a voice from heaven saying: Blessed are they that die in the Lord, for they rest from their labour and their works follow them.

There is joy when a man is born in the world, but there is greater joy when a Spirit has passed through great tribulation, when an Angel is born in Heaven.

Sorrow is better than joy – and even in mirth the heart is sad – and it is better to go to the house of mourning than to the house of feasts, for by the sadness of the countenance the heart is made better. Our nature is sorrowful but for those who have learnt and are learning to look at Jesus Christ there is always reason to rejoice. It is a good word that of St. Pauls: As being sorrowful yet always rejoicing. For those who believe in Jesus Christ, there is no death and no sorrow that is not mixed with hope – no despair – there is only a constantly being born again, a constantly going from darkness into light. They do not mourn as those who have no hope – Christian Faith makes life to evergreen life.

We are pilgrims in the earth and strangers – we come from afar and we are going far. The journey of our life goes from the loving breast of our Mother on earth to the arms of our Father in heaven. Everything on earth changes – we have no abiding city here – it is the experience of everybody: That is God's will that we should part with what we dearest have on earth – we ourselves we change in many respects, we are not what we once were, we shall not remain what we are now. From infancy we grow up to boys and girls – young men and young women – and if God spares us and helps us, to husbands and wives, Fathers and Mothers in our turn, and then, slowly but surely the face that once had the early dew of morning, gets its wrinkles, the eyes that once beamed with youth and gladness speak of a sincere deep and earnest sadness – though they may keep the fire of Faith, Hope and Charity – though they may beam with God's spirit. The hair turns grey or we loose it – ah – indeed we only pass through the earth, we only pass through life – we are strangers and pilgrims in the earth. The world passes and all its glory. Let our later days be nearer to Thee and therefore better than these.

Yet we may not live on just anyhow – no, we have a strife to strive and a fight to fight. What is it we must do? We must love God with all our strength, with all our might, with all our heart, with all our soul, we must love our neighbour as ourselves. These two commandments we must keep and if we follow after these, if we are devoted to this, we are not alone, for our Father in Heaven is with us, helps us and guides us, gives us strength day by day, hour by hour, and so we can do all things through Christ who

gives us might. We are strangers in the earth, hide not Thy commandments from us. Open Thou our eyes that we may behold wondrous things out of Thy law. Teach us to do Thy will and influence our hearts that the love of Christ may constrain us and that we may be brought to do what we must do to be saved.

On the road from earth to Heaven
Do Thou guide us with Thine eye
We are weak but Thou art mighty
Hold us with Thy powerful hand.

Our life, we might compare it to a journey, we go from the place where we were born to a far off haven. Our earlier life might be compared to sailing on a river, but very soon the waves become higher, the wind more violent, we are at sea almost before we are aware of it – and the prayer from the heart ariseth to God: Protect me o God, for my barque is so small and Thy sea is so great. The heart of man is very much like the sea, it has its storms, it has its tides and in its depths it has its pearls too. The heart that seeks for God and for a Godly life has more storms than any other. Let us see how the Psalmist describes a storm at sea. He must have felt the storm in his heart to describe it so. We read in the 107th Psalm: They that go down to the sea in ships that do business in great waters, these see the works of the Lord and His wonders in the deep. For He commandeth and raiseth up a stormy wind which lifteth up the waves thereof. They mount up to Heaven, they go down again to the depth, their soul melteth in them because of their trouble. Then they cry unto the Lord in their trouble and He bringeth them out of their distresses. He bringeth them unto their desired haven.

Do we not feel this sometimes on the sea of our lives? Does not everyone of you feel with me the storms of life or their forebodings or their recollections?

And now let us read a description of another storm at sea in the New Testament, as we find it in the VIth Chapter of the Gospel according to St. John in the 17th to the 21st verse. And the disciples entered into a ship and went over the sea toward Capernaum. And the sea arose by reason of a great wind that blew. So when they had rowed about five and twenty or thirty furlongs, they see Jesus walking on the sea and drawing nigh unto the ship and they were afraid. Then they willingly received Him into the ship and immediately the ship was at the land whither they went. You who have experienced the great storms of life, you over whom all the waves and all the billows of the Lord have gone – have you not heard when your heart failed for fear the beloved well-known voice – with something in its tone that reminded you of the voices that charmed your childhood – the voice of Him whose name is Saviour and Prince of peace, saying as it were to you personally – mind to you personally 'It is I, be not afraid.' Fear not. Let not your heart be troubled.

And we whose lives have been calm up to now, calm in comparison of what others have felt – let us not fear the storms of life, amidst the high waves of the sea and under the grey clouds of the sky we shall see Him approaching for Whom we have so often longed and watched, Him we need so – and we shall hear His voice: 'It is I be not afraid.'

And if after an hour or season of anguish or distress or great difficulty or pain or sorrow we hear Him ask us: 'Dost Thou love me?' then let us say: 'Lord, Thou knowest all things, Thou knowest that I love Thee. And let us keep that heart full of the love of Christ and may from thence issue a life which the love of Christ constraineth. Lord Thou knowest all things, Thou knowest that I love Thee. When we look back on our past, we feel sometimes as if we did love Thee, for whatsoever we have loved, we loved in Thy name. Have we not often felt as a widow and an orphan – in joy and prosperity as well and more even under grief, because of the thought of Thee.

Truly our soul waiteth for Thee more than they that watch for the morning – our eyes are up unto Thee, o Thou who dwellest in Heavens. In our days too there can be such a thing as seeking the Lord.

What is it we ask of God – is it a great thing? Yes it is a great thing: peace for the ground of our heart, rest for our soul – give us that one thing and

then we want not much more, then we can do without many things, then can we suffer great things for Thy name's sake. We want to know that we are Thine and that Thou art ours, we want to be thine – to be Christians. We want a Father, a Father's love and a Father's approval. May the experience of life make our eye single and fix it on Thee. May we grow better as we go on in life.

We have spoken of the storms on the journey of life, but now let us speak of the calms and joys of Christian life. And yet, my dear friend, let us rather cling to the seasons of difficulty and work and sorrow, even for the calms are treacherous often. The heart has its storms, has its seasons of drooping, but also its calms and even its times of exaltation. There is a time of sighing and of praying, but there is also a time of answer to prayer. Weeping may endure for a night, but joy cometh in the morning.

> The heart that is fainting
> May grow full to o'erflowing
> And they that behold it
> Shall wonder and know not
> That God at its fountains
> Far off has been raining.

My peace I leave with you – we saw how there is peace even in the storm. Thanks be to God who has given us to be born and to live in a Christian country. Has any of us forgotten the golden hours of our early days at home, and since we left that home – for many of us have had to leave that home and to earn their living and to make their way in the world? Has He not brought us thus far? Have we lacked anything? We believe, Lord, help Thou our unbelief. I still feel the rapture, the thrill of joy I felt when for the first time I cast a deep look in the lives of my Parents, when I felt by instinct how much they were Christians. And I still feel that feeling of eternal youth and enthusiasm wherewith I went to God, saying 'I will be a Christian too.'

Are we what we dreamt we should be? No – but still – the sorrows of life, the multitude of things of daily life and of daily duties so much more numerous than we expected – the tossing to and fro in the world, they have covered it over – but it is not dead, it sleepeth. The old eternal faith and love of Christ it may sleep in us but is not dead and God can revive it in us. But though to be born again to eternal life, to the life of Faith, Hope and Charity – and to an evergreen life – to the life of a Christian and of a Christian workman, be a gift of God, a work of God – and of God alone, yet let us put the hand to the plough on the field of our heart, let us cast out our net once more – let us try one more – God knows the intention of the spirit. God knows us better than we know ourselves, for He made us and not we ourselves. He knows of what things we have need. He knows what is good for us. May He give his blessing in the seed of His word that has been sown in our hearts.

God helping us, we shall get though life – with every temptation. He will give a way to escape.

Father we pray Thee not that Thou shouldest take us out of the world, but we pray Thee to keep us from evil. Give us neither poverty nor riches, feed us with bread convenient for us. And let Thy songs be our delight in the houses of our pilgrimage. God of our Fathers, be our God: may their people be our people, their Faith our faith. We are strangers in the earth, hide not Thy commandments from us, but may the love of Christ constrain us. Entreat us not to leave Thee or to refrain from following after Thee. The people shall be our people. Thou shalt be our God.

Our life is a pilgrim's progress. *I once saw a very beautiful picture*, it was a landscape at evening. In the distance on the right hand side a row of hills appearing blue in the evening mist. Above those hills the splendour of the sunset, the grey clouds with their linings of silver and gold and purple. The landscape is a plain or heath covered with grass and heather, here and there the white stem of a birch tree and its yellow leaves, for it was in Autumn. Through the landscape a road leads to a high mountain far, far away. On the top of that mountain a city whereon the setting sun casts a glory. On the road walks a pilgrim, staff in hand. He has been walking for a good long while already and he is very tired. And now he meets a woman, a figure in black that makes one think of St. Paul's word: 'As being sorrowful yet always rejoicing.' That Angel of God has been placed there to encourage the pilgrims and to answer their questions.

And the pilgrim asks her: 'Does the road go uphill then all the way?' And the answer is: 'Yes to the very end.' And he asks again: 'And will the journey take all day long?' And the answer is: 'From morn till night my friend.'

And the pilgrim goes on sorrowful yet always rejoicing, sorrowful because it is so far off and the road so long. Hopeful as he looks up to the eternal city far away, resplendent in the evening glow and he thinks of two old sayings he has heard long ago – the one is:

> There must much strife be striven
> There must much suffering be suffered
> There must much prayer be prayed
> And then the end will be peace.

and the other:

> The water comes up to the lips
> But higher comes it not.

And he says, I shall be more and more tired, but also nearer and nearer to Thee. Has not man a strife on earth? But there is a consolation from God in this life, an angel of God comforting men, that is the Angel of Charity. Let us not forget Her. And when everyone of us goes back to daily things and daily duties, let us not forget – that things are not what they seem, that God by the things of daily life teacheth us higher things, that our life is a pilgrim's progress and that we are strangers in the earth, but that we have a God and Father who preserveth strangers, and that we are all bretheren. Amen.

And now the grace of our Lord Jesus Christ, and the love of God, our Father, and the fellowship of the Holy Ghost, be with us for evermore. Amen

[Reading: Scripture Psalm XCI]

Tossed with rough winds and faint with fear,
Above the tempest soft and clear
What still small accents greet mine ear
'tis I, be not afraid!

'tis I, who washed thy spirit white;
'tis I, who gave thy blind eyes sight,
'tis I, thy Lord, thy life, thy light,
'tis I, be not afraid.

These raging winds, this surging sea
Have spent their deadly force on me
They bear no breath of wrath to Thee
'tis I, be not afraid.

This bitter cup I drank it first
To Thee it is no draught accurst
The hand that gives it thee is pierced
'tis I, be not afraid.

When on the otherside thy feet,
Shall rest, mid thousand welcomes sweet;
One well-known voice thy heart shall greet –
'tis I, be not afraid.

Mine eyes are watching by thy bed
Mine arms are underneath thy head
My blessing is around Thee shed
'tis I, be not afraid.

Richmond Methodist Church, 29 October 1876

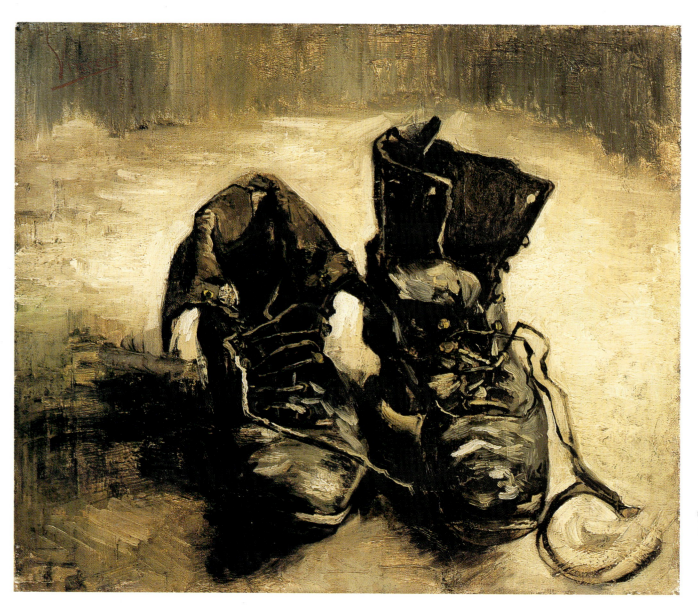

Vincent van Gogh *A Pair of Boots,* Autumn 1886 (cat.31)

CATALOGUE

Works by Van Gogh 1873-76

This catalogue is divided into five sections. The first covers Van Gogh's drawings, paintings and lithographs, listed chronologically. These are sub-divided into his 'English period' (1873-76) and later works (1881-90). The second section deals with Goupil prints, listed under artist. With one exception (cat.49), they were all published in the 1860s or early 1870s and were therefore handled by Van Gogh in London. The third section covers paintings which Van Gogh saw at the Summer Exhibitions of the Royal Academy, again listed under artist. Although in a few cases we are showing studies or replicas, these are versions of works originally displayed in 1873-76 (except for cat.75 which was exhibited in 1871). The fourth section consists of engravings by Black-and-White artists which were published in the *Illustrated London News* (*ILN*) or the *Graphic*. In most cases these are Van Gogh's own mounted copies. The final section includes memorabilia and printed books. The printed books are for illustrative purposes and are not Van Gogh's own copies.

Entries on individual exhibits are given in the following form: catalogue number, title, date, page where illustration appears and Van Gogh catalogue raisonée numbers (in brackets), medium and dimensions (height before width, in centimetres, then inches in brackets), description and comments, and owner.

Van Gogh's drawings and paintings are referred to throughout this volume by the De la Faille (F) number (*The Works of Vincent van Gogh*), followed by the Hulsker (H) number (*The Complete Van Gogh*) e.g. F970/H222. Hulsker only covers Van Gogh works from April 1881 onwards.

References to Van Gogh's letters are to the three-volume 1958 edition published by Thames & Hudson (*The Complete Letters of Vincent van Gogh*). Volume and page numbers are given (e.g. [II 27], is the second volume, page 27). Minor spelling and punctuation errors have been corrected. The latest Dutch edition of the letters (*De Brieven van Vincent van Gogh*) published in 1990, contains some material missing from the English translation. We acknowledge the help of Jaap Woldendorp for his help in translating these sections. Dating of the letters in this volume normally follows that given in the Dutch edition. Unpublished Van Gogh family letters, owned by the Van Gogh Foundation in Amsterdam and only recently opened up to scholars, are referred to by their inventory number, prefixed by U e.g. [U 2747].

Three books which provided important material are referred to by their short titles: Ronald Pickvance, *English Influences* (pagination of revised edition); Julian Treuherz, *Hard Times*; and Martin Bailey, *Young Vincent*. For details of other publications see bibliography at the end of this volume.

Brief biographies of the artists are given in their first entry. There is an artist index on p.152.

1 A LANE

Spring 1873
Illustrated p.24 (Fxiii)
Pencil and ink on paper, 18.5 x 22.5 (7¼ x 8¾)

The scene may well be on the outskirts of The Hague or near the Van Gogh family home at Helvoirt. Although normally dated to early 1873, it could be earlier (along with *A Canal* (cat.2) and *A Ditch* (cat.3)). The spindly trees are a distinguishing feature of Van Gogh's early sketches.

The sketch has been mounted on white card (26.2 x 30cm), probably by Van Gogh, and is signed on the mount in the lower left 'V.W. van Gogh'. It is the only one of his 1873-76 drawings which survives mounted and the only one with a signature.

On the reverse is a very rough sketch of a building, possibly by Van Gogh, along with some illegible writing (reproduced in Uitert, p.383).
Rijksmuseum Vincent van Gogh (Vincent van Gogh Foundation), Amsterdam (inv. no. 2.106)

2 A CANAL

Spring 1873
Illustrated p.23 (Fxvi)
Pencil and ink on paper, 25 x 25.5 (10 x 10)

On the far side of the canal is the same (or a similar) gate to the one in *A Lane* (cat.1). The trees, regularly spaced along both sides of the canal, are reflected in the water and provide a sense of perspective. On the reverse is a very rough sketch of a windmill and what could be trees (unpublished).
Rijksmuseum Vincent van Gogh (Vincent van Gogh Foundation), Amsterdam (inv. no. 2.110)

3 A DITCH

Spring 1873
Illustrated p.22 (Fxv)
Pencil and ink on paper, 24.5 x 18.5 (9½ x 7¼)

Drawn in the same area as *A Lane* (cat.1) and *A Canal* (cat.2). A church is visible in the distance, a feature which reappears in many of Van Gogh's later works.
Rijksmuseum Vincent van Gogh (Vincent van Gogh Foundation), Amsterdam (inv. no. 2.109)

4

4 LANGE VIJVERBERG, THE HAGUE

Spring 1873
Illustrated p.119 (Fxiv)
Pencil and ink on paper, 22 x 17 (8¾ x 6¼)

Lange Vijverberg, the elegant tree-lined road which overlooks the Hof Vijver lake in the centre of The Hague. Across the water is the medieval Binnenhof (the parliament building). The drawing was done from the corner of Plaats, close to Goupil's gallery. It probably dates from shortly before Van Gogh left The Hague in May 1873. The view today is relatively unchanged.
Rijksmuseum Vincent van Gogh (Vincent van Gogh Foundation), Amsterdam (inv. no. 2.108)

5 WAITING FOR CONFESSION (AFTER ROPS)

Spring 1873
Illustrated p.120 (Fxvii)
Pencil, heightened with a white chalk, inscription in ink, on paper, 26.5 x 19.5 (10½ x 7¼)

Inscribed in lower right 'd'après F. Rops'. Van Gogh's drawing, probably dating from spring 1873, is a copy of an illustration by the Belgian artist Félicien Rops (1833-98), published in *Uylenspiegel*, 29 March 1857. Entitled, *En attendant la confession*, it shows an old Breton woman asleep in a church.

On c29 October 1882 Van Gogh told Van Rappard that Rops did some 'beautiful' illustrations in *Uylenspiegel*, 'which I used to have, which I should be extremely glad to have again, but which, alas, I can't find.' [III 337-8] He also

5

wrote to Theo on the same day, saying that he had given these illustrations away in England to his Goupil colleague J. Richardson. [I 475]

Rijksmuseum Vincent van Gogh (Vincent van Gogh Foundation), Amsterdam (inv. no. 2.111)

6 First Sketchbook for Betsy Tersteeg

Spring 1873

Illustrated p.23 (F: Tersteeg sketchbook I)

Pencil and ink on white-ruled paper, 16.2 x 10.5 (6½ x 4¼)

A notebook, the first of three, filled with simple sketches for the young daughter of Van Gogh's boss in The Hague.

Inscribed (probably by Hermanus Tersteeg) on inside front cover: 'Getekend voor Betsy Tersteeg door Vincent van Gogh omstreeks 1873' (Drawn for Betsy Tersteeg by Vincent van Gogh about 1873). The sketches were probably done between January and May 1873, while Van Gogh was living in The Hague, and may well have been given as a leaving present just before he came to London. Betsy was born in 1869 and would therefore have been aged 3 or 4. The drawings may have been made for her to copy and some are defaced with childish squiggles.

The drawings in the sketchbook are as follows: 1. a snail (beneath the inscription), 2. two cocks/chickens and chicks, duck and ducklings, 3. two beetles, 4. a stag and goat, 5. a stork, 6. a parrot on a perch, 7. another parrot on a perch, 8. a man with a cap smoking a pipe, 9. a frog (defaced), 10. a dragonfly and tortoise, 11. a spider's web, 12. the inscription 'slak slak steek

je horens uit/Dan krijg je een stukje kaas en brood' (snail, snail, put out your eyes/then you will get a piece of cheese and bread), snail and grasshopper, 13. a cat and a pocket watch; 14. fruit and vegetables, 15. a caterpillar and butterfly, 16. a pond, wall/fence and four trees, 17. two rabbits, two plants and a bird on a perch, 18. an owl and a squirrel in a tree, 19. three mice, a cat, and two birds on perches, 20. a hunter with a gun and dog, 21. an elephant and two trainers, 22. a cock and a beetle, 23. a cat, mouse and parrot, 24. a dog wearing a hat and smoking a pipe and 25. a goldfish bowl.

The notebook has a brown marbled cover. Its existence was long forgotten, until it was tracked down in the early 1960s by the Polish art historian Anna Szymanska, who found it along with two similar books (dating from 1873/4 and 1874) with Betsy's elderly daughter, Mrs M. van Rijswijk. All three sketchbooks are reproduced in Szymanska. For Van Gogh's references to Betsy Tersteeg, see I 17, 56, 63 and his letter of 18 August 1876 (omitted in English edition).

Hermanus Tersteeg, who was the head of Goupil's gallery in The Hague, later encouraged Van Gogh to become an artist. In July 1879 he gave him a sketchbook and paintbox [I 190] and in September 1880 he lent him Bargue's *Exercises au Fusain* (Charcoal Exercises) and *Cours de Dessin* (Design Course) [cat.116]. [I 201, 203, 204]

Rijksmuseum Vincent van Gogh (Vincent van Gogh Foundation), Amsterdam (inv. no. 2.677)

7 Hackford Road

Spring 1874

Illustrated p.26

Pencil on blue coated paper, 9.1 x 16.6 (3¼ x 6½)

This intriguing drawing was discovered in 1972, and is said to have been given by Van Gogh to his landlady's daughter Eugenie Loyer when he was in love with her.

It depicts a terrace of five houses on the east side of Hackford Road, Brixton. The street name-plates, shown in white, appear to read 'Hackford Road' (on the left) and 'Russell Street' (on the right). The Loyer's house, 87 Hackford Road, is the second house from the left. In tiny writing, almost indecipherable, is a two-line name-plate on the railings just to the right of their front door, reading 'Loyer' (the top line, which could be 'Miss' or 'Mrs' is very difficult to decipher).

The drawing has been described as heightened with white (Wilkie, p.133), and it has been assumed that the marks in the sky are clouds. However, a more detailed examination suggests that it was drawn on blue-coated paper and that the marks in the sky are where the blue has worn

away (this has also occurred in the middle of the right side of the drawing). No other drawings by Van Gogh have been found on coated paper.

The work was discovered in a box of old family photographs by *Holland Herald* journalist Kenneth Wilkie in the attic of Eugenie Loyer's granddaughter Kathleen Maynard, in Stoke Gabriel, Devon (Wilkie, pp. 48-56 and 129-34).

On 14 December 1872 Dr Hans Jaffé authenticated this work as by Van Gogh, 'on the grounds of topographical evidence, the origin of the drawing, but especially on the grounds of the style' (Wilkie, p. 133). Jaffé told Wilkie that the detail which convinced him of its authencity was 'the way he drew the top part of the lamp-post'. However, the precise way that the buildings have been drawn (probably with a ruler) is unlike Van Gogh's usual technique.

The foliage on the trees suggests that it may have been done very soon after Van Gogh's arrival in London in August-September 1873 or, more likely, the following spring.

Van Gogh is known to have made other drawings of Hackford Road, although no others survive. [U 2673, 2710]

Russell Street was renamed Hillyard Street in 1937. The three houses to the right of 87 Hackford Road were destroyed in the Second World War.

In 1971, Paul Chalcroft, a retired London postman, discovered that Van Gogh had lived in Hackford Road (see *Young Vincent*, pp.26-9). Two years later, a blue plaque was erected on 87 Hackford Road. Sadly, Mr. Chalcroft died in March 1991, and we would like to acknowledge his important contribution to research on Van Gogh's stay in London.

Mrs. Kathleen Maynard, on permanent loan to the Rijksmuseum Vincent van Gogh, Amsterdam

8 Notebook with Portrait Sketch

March 1876

Illustrated p.26

Pencil on paper, 15.5 x 10.6 (6 x 4¼)

The sketch is in a notebook which Van Gogh filled with poetry for Matthijs Maris, a Hague School artist working in Paris. Van Gogh probably did the sketch shortly before he left Paris at the end of March 1876.

Van Gogh's main sketch, a figure against a black background, appears to be an elderly woman in a shawl, wearing a brooch. There are also two smaller sketches of men (the top one is bearded). The identity of all three people is unknown. The technique of shading around the head is similar to a portrait Van Gogh drew in his third sketchbook for Betsy Tersteeg (reproduced *Young Vincent*, p.42).

The notebook, which has a green-black cover, contains 65 pages of text (as well as 11 blank pages and 4 of drawings). The text consists of extracts from Ludwig Uhland, Heinrich Heine, Wolfgang von Goethe and Hans Christian Andersen. [I 46, 48]

The drawings comprise: on the inside front cover, an unclear sketch; on the page before the inside back cover, two women in profile by Maris; on the left side of the inside back cover, a portrait against a black background and two smaller profiles of men by Van Gogh; on the right side, another profile of a woman by Maris. The entire book is reprinted in facsimile in Pabst, pp. 38-59.

Saved along with the notebook is a letter in Dutch from Maris to Amsterdam art dealer W. van Meurs, dated 24 November 1909, which claims that he never opened the album. 'No doubt there may be some very good things in it,' Maris wrote. There is also a note by Van Meurs: 'The little book, in Vincent van Gogh's handwriting, was presented to Thijs [Matthijs] Maris in Paris as a token of Van Gogh's esteem. On the first page of the last leaf are two sketches by Th. Maris, and on the last page portrait sketches by Van Gogh.' Van Meurs does not identify the artist of the last sketch on the back inside cover.

Van Gogh admired Maris greatly. [I 17, 21, 22, 23, 24, 29] They are believed to have become friends in Paris in 1875-6 (although in October 1883 Van Gogh inexplicably exclaimed that he only 'spoke once or twice to Thijs Maris', [II 163]). In May 1885 Van Gogh still regarded his work highly: 'I think of that fellow so often, Theo, how marvellous his work is. It is as if he dreams – but what an artist he is!'. [II 381]

In 1877 Maris moved to London where he lived until his death in 1917. His artistic work quickly declined in England. His two brothers, Jacob (1837-99) and Willem (1844-1910) were both also successful painters.
Teylers Museum, Haarlem, Netherlands

9 ETTEN PARSONAGE AND CHURCH

April 1876
Illustrated p.27 (Fxxi)
Pencil and ink on paper, 9.1 x 17.8 (3½ x 7)
This fine drawing of Etten dates from the first half of April 1876, while Van Gogh was visiting his family. On the reverse of the sketch is an unpublished inscription (probably by Van Gogh): 'Van Vincent voor Wil' (From Vincent for Wil).

The parsonage at 4 Roosendaalsweg was the Van Gogh family home from 1875-82. The building was demolished in 1905 (a 1904 photograph is reproduced in Rozemeyer, p. 21). Van Gogh's father's church is at the right of the drawing. Dating from 1771, it was converted into the town

11

council's meeting room in 1985.
Rijksmuseum Vincent van Gogh (Vincent van Gogh Foundation), Amsterdam (inv. no. 2.113)

10 ETTEN PARSONAGE

April 1876
Illustrated p.25 (Fxxii)
Pencil and ink on paper, 5.8 x 11.7 (2¼ x 4½)
This view shows the Van Gogh family parsonage (without the church). It appears to have been drawn from the front garden of the parsonage, presumably near the fence depicted in *Etten Parsonage and Church* (cat.9).

Van Gogh probably gave this drawing to one of his sisters (it is said to have originally belonged to Wil and was then acquired by Anna). Van Gogh later drew the parsonage garden during his stay in Etten in 1881 (F902/H9).
Private Collection

11 RAMSGATE

April-May 1876
Illustrated p.121 (Fxxvi)
Pencil and ink on paper, 6.7 x 10.8 (2¼ x 4¼)
The view from the schoolroom on the ground floor of 6 Royal Road, Ramsgate, looking towards a garden on the seafront above West Cliff. The schoolmaster, William Stokes (c1832-1890), had been a professional artist and drawing master until he established his school (*English Influences*, p.13).

It has been assumed that this drawing was done within a few days of Van Gogh's arrival and

sent to Theo on 21 April 1876. In this letter he wrote: 'I should like to give you a peep through the school window. The house stands in a square (all the houses around it are the same) which is often the case here. In the middle of the square is a large lawn, shut off by iron railings and surrounded by lilac bushes; the boys play there during the recreation hour. The house where I stay is in the same square'. [I 54] However, Van Gogh appears to be describing Spencer Square, which is directly in front of 6 Royal Road, whereas the present drawing is of the garden by the seafront (the same view as in cat.12).

The fact that on 31 May Van Gogh sent Theo another drawing (cat.12), with no comment about it being a later version of an earlier sketch, is additional evidence to suggest that this present work was not posted to Theo on 21 April. The present work may well have been sent to Van Gogh's parents or one of his sisters.

The main differences between the two Ramsgate sketches is that this rectangular version is 'stretched' horizontally and has a stormy sky.
Rijksmuseum Vincent van Gogh (Vincent van Gogh Foundation), Amsterdam (inv. no. 2.114)

12 RAMSGATE

May 1876
Illustrated p.25 (Fxxvii)
Pencil and ink on paper, 5.6 x 5.7 (2¼ x 2¼)
This work was sent to Theo in a letter dated 31 May 1876: 'Enclosed is a little drawing of a view from the school window through which the boys

wave goodbye to their parents when they are going back to the station after a visit. None of us will ever forget the view from the window... The boys made an oil stain on your drawing, please excuse them'. [I 58] The oil stain in the bottom-right corner confirms that this is the drawing referred to in this letter.

Van Gogh loved the view from Royal Road. In his first Ramsgate letter to Theo, on 17 April 1876, he remarked that 'one of my first impressions was that the window of this not-very-large school looks out on the sea'. [I 53, also 52] After he had left Ramsgate, Van Gogh recalled that 'there were many bugs at Mr. Stokes', but the view from the school window made one forget them all'. [I 64]

Rijksmuseum Vincent van Gogh (Vincent van Gogh Foundation), Amsterdam (inv. no. 2.115)

13 HOUSES AT ISLEWORTH

July 1876

Illustrated p.20 (Fxxiv)

Pencil on paper, 14.4 x 14.7 (5¼ x 5¾)

The subject of this drawing remains a mystery. Traditionally entitled *Houses at Isleworth*, it is said to have been enclosed with Van Gogh's letter to Theo of 5 July 1876, sent a week or two after his arrival. [I 61-2] However, there is nothing in this letter about the drawing (De la Faille erroneously links it to a walk to Hampton Court).

The sketch presumably depicts a house of special significance. Linkfield House, which was the schoolhouse of William Stokes, is now demolished and no photographs of it survive. However, it is shown on maps as an isolated house and could not be the one in this drawing. Holme Court, where Van Gogh moved to on c 5-8 July, still stands and is also not the house in this sketch.

The drawing has more shading than most of Van Gogh's works of this period. It has been worked in pencil only, whereas his usual practice at this time was to finish a drawing with ink.

Rijksmuseum Vincent van Gogh (Vincent van Gogh Foundation), Amsterdam (inv. no. 2.116)

14 AUSTIN FRIARS CHURCH

November 1876

Illustrated p.8 (Fxxv)

Ink on paper, 9.5 x 15.2 (3¾ x 6)

The drawing has been captioned by Van Gogh (in Dutch): 'This little church is a remarkable remnant of an old Augustinian foundation (Austin Friars) dating at least from the year 1534 if not 100 years earlier. Since as long ago as 1550, as a result of a voluntary gift of Edward VI, the

Dutch Reformed Parish has held its gatherings there.'

Van Gogh may have sketched the church in late 1876 on one of his visits from Isleworth. The bare trees suggest that it could have been drawn on 18 November. Van Gogh has done the drawing from the north-west corner of the church, in an alley also called Austin Friars. A photograph taken in 1892 from almost the same position shows that he has succeeded in producing an accurate representation of the church (reproduced in *Young Vincent*, p.101).

If done on the spot, the sketch is most accomplished, reflecting a greater confidence than his drawings of 1873. It is unusual for being executed in ink alone. However, it is possible that the drawing was based on a photograph or illustration (although none has been found which corresponds precisely with this work).

On the reverse of the sketch is the unpublished inscription: 'Vincent van Gogh/gekregen van zijn zuster Mevr van Houten 1914/J. Nieweg' (Vincent van Gogh/Received from his sister Mrs van Houten 1914/J. Nieweg). This suggests that Van Gogh gave the drawing to his sister Anna (whose married name was Mrs van Houten). In 1876 Anna was still in Welwyn, and she may have occasionally visited Austin Friars with Van Gogh.

Austin Friars Church, originally the church of the Augustian Friars, was built in the City of London in 1253. Since 1550 it has served the Dutch community. The church was bombed in the Second World War and has been rebuilt in a different style.

This drawing is exhibited in Britain for the first time.

Rijksmuseum Vincent van Gogh (Vincent van Gogh Foundation), Amsterdam (inv. no. 2.117)

Works by Van Gogh 1881-90

15 THE BEARERS OF THE BURDEN

April 1881

Illustrated pp.104-105 (F832)

Pen and pencil on paper, 43 x 60 (17 x 23½)

Inscribed in the bottom right corner (in English): 'The Bearers of the Burden'. Three women are bent double, carrying coal sacks on their backs. Behind them is a railway bridge, a mining town and a church spire. The crucifix on the ivy-covered tree trunk beside the path suggests a religious dimension to the picture.

The drawing was probably done in Brussels on a visit to Van Rappard's. On 12 April 1881 Van Gogh told Theo: 'I have sketched two drawings at Rappard's, *The Lampbearers* and *The Bearers of the Burden*, [both titled in English]. [I 222] Van Gogh added that he hoped to work them up into finished compositions to send to publishers.

The title of the surviving drawing may well be related to Boughton's painting of the same title exhibited at the 1875 Royal Academy Summer Exhibition (cat.60). A visual reference which could have influenced Van Gogh is an illustration in his collection of two women carrying sacks (Caton Woodville's *The State of Ireland: Women Carrying Home Meal-sacks from the Relief Committee* from the *ILN*, 20 November 1880, reproduced in *English Influences*, p.720). [III 365]

Van Gogh tackled the same subject again in October 1882 (*Miners' Wives*, F994/H253). [I 481] Following this work he wrote: 'Not without some trouble I have at last discovered how the miners' wives in the Borinage carry their sacks. You may remember that when I was there I did some drawings of it – but they were not yet the real thing'. [III 339] This suggests that Van Gogh made preliminary drawings for *The Bearers of the Burden* while still in the Borinage.

The pendant to this drawing, *The Lampbearers*, now lost, presumably also depicted miners. In November 1878 Van Gogh described the job of a miner: 'He works laboriously by the pale, dim light of a lamp, in a narrow tunnel, his body bent double... when he goes down into the shaft, wearing on his hat a little lamp to guide him in the darkness, he entrusts himself to God'. [I 179]

On the reverse of *The Bearers of the Burden* is a rough sketch of a girl and mother with a child.

Rijksmuseum Kröller-Müller, Otterlo (inv. no. 3a)

16 SORROW

November 1882

Illustrated p.74 (F1655/H259)

Lithograph, 38.5 x 29 (15¹/₄ x 11¹/₂)

Inscribed in lower right (in English): 'Sorrow'. The model was Sien, who was six months pregnant.

The lithograph is based on a series of three drawings made in April 1882. Van Gogh described one of them as the 'best figure' he had drawn to date. [I 336] He added: 'Of course I don't always draw this way, but I'm very fond of the English drawings done in this style, so no wonder I tried it for once'. [I 337]

When Van Gogh drew *Sorrow* he found the image had left an impression on two sheets underneath. [I 338, 342] The top version he gave to Van Rappard (F929/H129), now in a private collection in Switzerland. He 'touched-up' the other sheet, inscribing it with the words: 'Comment se fait-il qu'il y ait sur la terre une femme seule – délaissé. Michelet' (How can there be on earth a woman alone – abandoned. Michelet). This version is now at Walsall Museum & Art Gallery. Van Gogh also drew a larger version for Theo's birthday on 1 May, but this is lost. [I 360, 363, 371, 394, 406, 416, 419, 426]

Van Gogh discussed plans to make the lithograph on 5 November 1882 and on 14 November wrote to Theo: 'I made another trial last week with the little figure, *Sorrow*.' [I 483, 486] Two days later he sent a print to Theo: 'You will receive the *very first* print of *Sorrow*.' [I 488] He added, on 22 November: 'I hope you received the roll with lithographs containing *Sorrow*.' [I 409]

Rijksmuseum Vincent van Gogh (Vincent van Gogh Foundation), Amsterdam (inv. no. 2.157a)

17 ORPHAN MAN DRINKING COFFEE

November 1882

Illustrated p.74 (F1657/H266)

Lithograph, 57 x 37.5 (22¹/₂ x 14¹/₄)

The model for this work was Adrianus Zuyderland, a resident of the Dutch Reformed Old Men's and Old Women's Home in Warmoezierstraat, The Hague. The lithograph is based on a drawing (F1682/H263).

Van Gogh worked on a series of drawings of orphan men from September 1882 to January 1883. His decision to draw these elderly men must have been partly inspired by Herkomer's *Sunday at Chelsea Hospital* (cat.89) and *The Last Muster – Sunday at the Royal Hospital, Chelsea* (*Graphic*, 15 May 1875). Van Gogh used the Dutch word 'weesmannen' (orphan men) to describe the models in his own drawings and Herkomer's illustrations. [III 355, I 465]

On 22 November 1882 Van Gogh wrote to Theo: 'Along with this letter you will receive the first proofs of a lithograph... *Man Drinking Coffee*'. [I 489, also 490-1] Four days later he told Van Rappard that the work had been 'more striking as a drawing; in the lithograph I have used autographic ink, which did not transfer very well, and the "quickness" of the drawing has to a great extent gone out of it.' [III 343]

Rijksmuseum Vincent van Gogh (Vincent van Gogh Foundation), Amsterdam (inv. no. 2.159b)

18 AT ETERNITY'S GATE

1882

Illustrated p.123 (F1662/H268)

Lithograph, 55.5 x 36.5 (22 x 14¹/₂)

The lithograph is based on a similar drawing, presumably done shortly before (F997/H267). Seven copies of the lithograph are known. On one copy (De La Faille impression III) Van Gogh has inscribed 'At Eternity's Gate' (in English) in the lower left corner. This title could be related to Herkomer's *At Death's Door* (cat.69).

On 26 November 1882 Van Gogh told Theo that 'tomorrow I hope to get the proof of a little old man'. [I 494] The following day he added: 'This morning I had to go to the printing office with my little old man... Enclosed you will find the first print... I have tried to express... the existence of God and eternity – certainly in the infinitely touching expression of such a little old man, which he himself is perhaps unconscious of, when sitting quietly in his corner by the fire.' [I 494-5, also 501]

Van Gogh also explained to Van Rappard on 26 November that his latest work was similar to *Worn Out* (F863/H34): 'It shows an old workman sitting lost in thought, his elbows on his knees, and his hands clasping his head (this time with a bald crown.' [III 343]

The pose of the bald figure is very similar to an illustration by Arthur Boyd Houghton, *Father and Son* (cat.121) in *Hard Times* by Dickens. See Tilburg, p.122.

Rijksmuseum Vincent van Gogh (Vincent van Gogh Foundation), Amsterdam (inv. no. 160a)

19 FISHERMAN IN SOU'WESTER

January 1883

Illustrated p.79 (F1014/H310)

Pencil, ink, washed with bistre and heightened with white, on paper, 50.5 x 31.5 (20¹/₄ x 12¹/₄)

Herkomer's *Coastguardsman* (cat.91) from the *Graphic*'s 'Heads of the People' series appears to have influenced this drawing by Van Gogh.

On c11 December 1882 Van Gogh had said

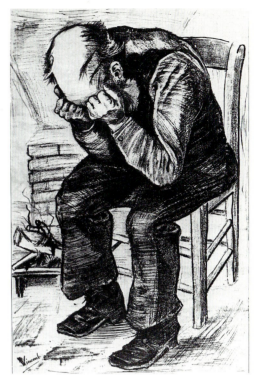

18

that 'I do try my best to make "Heads of the people" [written in English]. You know, Theo, I would like to do the kind of work those who started the *Graphic* did, though I do not count myself their equal'. [I 511-2]

On c15 January 1883 Van Gogh told Van Rappard: 'I hope to learn a few more things about the forces of black and white from these *Graphics*... What I have been working at especially of late is heads – Heads of the people [written in English] – fishermen's heads with sou'westers, among other things.' [III 354]

On c21 January 1883 Van Gogh wrote to Theo: 'Tomorrow I get a sou'wester for the heads. Heads of fishermen, old and young, that's what I have been thinking of for a long time, and I have made one already, then afterwards I couldn't get a sou'wester. Now I shall have one of my own, an old one over which many storms and seas have passed.' [I 528] On c15 February 1883 he added: 'I have been drawing with such delight – fishermen's heads with that sou'wester I told you about; the fish scales were still sticking to it when I got it'. [I 543] On c2 March 1883 he told Theo that 'the large studies of heads', such as those with sou'westers, would serve for watercolour compositions. [I 554]

Van Gogh drew at least eight pictures of this subject in January-February 1883.

Rijksmuseum Vincent van Gogh (Vincent van Gogh Foundation), Amsterdam (inv. no. 2.178)

20 WOMAN WEEPING

February 1883

Illustrated p.79 (F1060/H326)

Black chalk, washed, heightened with white, on paper, 47.5 x 29.5 (19 x 11¹/₄)

Van Gogh's drawing may well have been based on a figure in the foreground of Edward Dalziel's *London Sketches – Sunday Afternoon, 1pm: Waiting for the Public House to Open*, published in the *Graphic* (cat.83). In his letter to Van Rappard of 27 February 1883 Van Gogh described Dalziel's illustration as 'excellent'. [III 368]

The model is Van Gogh's lover, Sien.

Rijksmuseum Kröller-Müller, Otterlo (inv. no. 63)

21 THE SOUP KITCHEN

March 1883

Illustrated p.86 (F1020a/H330)

Black chalk on paper, 57 x 44.5 (22¹/₂ x 17¹/₂)

Van Gogh used an analogy from *Felix Holt* to explain this drawing, comparing his own 'family' in The Hague with characters from Eliot's novel. [II 2] His drawing shows Sien (on the right), her six-year-old daughter Maria walking away with a pitcher of soup, Sien's younger sister Maria getting a pitcher filled and her mother Maria holding baby Willem in her arms. The family were very poor and probably had made use of soup kitchens.

On c28-30 December 1882 Van Gogh first talked of drawing a soup kitchen. [I 517] On c3 March 1883 Van Gogh tackled the subject. He explained in a letter to Theo: 'They sell the soup in a large passage where the light falls from above, through a door to the right. Now I tried to find the same effect in the studio.' [I 557-558]

The following day he wrote again about a failed attempt to do a watercolour of the soup kitchen and a successful version in black crayon, the present work. Van Gogh enclosed this drawing and explained: 'I don't think it finished enough, but as a "sketch from life" there is perhaps some life in it, and some human sentiment.' He then made the analogy with *Felix Holt*. [II 1, 2] Van Gogh also wrote to Van Rappard on c5 March describing his medium for the drawing – black crayon: 'Yesterday I made a drawing with it – women and children at the serving window of the public soup kitchen. And I can tell you that I was delighted with the experiment.' [III 370]

Another black chalk version of *The Soup Kitchen* survives (F1020b/H331). Small sketches are included in three of Van Gogh's letters (I 558/H328, II 1/H332, II 4/F1020/H333).

Rijksmuseum Vincent van Gogh (Vincent van Gogh Foundation), Amsterdam (inv. no. 2.187)

22 INTERIOR WITH WEAVER

July 1884

Illustrated p.77 (F37/H501)

Oil on canvas, 61 x 93 (24 x 36¹/₂)

Van Gogh completed a series of over thirty paintings and drawings of weavers in Nuenen. The scenes depicted are of the traditional craft-based cottage weavers. Van Gogh portrays them with a sensitivity that mirrors the approach of the Social Realist artists in England. It was on 24 September 1880, four years previously, that Van Gogh had first shown his enthusiasm for the subject, writing: 'The miners and the weavers still constitute a race apart from other labourers and artisans, and I feel a great sympathy for them. I should be very happy if someday I could draw them'. [I 206]

In early July 1884 Van Gogh wrote to Theo: 'I am quite absorbed again in two new large studies of weavers' interiors'. He described one of them as showing 'an interior, with three small windows, looking out on the yellowish greenery, contrasting with the blue of the cloth that is being woven on the loom and with the blouse of the weaver, which is again of another blue.' [II 298] Van Gogh's chiaroscuro effect emerges in a similar picture he was doing at the same time (F24/H500). The same interior with three windows appears in a watercolour (F1115/H502).

Rijksmuseum Kröller-Müller, Otterlo (inv. no. 164)

23 INTERIOR WITH WEAVER

July 1884

Illustrated p.94 (F27/H503)

Oil on canvas, 47.5 x 61.3 (18¹/₂ x 24¹/₄)

This was the other painting referred to in Van Gogh's letter of early July 1884. He explained that 'one shows a part of the loom with the figure and a small window'. [II 298] On the loom Van Gogh has written 'Anno' (on the left pole) and '1726' (on the right pole).

In this work the interior is claustrophobic, with the weaver 'imprisoned' by his loom. His head is vacant and ungainly, separated from the rest of his body. It is the most disturbing of Van Gogh's weavers.

Van Gogh found literary accounts of weavers in Charlotte Brontë's *Shirley* [I 236, 271] and Eliot's *Silas Marner* [I 163 and his letter of early August 1878, omitted from English edition].

Museum Boymans-van Beuningen, Rotterdam

24 LANE OF POPLARS IN AUTUMN

October 1884

Illustrated p.71 (F122/H522)

Oil on canvas (on panel), 98.5 x 66 (38¹/₄ x 26)

In late October 1884 Van Gogh wrote to Theo: 'The last thing I made is a rather large study of an avenue of poplars, with yellow autumn leaves, the sun casting, here and there, sparkling spots on the fallen leaves on the ground, alternating with the long shadows of the stems. At the end of the road is a small cottage, and over it all the blue sky through the autumn leaves.' [II 320] Van Gogh was particularly interested in the complementary effect of orange and blue.

Van Gogh may have been referring to this work when he wrote in August 1885 that a Utrecht painter friend called Willem Wenckebach liked his 'avenue of autumn trees.' [II 394] Other related works are *Country Lane* (F120/H519), *Lane of Poplars* (F1246/H520) and *Lane of Poplars at Sunset* (cat.30).

The tree-lined path was one of Van Gogh's favourite motifs, which he drew and painted throughout his career. These pictures, often with a lone figure, can be seen as a graphic portrayal of his view of life as a 'pilgrimage'.

Rijksmuseum Vincent van Gogh, Amsterdam (inv. no. 1.62)

25 HEAD OF A PEASANT WOMAN

January 1885

Illustrated p.109 (F154/H608)

Oil on canvas, 40 x 30 (15¹/₄ x 11¹/₄)

Van Gogh painted a series of peasants' portraits in Nuenen, directly inspired by the *Graphic*'s series 'Heads of the People'.

In late October 1884 Van Gogh talked of painting 'thirty studies of heads' of peasants. [II 321] By February 1885 he wrote that he was 'very busy' painting these heads. 'I paint in the daylight and draw in the evening. In this way I have already painted at least some thirty and drawn as many', he added. [II 349]

This is one of the earlier peasant heads. Two sketches of this painting also exist (H607, F1177/H609) and the model appears in three other works (F65/H627, H628/II 347, F1667/H629). The identity of the woman is unknown. Like all Van Gogh's Nuenen portraits, the present work is painted with a dark, earthy palette.

Rijksmuseum Kröller-Müller, Otterlo (inv. no. 171)

26 HEAD OF AN ELDERLY PEASANT WOMAN

February/March 1885

Illustrated p.108 (F74/H648)

Oil on canvas, 37.5 x 28 (15 x 11)

Van Gogh painted the same old woman in a white cap in December 1884 (F75/H550, F146/H551, F1193a/H552) and in early 1885 in a dark

27 HEAD OF A PEASANT WOMAN

April 1885

Illustrated p.81 (F140/H745)

Oil on canvas (on cardboard), 47.5 x 35.5 (19 x 14)

The model is Gordina de Groot (1855-1927), who appears in many of Van Gogh's 'heads' from this period, as well as *The Potato Eaters* (cat.28). When Van Gogh lived in Nuenen there was malicious gossip that he had got one of his models pregnant. [II 412] This is assumed to have been Gordina de Groot, whom Van Gogh called Sien. [III 427]

National Gallery of Scotland

28 THE POTATO EATERS

April 1885

Illustrated p.82 (F1661/H737)

Lithograph, 26.5 x 30.5 (10¹/₂ x 12)

The 'Heads of the People' series played an important role in encouraging Van Gogh's own peasant portraits, which in turn culminated in his painting of *The Potato Eaters* (fig.36). In 1887 he told his sister Wil that the painting was his 'best' work. [III 427]

Van Gogh began by making an oil study from life for *The Potato Eaters* in the De Groot home in early April 1885 (F78/H734). It was after this initial oil study that he made the lithograph. The image shows Gordina de Groot (cat.27) in the white cap under the lamp and the man on the right may be her brother, Gijsbertus (cat.29).

On *c*13 April Van Gogh went to Eindhoven to order a lithographic stone. [II 361] The lithograph was finished a few days later. On 13-17 April he wrote that 'by the same mail you will receive a few copies of a lithograph' and he sent further copies on 21 April. [II 364, 366] Theo then replied that the lithograph had a 'woolly' effect, with Van Gogh writing back in agreement in early May. [II 372]

On *c*30 April 1885 Van Gogh wrote to Theo: 'I have tried to emphasize that those people, eating their potatoes in the lamplight, have dug the earth with those very hands they put in the dish, and so it speaks of *manual labour,* and how they have honestly earned their food.' Van Gogh added that he hoped that *The Potato Eaters* would be 'a real peasant picture... I personally am convinced that I get better results by painting them in their roughness than by giving them a conventional charm... If a *peasant picture* smells of bacon, smoke, potato steam – all right, that's not unhealthy'. [II 370]

Van Gogh also sent the lithograph to Van Rappard, who was very critical of it, writing on 24 May : 'such work is not meant seriously.' [III 410] Van Gogh responded in the second half of June to say that you 'had no right to condemn my whole work in the insulting way you did'. [III 410] Van Gogh added an important comment a few days later: 'Here is my explanation of the lithograph. I did it entirely from memory and in a single day; I thought a certain composition somewhat forced, and was using an altogether different process in an attempt to find a new idea to put it together. Besides, it was only an experiment and nothing more'. [III 413] In the second half of August Van Gogh wrote again: 'That scene of the potato eaters – you saw the lithograph of it – is a subject that I tried to paint, being inspired by the peculiar light effect in that grimy cottage.' [II 418]

This dispute with Van Rappard ended their friendship, in which Van Gogh had found a companion who shared his enthusiasm for the English Black-and-White illustrators.

Shortly after completing the lithograph, Van Gogh began the final painting (F82/H764).

There are numerous influences in the painting, although it still remains a highly individual work. One such influence may well have been a painting by Israëls, *The Frugal Meal,* 1876 (Glasgow Art Gallery) which Van Gogh referred to in March 1882. He described it as showing 'a peasant family at mealtime'. [I 325-6] Two small details in *The Potato Eaters* are also similar to a *Graphic* print in Van Gogh's collection, *Life in Russia: Drosky or Sledge Drivers in a Tea House – A Hint for our Cabmen* (cat.82).

Rijksmuseum Vincent van Gogh (Vincent van Gogh Foundation), Amsterdam (inv. no. 2.289a)

29 HEAD OF A YOUNG PEASANT

May 1885

Illustrated p.80 (F163/H687)

Oil on canvas, 39 x 30.5 (15¹/₈ x 12)

The model may well be Gijsbertus de Groot, brother of Gordina (Hulsker, *Vincent and Theo van Gogh,* p.152). He appears to be the same model in *The Potato Eaters,* sitting at the end of the table.

Although Van Gogh finished his series of 'heads' in 1885, he never forgot the inspiration of the *Graphic.* On *c*18 August 1888 he wrote to Emile Bernard about his portrait of the peasant Patience Escalier (F443/H1548), saying that 'I have another figure... which is an absolute continuation of certain studies of heads I did in Holland'. [III 510] A year later, on 5-6 September 1889, he told Theo about a portrait of the asylum attendant Charles Trabuc (F629/H1774), saying that he was 'of the people'. [III 203]

Musées royaux des Beaux-Arts de Belgique, Bruxelles

30 LANE OF POPLARS AT SUNSET

October-November 1885

Illustrated p.70 (F123/H518)

Oil on canvas, 46 x 33 (18 x 13)

A lone figure in black walks down a lane of poplars silhouetted against the setting sun. Painted at Nuenen, probably in October-November 1885 (although Hulsker dates it to October 1884, the same period as *Lane of Poplars in Autumn* (cat.24)).

Van Gogh continued to paint the motif of a tree-lined path with figures in his later work. Examples include: from Paris, *Road Along the Seine at Asnières,* (F299, H1254); from Arles, *The Alyscamps, Avenue at Arles* (F569/H1623); from St-Rémy, *Pine Trees Against the Setting Sun* (F652/H1843); and from Auvers, *Couple Walking between Rows of Trees* (F773/2041).

Rijksmuseum Kröller-Müller, Otterlo

31 A PAIR OF BOOTS

Autumn 1886

Illustrated p.118 (F255/H1124)

Oil on canvas, 37.5 x 45.5 (14³/₄ x 18)

A 'still life' of a pair of boots, rough and worn, each with its own distinctive shape and character. Van Gogh himself was a wanderer, never settling down anywhere for long. He also loved walking. When in England he walked a hundred miles from Ramsgate to Welwyn to visit his sister Anna. He also once walked from London to Brighton. [I 49] Intentionally or not, this painting symbolises Van Gogh's restless travels.

Van Gogh painted six other pictures of shoes or boots, one of which includes the same pair (F332/H1234). This present work, done in Paris, may well have been the one which his fellow student François Gauzi (1862-1933) saw in his studio. Gauzi later recalled: 'At the flea market he'd bought an old pair of clumsy, bulky shoes – peddler's shoes – but clean and freshly shined. They were fine old clonkers, but unexceptional. He put them on one afternoon when it rained and went for a walk along the old city walls. Spotted with mud, they had become interesting... Vincent faithfully copied his pair of shoes.' (quoted in Stein, p.72).

This work was exhibited at Van Gogh's first one-man show in London, at the Leicester Galleries in 1923.

Rijksmuseum Vincent van Gogh (Vincent van Gogh Foundation), Amsterdam (inv. no. 1.130)

At the top of the first column (continuation):

cap (H646, F1149/H647, F151/H649 and the present work). The model has not been identified.

Rijksmuseum Kröller-Müller, Otterlo (inv. no. 170)

32 VAN GOGH'S CHAIR (THE CHAIR AND THE PIPE)

November 1888

Illustrated p.84 (F498/H1635)

Oil on canvas, 93 x 73.5 (36¼ x 29)

A simple straw-seated chair, with Van Gogh's pipe and tobacco on it. Behind is a box with sprouting onions or bulbs, signed 'Vincent'. Just beside the chair is a door. It is a day-time scene, painted in complementary greens and reds. The tiled floor gives the painting a dizzy perspective. At the same time Van Gogh also painted a night-time pendant, *Gauguin's Chair* (fig.26) (F498/H1636).

Van Gogh's Chair can be read as an unusual self-portrait. However, it has also been interpreted as reflecting the impending crisis that led to Gauguin's departure and eventually to his own suicide.

On *c*23 November 1888 Van Gogh wrote to Theo about the 'empty chair' paintings: 'The last two studies are odd enough. Size 30 canvases, a wooden rush-bottomed chair all yellow on red tiles against a wall (daytime). Then Gauguin's armchair, red and green night effect, walls and floor red and green again, on the seat two novels and a candle, on thin canvas with a thick impasto'. [III 108]

Following the crisis when Van Gogh mutilated his ear, he retouched the painting of his own chair. On 17 January 1889 he wrote to Theo, saying that he wanted their artist friend Meyer de Haan (1852-95) to see the two paintings: 'I should like De Haan to see a study of mine of a lighted candle and two novels (one yellow, the other pink) lying on an empty armchair (really Gauguin's chair), a size 30 canvas, in red and green. I have just been working again today on its pendant, my own empty chair, a white deal chair with a pipe and tobacco pouch. In these studies, as in others, I have tried for an effect of light by means of clear colour'. [III 121]

A year later, on *c*10-11 February 1890, Van Gogh wrote to art critic Albert Aurier about Gauguin: 'A few days before parting company, when my disease forced me to go into a lunatic asylum, I tried to paint "his empty seat". It is a study of his armchair of sombre reddish-brown wood, the seat of greenish straw, and in the absent one's place a lighted torch and modern novels'. [III 256] (Van Gogh's comments on timing are misleading, because he did the main work on the two paintings in November 1888, a month before the crisis and five months before he went to St-Rémy).

The chair which Van Gogh depicted as his own was probably among the dozen which he bought on 8 September 1888 for the Yellow House, just before Gauguin's arrival. [III 30, 442] Two similar chairs are depicted in paintings of his *Bedroom* (F482-4/H1608, H1771, H1793). Van Gogh's simple, rough chair contrasts with the more luxurious and elegant armchair of Gauguin.

Van Gogh linked the theme of the 'empty chair' with parting or death, emphasized by his explanation of the Fildes illustration of Dickens chair (cat.85). [I 509]

In a letter from Isleworth, dated 25 November 1876, he had copied out a poem called 'The Three Little Chairs' which describes how two elderly parents sat alone by a fire looking at the chairs of their three dead children (omitted from English edition). The poem, by an unidentified writer, referred to 'those empty chairs'.

Van Gogh later did drawings of empty chairs in St-Rémy (F1508v, F1510-12, F1549r/H1963-6). Kodera also gives a more detailed listing of paintings by Van Gogh which depict chairs (Kodera, p.154).

The unlit pipe and tobacco pouch are reminiscent of those of his father, which he sketched in a still-life in April 1885, just after his death (*Honesty in a Vase*, H726). [II 355-6]

This painting has an interesting provenance. It was sent to Theo, who responded on 21 May 1889, saying that 'the chair with the pipe and tobacco pouch' was among those he liked best. [III 542] At Theo's death in 1891 it was inherited by his wife, Jo Bonger.

It was among the paintings shown at the first one-man exhibition of Van Gogh's work in London, at the Leicester Galleries in 1923, where it was titled *The Yellow Chair*. The organiser, Oliver Brown, later recalled: 'A few of the best pictures were not for sale, notably *The Chair* and *The Sunflowers*, but the Trustees of the Tate Gallery were so anxious to have these two that the family were persuaded to part with them to the Tate in the end through the Trustees of the Courtauld Fund' (*The Memoirs of Oliver Brown*, 1968, pp. 83-5).

In 1924 the Tate Gallery acquired *Van Gogh's Chair*, purchased with funds from Samuel Courtauld. The price was £696. It was among the first Van Gogh paintings to enter a public gallery in England (along with *Wheatfield with Cypresses* F615/H1755 and *Sunflowers*, F454/H1562). For further details, see Martin Bailey, 'Flower Power', *Observer* (magazine), 19 January 1991, p.15. *Van Gogh's Chair* was transferred to the National Gallery in 1961.

The Trustees of the National Gallery, London

33 AT ETERNITY'S GATE

May 1890

Illustrated p.91 (F702/H1967)

Oil on canvas, 81 x 65 (31¾ x 25½)

A painting of Van Gogh's lithograph of the same title (cat.16). It is also known as *Old Man in Sorrow*. This is the only occasion when he 'translated' an early drawing into a later oil painting. There are slight differences between the lithograph and painting (such as the floor and fireplace).

On 29 April 1890 Van Gogh talked of painting 'memories of the North' from his younger days. [III 261] He also asked his family to send some of his drawings from Brabant, and this lithograph was probably among those he received. [III 262, 263 and 570] Van Gogh painted *At Eternity's Gate* just a few weeks before leaving the asylum at St-Rémy. 'Those last days at St-Rémy I still worked in a frenzy', he told his sister Wil. [III 469]

The seated old man, approaching death, is about to 'vacate' his chair. Although he may not have realised it, Van Gogh was then nearing his own death.

Rijksmuseum Kröller-Müller, Otterlo (inv. no. 251)

Goupil Prints

ANKER, ALBERT (1831-1910)

Swiss Realist painter of peasant life.

34 UN BAPTÊME (A BAPTISM)

1862 (painting)

Illustrated p.127

Photograph mounted on card, 25 x 29.8 (10 x 11½)

Goupil photograph. In October 1873 Van Gogh referred to this work, commenting that the artist 'painted a variety of subjects, all equally intimate and delicate of feeling'. [I 15]

Bibliothèque Nationale, Paris

35 UN VIEUX HUGUENOT (AN OLD HUGUENOT)

1875 (painting) 1875 (print)

Illustrated p.28

Photograph mounted on card, 34.7 x 27.5 (13½ x 11)

Goupil Galerie Photographique no.1525. The painting was exhibited at the Paris Salon in 1875. On 29 June 1875 Van Gogh sent a reproduction of *An Old Huguenot* to his father, for his study. [I 28] The work was also reproduced in the *ILN*, 26 August 1876.

Bibliothèque Nationale, Paris

34

BOUGHTON, GEORGE (1833-1905)

Painter and popular illustrator who concentrated on literary and historical subjects. Born in Norwich and spent his childhood in America. In 1859 he went to Paris to study art and came to London three years later. His paintings were influenced by Fred Walker. Elected ARA in 1879 and RA 1896.

36 PURITAINS ALLANT À L'ÉGLISE (PURITANS GOING TO CHURCH)

1867 (painting)

Illustrated p.32

Photograph mounted on card, 27.7 x 41.6 (11 x 16½)

Goupil Galerie Photographique no.5. On 20 July 1873 Van Gogh mentioned that *Puritans Going to Church* was in Goupil's Galerie Photographique. [I 10] Four months later, Van Gogh referred to this work, describing Boughton as 'one of the best painters here'. [I 15] The original painting of 1867, exhibited at the RA, is now in the collection of the New York Historical Society.

Other works by Boughton which Van Gogh admired included *God Speed!* (cat.59), *The Heir* (cat.60a), *The Bearers of the Burden* (cat.60), *New England Pilgrims Waiting for the Relief Ship* [II 195], *Waning of the Honeymoon* (exhibited at the RA in 1878, now at Baltimore, Walters Art Gallery) [III 358] and *Widows Field* (presumably

38

Widow's Acre of 1879) [III 331].
Bibliothèque Nationale, Paris

BOUGUEREAU, ADOLPHE (1825-1905)

French painter, particularly successful in the 1850s; known for his traditional academic style. His subject matter ranged from sentimental religious works to coyly erotic nudes.

37 LE JOUR (THE DAY)

Illustrated p.31

Etching, 12 x 6.2 (4¾ x 2½)

Goupil Estampe Miniature no. 328. Bouguereau was among Goupil's best-selling artists. In August 1888 Van Gogh told Theo: 'If I painted prettily like Bouguereau, people would not be ashamed to let themselves be painted, but I think I have lost models because they thought they were "badly done".' [III 15]

Witt Library, Courtauld Institute of Art

BRION, GUSTAVE (1824-77)

French genre and history painter.

38 LES ADIEUX (THE FAREWELL)

1866 (print)

Illustrated p.127

Photograph mounted on card, 8.9 x 12.4 (3½ x 5)

Musée Goupil photograph no.523. A departing son accepts a final drink from his father while his mother weeps. Van Gogh found farewells difficult and the subject matter of this print must have therefore had a particular personal significance. [I 51-2, 78, 160]

In December 1875 Van Gogh made this print the centre of a 'triptych', with two family photographs. He described this arrangement to his brother: 'Take the portraits of our father and mother and the *Farewell* by Brion, and read

UN BAPTÊME

Heine with those three before you'. [I 45] Van Gogh liked the German poet Heinrich Heine and copied out 'Meeresstille' (Calm Sea) in a book which he prepared for Theo in February 1875 (cat.103). [I 23] He also gave a print of *Farewell* to Anna (letter of 6 October 1875, omitted from English edition).
Witt Library, Courtauld Institute of Art

BROCHART, CONSTANT (1816-99)
French painter.

39 L'HEUREUX ANNIVERSAIRE (HAPPY BIRTHDAY)

1872 (print)
Illustrated p.28
Engraving, 30.2 x 23.5(11⅞ x 9¼)
Goupil burin engraving. On 19 November 1876 Van Gogh wrote: 'Here the ordinary engravings after Brochart do not sell at all, the good burin engravings sell pretty well'. [I 16]
Trustees of the British Museum, London

DE NITTIS, GUISEPPE (1846-84)
Italian-born painter, who specialised in city views. He settled in Paris in 1867 and showed at the first Impressionist exhibition in 1874. He visited London regularly from 1874.

40

40 FAIT-IL FROID! (HOW COLD IT IS!)

1874 (painting)
Illustrated p.128
Photograph mounted on card, 18.3 x 25 (7¼ x 9¾)
Goupil Galerie Photographique no.1350. The painting was exhibited at the Paris Salon in 1874. Van Gogh liked De Nittis and did a small sketch of his painting *Westminster* (fig.3)(Fxxiii).
Witt Library, Courtauld Institute of Art

DELAROCHE, PAUL (1797-1856)
French painter, who achieved great popularity with his historical scenes. His style was one of highly finished realism. Many of his melodramatic subjects were based on English history.

41 LE CHRIST AU JARDIN DES OLIVIERS (CHRIST IN THE GARDEN OF OLIVES)

Illustrated p.34
Photograph mounted on card, 20.8 x 14.7 (8¼ x 5¾)
Goupil photograph. Van Gogh pasted a similar reproduction of this print (with rounded top corners) in the autograph book of Annie Slade-Jones (reproduced in Pabst, p. 69). He also gave a copy of the print to Anna (I 60 and letter of 6 October 1875, omitted from English edition).

Christ in Gethsemane, or the Garden of Olives, was the only purely religious subject which Van Gogh himself ever painted. In 1888 he did two versions, but was dissatisfied at the result and destroyed them both. [II 601, III 46, 517]
Witt Library, Courtauld Institute of Art

42 MATER DOLOROSA

Illustrated p.34
Photograph mounted on card, 18.6 x 12.8 (7¼ x 5)
Goupil photograph. Van Gogh gave a copy of this print to Anna. When he visited her in Welwyn in June 1876 he told Theo that 'you would like her little room as much as I do, with... *Mater Dolorosa* by Delaroche framed in ivy' and several months later he recalled that 'the *Mater Dolorosa* by Delaroche hung over her bed'. [I 60, 84 and letter of 6 October 1875 omitted in the English edition]. In March 1877 he wrote to Theo: 'The photograph *Mater Dolorosa* which you sent me is hanging in my room. Do you remember, it was always hanging in Father's study at Zundert'. [I 98]
Witt Library, Courtauld Institute of Art

FEYEN, EUGENE (1815-1908)
French genre painter, pupil of Delaroche. His brother, François Feyen-Perrin, was a more successful painter.

43 LA LUNE DE MIEL (THE HONEYMOON)

1869 (painting)
Illustrated p.33
Photograph mounted on card, 17 x 24.8 (6¼ x 9¾)
Goupil Galerie Photographique no. 792. A young woman lost in thought, with her new bridegroom leaning against her. In October 1873 Van Gogh wrote that 'The Honeymoon is after Eugène Feyen, one of the few painters who pictures intimate modern life as it really is, and does not turn it into fashion plates'. [I 15] The subject may have had a personal appeal for Van Gogh, who was then falling in love with Eugenie.
Witt Library, Courtauld Institute of Art

FRERE, EDOUARD (1819-86)
French painter who studied under Delaroche and exhibited regularly in London at the RA. Frère's students included George Boughton.

44 LES YEUX DE LA GRAND-MÈRE (THE EYES OF THE GRANDMOTHER)

Illustrated p.129
Etching, 11.6 x 9.3 (4½ x 3¾)
Goupil Estampe no.230. A granddaughter

threading a needle. A letter of July 1875 informs us that Van Gogh had hung two of Frère's prints on his wall, *Seamstresses* and *A Cooper*. [I 29]

Van Gogh compared his situation to Frère's career in September 1883, saying that once he was established he would return to London. 'In England they are very serious once they start something: whoever catches the public's fancy in England finds faithful friends there. Take, for instance, Ed. Frère,' he explained. [II 129]
Witt Library, Courtauld Institute of Art

LES ILLUSIONS PERDUES

45

GLEYRE, CHARLES (1808-1874)
Swiss painter, known for his ancedotal scenes. He was a renowned teacher whose pupils included Whistler, Monet, Renoir and Sisley.

45 LES ILLUSIONS PERDUES (LOST ILLUSIONS)

1843 (painting)

Illustrated p.129

Photograph mounted on card, 19 x 33.9 (7½ x 13¼)

Goupil Galerie Photographique no. 492. In July 1875 Van Gogh wrote to Theo, mentioning that *Lost Illusions* was one of Uncle Cent's 'favourite pictures'. [I 30] Three months later Van Gogh took his friend Gladwell to the Luxembourg Museum, where they saw the original painting (now at Musée d'Orsay). [I 41]
Witt Library, Courtauld Institute of Art

44

GOUPIL, JULES (1839-1883)
French painter, known for his portraits. He was the son of Adolphe Goupil, founder of the gallery.

46 UN JEUNE CITOYEN DE L'AN V (A YOUNG CITIZEN IN THE YEAR FIVE)

1873 (painting)

Illustrated p.28

Photograph mounted on card, 14.3 x 11.8 (5¼ x 4¾)

Goupil photograph. The painting was exhibited at the Paris Salon in 1873. It was then shown at Goupil's first exhibition in London in May 1874. In October 1877 Van Gogh wrote: 'For a whole week I have been thinking of that picture and the etching after it, *A Young Citizen in the Year Five* by Jules Goupil. I saw the picture in Paris, indescribably beautiful and unforgettable'. [I 144] A month later he talked of sending a photograph of it for his father's birthday. [I 150] The print hung in his bedroom in Amsterdam. [I 153, also 145, 174, 184]
Bibliothèque Nationale, Paris

HEBERT, ANTOINE (1817-1908)
French painter who worked in a classical style. He specialised in portraits, historical subjects and genre scenes.

47 LA MAL'ARIA

1849 (painting)

Illustrated p.130

Photogravure, 13.2 x 19.7 (5¼ x 7¾)

A boat in marshland in Italy (the title means 'bad air', an expression used to describe marshy areas). Van Gogh saw the painting at the Luxembourg Museum in October 1875 (now at Musée Hébert, La Tronche). [I 41] It is among Hébert's most successful works.

In February 1875 Van Gogh said that Goupil's in The Hague would be sending 'the best things available', such as *La Mal'aria*. [I 23] Goupil's was presumably selling a replica (possibly the version now at the Musée Condé, Chantilly). In September 1880 Theo obtained a print of *La mal'aria*. [I 203]
Witt Library, Courtauld Institute of Art

INGRES, JEAN (1780-1867)
French history and portrait painter, who worked in a Realist style. Leading exponent of Neo-classicism.

48 VENUS ANADYOMENE

1848 (painting)

Illustrated p.31

Etching, 46 x 30.5 (18¼ x 12)

On 19 November 1873 Van Gogh wrote: 'From the *Venus Anadyomene* after Ingres we have

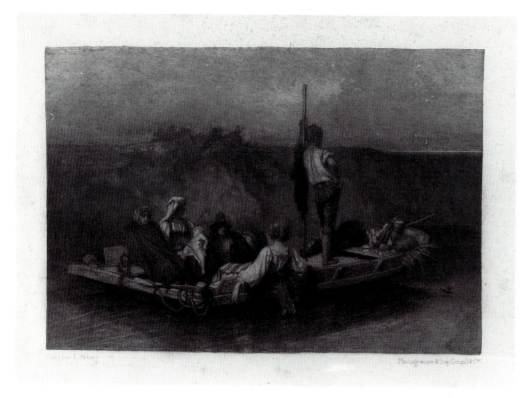

47

This is probably the painting exhibited at Goupil's first exhibition in London in May 1875. When describing the pictures for the show, Van Gogh named Maris among seven artists whose work he described as 'splendid'. [I 23] Jacob Maris, whose work Van Gogh admired, was the brother of his friend Matthijs. [I 21, 24, 27]

Goupil's stockbooks from the Hague show that a painting entitled *Pont-Levis* (Drawbridge) was sent to London on 3 April 1875. Goupil's in The Hague had bought it from Maris for 282 guilders and was offering it for sale at 500 guilders. The painting was subsequently sold to their London branch in May 1875 for £44. It was purchased, possibly from Goupil's, by Hamilton Bruce of Edinburgh and in 1903 was sold to Jean Drucker, who presented it to the National Gallery in 1910.

There are interesting comparisons between this work and Van Gogh's 1888 paintings of the Langlois drawbridge in Arles (such as F397/H1368).
The Trustees of the National Gallery

REMBRANDT, HARMENSZ VAN RIJN (1606-69)
Dutch painter, etcher and draughtsman who has always been regarded as among the great Old Masters.

50

already sold twenty épreuves d'artiste [artist's proofs]'. [I 16]
Trustees of the British Museum

ISRAELS, JOZEF (1824-1911)
Dutch painter, known for his sentimental scenes of peasants and fishermen. In 1870 he moved to The Hague, becoming a leading member of the Hague School.

49 DIALOGUE SILENCIEUX (SILENT DIALOGUE)

1882 (print)
Illustrated p.35
Photograph mounted on card, 23.4 x 15.3 (9¼ x 6)
Goupil photograph no.1679. Van Gogh greatly admired Israëls' work. [I 17, 23] This painting, exhibited at the 1882 Salon (and published by Goupil's after Van Gogh had left the gallery), depicts an old man with his faithful dog. It has some parallels with Van Gogh's own drawings of elderly men, sitting deep in thought.
Musée Goupil, Conservatoire de l'image Industrielle, Bordeaux

JACQUET, GUSTAVE (1846-1909)
French painter, who specialised in portraits and genre scenes. Pupil of Bouguereau.

50 JEUNE FILLE TENANT UNE ÉPÉE (YOUNG GIRL WITH A SWORD)

1872 (painting)
Illustrated p.130
Photograph mounted on card
Goupil photograph no. 1424. On 30 April 1874 Van Gogh wrote to Theo, just before his brother's birthday: 'A few days ago I sent you a photograph, *Young Girl with a Sword* by Jacquet, as I thought you would like to have it'. [I 20] An unpublished letter of early July 1874 from his sister Lies to Theo confirms that he also sent her a copy of the photograph.' [U 2708]
Bibliothèque Nationale, Paris

MARIS, JACOB (1837-99)
Dutch painter of the Hague School. He moved to Paris in 1865 and returned to The Hague in 1871. Known for his landscapes and town views.

51 THE DRAWBRIDGE

1875
Illustrated p.131
Oil on canvas, 30.5 x 22.9 (12 x 9)

JEUNE FILLE TENANT UNE ÉPÉE
(Salon de 1872)

51

52 DES PÉLERINS D'EMMAUS (PILGRIMS OF EMMAUS)

1646 (painting) 1875 (print)

Illustrated p.30

Etching, 52.5 x 42.2 (20¼ x 16½)

Goupil etching. This was one of Van Gogh's favourite works by Rembrandt. He saw the original at the Louvre in May 1875. [I 27]

On 2 September 1875 Van Gogh told Theo: 'The Rembrandt, *The Men of Emmaus*, which I wrote you about has been engraved; Messrs. Goupil & Co. will publish the engraving'. [I 33] Five days later he added that he has just received the Rembrandt: 'It looks fine, the figure of Jesus especially is beautiful, and the whole is noble'. [I 34] We know from a letter of 6 October 1875 that Van Gogh hung the Rembrandt on his wall in Paris (omitted from English edition).

In another letter of 28 March 1876, Van Gogh referred to the pilgrims in Rembrandt's work and compared their attitude to that of the French artist Georges Michel (1763-1843), writing that he thought they 'saw nature in the same way'. [I 49-50]

In February 1877, in Dortrecht, Van Gogh noted that he now had two English woodcuts of the *Pilgrims of Emmaus* on his wall. [I 93, 135] He also suggested in August that he might send the print to his mother as a present. [I 136, 138]

In November 1885 he said that Rembrandt put 'soul in a body', particularly in his *Pilgrims of Emmaus*. [II 441]

On 25 June 1889 he suggested giving a print of *Pilgrims of Emmaus* to the Revd. Frédéric Salles,

a Protestant pastor from Arles who had helped him after his mental attack. [III 186, also 547] A week later he talked about Rembrandt's 'tenderness of gaze' in *Pilgrims of Emmaus*. [III 187]
Musée Goupil, Conservatoire de l'image Industrielle, Bordeaux

SCHEFFER, ARY (1795-1858)

Dutch painter who worked in Paris. Known for his literary and religious subjects.

53 CHRIST CONSOLATEUR

1837 (painting)

Illustrated p.64

Photograph mounted on card, 20.1 x 22.6 (8 x 9)

Goupil Album de Photographies no.62. In July 1876 Theo sent Van Gogh an engraving of *Christ Consolateur*, which he hung in his room in Isleworth. [I 62] Van Gogh commented that 'the words that are written over *Christ Consolateur* – "He has come to proclaim liberty to the captives" – are true to this day'. [I 63] This quotation is from Isaiah 61:1.

Christ Consolateur was among Van Gogh's favourite prints [I 76, 93, 161, 543 and references in letters of 21 May 1877, 25 November 1877 and 9 January 1878, omitted from English edition]. He hung the print in his rooms in Dordrecht [I 92], Amsterdam [I 157] and The Hague [I 400]. Van Gogh particularly admired the figures in the background. [I 492]

Van Gogh saw Scheffer's original at the Dordrecht Museum in early 1877. Scheffer had also painted a replica in 1861, which was sold the following year through Goupil's in Paris.
Bibliothèque Nationale, Paris

54 CHRIST RÉMUNÉRATEUR

1848 (painting)

Illustrated p.64

Photograph mounted on card, 20.1 x 22.3 (8 x 9)

Goupil Album de Photographies no.63. Theo sent Van Gogh an engraving of *Christ Rémunérateur* in July 1876 (along with is pendant, *Christ Consolateur* (cat.53)). [I 62] Van Gogh hung reproductions of both in his room in Isleworth, Dordrecht [I 92] and Amsterdam [I 157]

Van Gogh saw the original painting at the Dordrecht Museum. Again Scheffer painted a replica in 1861, which was sold through Goupil's. See also letters of 21 May 1877, 25 November 1877 and 9 January 1878 (omitted in English edition).
Bibliothèque Nationale, Paris

55 L'ENFANT PRODIGUE (THE PRODIGAL CHILD)

1857 (painting)

Illustrated p.131

Photograph mounted on card, 58 x 42.3 (23 x 16½)

Goupil photograph no.427. Van Gogh hung this print in his room in Isleworth. [I 76] In September 1876 he asked Theo to send a reproduction to their mother for her birthday. [I 83] Four months later he saw a study for the painting in the Dordrecht Museum.

The original painting had been acquired by Sir Richard Wallace in 1872, and is now in the Wallace Collection, London. There is no evidence that Van Gogh saw the original, although he did see Scheffer's *Margaret at the Well* with Wallace's paintings shown at the Bethnal Green Museum. [I 22, 38]
The Trustees of the British Museum

56 LES SAINTES FEMMES AU TOMBEAU DU CHRIST (THE HOLY WOMEN AT THE TOMB OF CHRIST)

1845 (painting)

Illustrated p.30

Photograph mounted on card, 20 x 16.4 (8 x 6½)

Musée Goupil photograph no.129. Another image by Scheffer that Van Gogh hung in his bedroom at Isleworth in the autumn of 1876. [I 76] In October 1877 he wrote: 'How beautiful that engraving after Ary Scheffer, *The Holy*

55

L'ENFANT PRODIGUE

Women at the Tomb of Christ, is – I am so glad I have it. The old woman especially is splendid'. [I 144]

The original painting is in the collection of Manchester City Art Galleries.
Bibliothèque Nationale, Paris

TISSOT, JAMES (1863-1902)

French-born artist, whose early work concentrated on historical subjects. He later became celebrated for his fashionable contemporary scenes. Fleeing from the Paris Commune in 1871, he settled in London and stayed until 1882.

57 PROMENADE SUR LES REMPARTS (A WALK ON THE RAMPARTS)

1864 (painting)
Illustrated p.132
Photograph mounted on card, 32.2 x 26.7 (12⅔ x 10½)
Goupil Galerie Photographique no.429. The image is based on Johann Goethe's *Faust*. On 10 August 1874 Van Gogh compared this Tissot picture with a version by the Belgian artist Henri Leys (1815-69). [I 22]
Bibliêthoque Nationale, Paris

58 MÉLANCOLIE

c 1868 (painting)
Illustrated p.28
Photograph mounted on card, 12 x 8.9 (4¼ x 3½)
Musée Goupil no.1109. On 20 July 1873 Van Gogh wrote: 'Some good French painters live here, including Tissot, of whose work there are several photographs in our Galerie Photographique'. [I 10] Among other works published by Goupil's were *Les patineuses* (Skaters), *L'aveu* (The Confession), *La sortie du confessionnal* (Leaving Confession), *Une messe en musique* (A Mass with Music), *Tentative d'enlèvement* (The Attempted Abduction), *Marguerite au rempart* (Margaret on the Rampart), *Le goûter* (The Taste) and *Chinoiseries*.
Witt Library, Courtauld Institute of Art

PEINT PAR TISSOT 429 PHOTOGRAPHIE PAR GOUPIL & Cⁱᵉ

PROMENADE SUR LES REMPARTS

Galerie Photographique

Publié par GOUPIL & Cⁱᵉ Editeurs
PARIS.LONDRES.BERLIN.BRUXELLES.LAHAYE.NEW-YORK

57

Paintings at the Royal Academy

BOUGHTON, GEORGE (1833-1905)

59 GOD SPEED!

1874

Illustrated p.62

Oil on canvas, 122 x 184 (48 x 72½)

This was the most important painting Van Gogh saw in England. It was exhibited at the 1874 RA under the title *God Speed! Pilgrims Setting out for Canterbury; Time of Chaucer*. On the back of the canvas is a label with an inscription by Boughton which includes an extract from the 'Prologue' of Geoffrey Chaucer's *Canterbury Tales*: 'Ye go to Canterbury, God you speed!'

Although Van Gogh saw the painting at the 1874 RA, he did not mention it until his letter of 26 August 1876, when he wrote to Theo: 'Did I ever tell you about that picture by Boughton, *The Pilgrim's Progress*? It is toward evening. A sandy path leads over the hills to a mountain, on the top of which is the Holy City, lit by the red sun setting behind the grey evening clouds. On the road is a pilgrim who wants to go to the city; he is already tired and asked a woman in black, who is standing by the road and whose name is "Sorrowful yet always rejoicing".' Van Gogh then quoted Christina Rossetti, and added: 'The land-scape through which the road winds is so beautiful – brown heath, and occasional birches and pine trees and patches of yellow sand, and the mountain far in the distance, against the sun. Truly, it is not a picture but an inspiration.' [I 66]

This description is very similar to the one given in Van Gogh's sermon on 31 October 1876, when he neither named the artist nor title (see p.117). [I 90-1]

Van Gogh mentioned the work a final time in his letter to Theo of 25 November 1876: 'At Mr. Obach's I saw the picture, or rather sketch, by Boughton, *The Pilgrim's Progress*. If you ever have an opportunity to read Bunyan's *Pilgrim's Progress*, you will find it greatly worth while. For my part I am exceedingly fond of it.' [I 78] Since Goupil's handled Boughton, it would not have been surprising for Obach to have acquired a 'sketch', possibly a study. The existence of a study or other version is also suggested by another picture titled *Godspeed*, which was shown at the Leicester Galleries, London, in May-June 1905.

Identification of the RA painting *God Speed!* as the work which had inspired Van Gogh's sermon was first made in 1974 (*English Influences*, p.23). At this time the painting was lost and no reproductions had been found. Hope Werness later identified it as once having belonged to the Layton Collection (Milwaukee Art Center) and deaccessioned in 1960 (see Werness). It was subsequently established that *God Speed!* had been commissioned in 1874 by the Duke of Buckingham, who sold it at Christie's in 1889. Seven years later it was bought by the American collector Angus Smith, who donated it to the Layton Art Center (*Milwaukee Sentinel*, 25 April 1896).

In 1985 *God Speed!* was spotted by Ronald Pickvance in the Fine Art Society gallery in London and later purchased by the Van Gogh Museum (see Leistra).

Xander van Eck has subsequently argued that *God Speed!* is *not* the painting which inspired Van Gogh's sermon (*Burlington Magazine*, August 1990). Among 'the long list of differences' between Van Gogh's description and *God Speed!*, he cites the following: 'There are, for instance, four women in the foreground instead of just the one that Van Gogh mentions; there are two pilgrims instead of one; the city is not on a mountain; there are no clouds; the woman is not in black; the sun is not setting and the season is spring rather than autumn.'

Some of Van Eck's points are valid. There is no evidence of a setting sun in the painting and it is a spring, not an autumn scene. The main figure is not 'a woman in black' (an expression often used by Van Gogh for a mourning woman), but wears a white tunic. But some of his arguments are questionable. Although *God Speed!* depicts four women, only one is central to the action (as is one of the two pilgrims). The city may not be on a 'mountain', but it is nevertheless on a hill. The painting does indeed have clouds.

Since Van Gogh must have seen *God Speed!* at the 1874 RA, when Boughton was his favourite British artist, it would be curious if he later saw a very similar picture and then failed to link it to the RA version. Extensive checks have failed to reveal the existence of any Boughton paintings titled 'The Pilgrim's Progress' or other works portraying a scene similar to the one which Van Gogh describes.

Van Gogh's confusion over the painting may have been due to having just seen the 'sketch' at the home of Obach, two years after he had seen the original. Van Gogh also frequently made slight alterations to titles of pictures (e.g. Fildes, *Houseless and Hungry* (cat.84)). The painting's full title is cumbersome and the *ILN* dropped the main title in its review, simply calling it *Pilgrims Setting Out for Canterbury* (16 May 1874). This may help account for Van Gogh's 'retitling'.

Van Gogh's 'The Pilgrim's Progress' is therefore almost certainly the painting which Boughton called *God Speed!*, and the image which inspired his first sermon.
Rijksmuseum Vincent van Gogh, Amsterdam (inv. no. 1.342)

60 THE BEARERS OF THE BURDEN

1875 (painting)

Illustrated p.134

Engraving, 16.6 x 24 (6½ x 9½)

The original painting of this print was exhibited at the RA in 1875. It was also shown at the World's Fair in Paris in 1878, where Theo worked at the Goupil stand. Its present where-abouts are unknown.

Other paintings by Boughton which were exhibited at the RA in 1875 were *A Path of Roses* and *Grey Days* (the following year he showed *Master Graham Pettie* and *A Surrey Pastoral*).

Van Gogh gave the title *The Bearers of the Burden* to one of his own works, a particularly fine early drawing (cat.15).
Witt Library, Courtauld Institute of Art

60a THE HEIR

1873 (painting)

Illustrated p.38

13.5 x 23 (5¼ x 9)

The original painting was exhibited at the RA in 1874 and later sold by Goupil's branch in New York. It was acquired by the Corcoran Gallery and deaccessioned in 1948 (present location unknown). Van Gogh saw the painting at the RA and at Goupil's, where he sketched it. [III 345]
Witt Library, Courtauld Institute of Art

FAED, THOMAS (1826-1900)

Scottish artist, known for his cottage interiors, painted in a Social Realist style. Elected ARA in 1861 and RA in 1864.

61 A LOWLAND LASSIE

1873

Illustrated p.49

Oil on canvas, 100.3 x 73.7 (39½ x 29)

Exhibited at the RA 1873. In November 1882 Van Gogh wrote to Theo: 'It took a long time before I could admire Thomas Faed's work, but now I do not hesitate about it any more'. [I 482]
Kirkcaldy Museum and Art Gallery

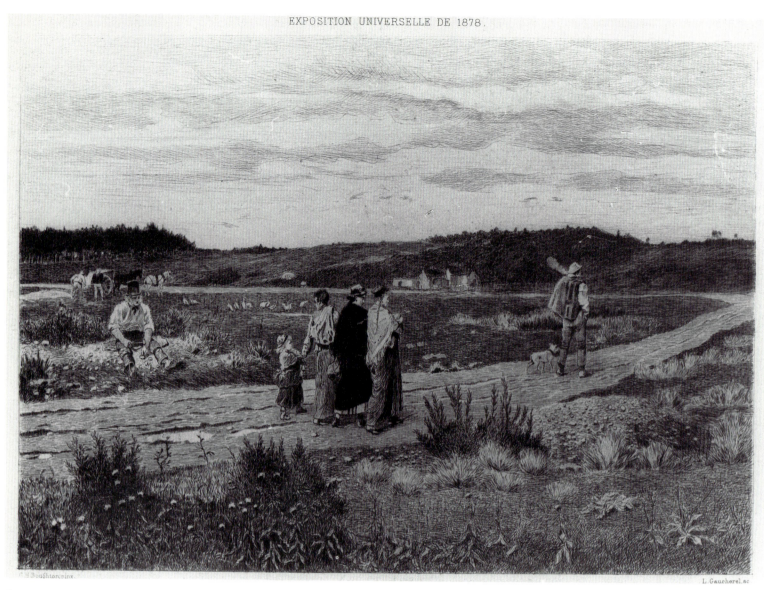

C.H.Boughton.pinx. L.Gaucherel.sc

60

62 FORGIVEN

1874

Illustrated p.50

Oil on canvas, 35.6 x 48.2(14 x 19)

The interior of a cottage, with a mother comforting her daughter after she has returned with a baby. The angry father is walking out the house, having earlier refused her permission to marry. Along with the painting Faed quoted a letter (possibly imaginary) from the mother: 'God be praised! Mary's come hame, she slipped in last Thursday. I nearly fainted... He treated her, she says, fair enough for a while while they were married, but the black scum floated at last... She has suffered for her disobedience poor lassie – but she's hame now.'

This is an oil study for the original painting which was exhibited at the RA in 1874 (auctioned in Stockholm in 1984 and present location unknown).
Guildhall Art Gallery, Corporation of London

FILDES, LUKE (1843-1927)

English illustrator and painter. He helped launch the *Graphic* in 1869. The following year he illustrated *Edwin Drood* for Dickens. After his Social Realist phase in the 1870s he became a successful portrait artist. Elected ARA in 1879 and RA in 1887. Knighted in 1906.

63 APPLICANTS FOR ADMISSION TO A CASUAL WARD

after 1908 (original 1874)

Illustrated pp.56-57

Oil on canvas, 57.1 x 94 (22¹/₂ x 37)

In 1874 Fildes did an oil painting of his most successful illustration in the *Graphic*, *Houseless and Hungry* (cat.84). The oil painting has more detail, including several additional figures and a wider viewpoint. When exhibited it was accompanied with an extract from a letter that Dickens had written after a visit to a Whitechapel workhouse: 'Dumb, wet, silent horrors! Sphinxes set up against that dead wall and none likely to be at the pains of solving them until the *general overthrow*.'

The painting caused considerable controversy when it was exhibited at the RA in 1874. A special protective railing had to be installed to hold back the crowds.

Van Gogh preferred the original *Graphic* version to the painting. In February 1883 he told Van Rappard that the painting lacked the 'feeling and character in the unpolished black and white'. [III 347]

This is a smaller replica of the original version, which is now in the collection of Royal Holloway and Bedford New College in Egham, Surrey (fig.17).
Tate Gallery, purchased 1970

64 BETTY

1875

Illustrated p.42

Oil on canvas, 31.6 x 22.1 (12½ x 8¾)

The artist's wife Fanny, portrayed as a milkmaid (it is unclear why it was titled *Betty*). The original version was exhibited at the RA 1875 (location unknown). This work is a contemporary replica, done for the artist's patron George Sala.

This happy image could hardly be more of a contrast to the Social Realist works which Fildes showed at the RA the year before and after at the RA, *Casual Ward* (cat.63) and *The Widower* (cat 65).

The Forbes Collection, London

65 THE WIDOWER

1902 (original 1876)

Illustrated p.48

Oil on canvas, 66.3 x 94.0 (26 x 37)

A farmworker is comforting a sick child. The distraught oldest daughter looks on while she does the housework, as the three young children play oblivious to the misfortune that has befallen the family. Fildes' figure of the father was inspired by the standing man cradling his daughter who modelled for *Casual Ward* (cat.63).

This is a replica of the original version exhibited at the RA 1876 (Art Gallery of New South Wales). Its style is reminiscent of the Dutch artists Israëls, whom Van Gogh greatly admired.

Walker Art Gallery, Liverpool

FOSTER, MYLES BIRKET (1825-99)

English painter and illustrator. He specialised in watercolours of rustic scenes, produced in a sweetly sentimental style.

66 THE BROOK

1874

Illustrated p.51

Oil on canvas, 77.5 x 63.5 (30½ x 25)

Exhibited at the RA 1874. In October 1882 Van Gogh referred to Foster, writing that he had always admired his landscapes 'even though they're considered old-fashioned'. [III 337]

Manchester City Art Galleries

HERKOMER, HUBERT (1849-1914)

Born in Germany, Herkomer's family emigrated to America in 1851 and came to England six years later, where he lived for the rest of his life. Herkomer was strongly influenced by Fred

Walker. After his early Social Realist works (which were reproduced in the *Graphic*) he became a successful portrait artist. Elected ARA in 1879 and RA in 1890. Knighted in 1907.

67 AFTER THE TOIL OF THE DAY

1873

Illustrated p.52

Oil on canvas, 117.5 x 202 (46¼ x 79½)

An evening scene in Bavaria, with villagers who have returned from work resting on benches outside. Herkomer made sketches for this work during a visit to Garmisch in summer 1872 and later completed the painting in London. Exhibited at the RA 1873. Herkomer's intention was that the picture should convey a sense of 'peace'.

Private collection

68 THE LAST MUSTER – SUNDAY AT THE ROYAL HOSPITAL, CHELSEA

1909 (painting 1874)

Illustrated p.135

Lithograph, 61 x 45.7 (24 x 18)

A lithograph of the painting originally exhibited at the RA in 1874 (Port Sunlight Art Gallery, Liverpool). It depicts a group of Chelsea Pensioners in the Royal Chapel, with an elderly man who has just died.

The 1874 painting was based on an earlier illustration for the *Graphic*, 18 February 1871, entitled *Sunday at Chelsea Hospital* (cat.89). The *Graphic* later reproduced a detail of the painting (15 May 1875). Van Gogh admired both these illustrations.

In February 1883 Van Gogh told Theo that the *Graphic* had almost rejected Herkomer's original drawing: 'This is the origin of a picture which has since gained the wonder and admiration of the best, in Paris as well as in London'. [I 533] The painting won a medal of honour when it was exhibited at the World's Fair in Paris in May 1878. Herkomer's painting prominently appears in the illustration *The Paris Exhibition – A Sketch in the English Art Court*, in the *Graphic*, 29 June 1878 (cat.98).

The Trustees of the Victoria and Albert Museum

69 AT DEATH'S DOOR

1876

Illustrated p.58

Oil on canvas, 121.9 x 187.9 (48 x 74)

Herkomer subtitled the painting: 'Peasants of the Bavarian Alps in prayer, awaiting the arrival of the priest who is to administer the last rites to a member of the family.' Exhibited at the RA 1876.

68

At Death's Door was reproduced in the *Graphic* soon after being shown at the RA. On *c* 27 February 1883 Van Gogh wrote that he was going to give a copy of the print to a friend, Herman van der Weele. [III 367]

Private collection

HOLL, FRANK (1845-88)

English illustrator and painter. Worked for *Graphic* in the 1870s. His moody and sentimental Social Realist work was much influenced by Israëls. Elected ARA in 1878 and RA in 1883.

70 LEAVING HOME

1873

Illustrated p.55

Oil on canvas, 71 x 106.5 (28 x 42)

A forlorn young woman sits outside a waiting room, prominently inscribed '3rd class', and counts her change. A soldier and his parents are on the bench. Holl's initial study was reproduced in the *Graphic* (cat.92). This painting, which is a reverse of the *Graphic* image, was exhibited at the RA in 1873.

Private collection

71 DESERTED

1874

Illustrated p.54

Oil on canvas, 5.2 x 76.2 (21¼ x 30)

Set at Bankside, on the south side of the Thames, a policeman is carrying an abandoned

infant while the poverty-stricken mother collapses by the riverside. This is an oil study for the final painting, which was exhibited at the RA 1874 (sold in 1919 and present location unknown). Holl also produced a version of this study for the *Graphic* (cat.93).

Holl later made some changes in the final painting, moving the mother to the other side of the policeman. The final painting was reproduced in the *Art Journal* (January 1876).

The RA painting, *Deserted*, should not be confused with two other works by Holl: the painting *Deserter* (also dating from 1874, Forbes Collection, London) or the *Graphic* illustration *London Sketches – The Deserter* (25 September 1875), which Van Gogh referred to in May 1882. [I 359]
Private collection

72 HER FIRSTBORN

1876
Illustrated p.59
Oil on canvas, 109.2 x 155.5 (43 x 61¼)
The funeral procession is led by four young girls, carrying a tiny coffin. Behind is the father, with his weeping wife, grandfather and son. The mother appears to be the same model Holl used in *Deserted* (cat.71).

The painting was exhibited at the RA 1876. It was shown in the same year as two other images of death, Fildes' *The Widower* (cat.65) and Herkomer's *At Death's Door* (cat.69). Two smaller replicas of *Her Firstborn* exist, both dated 1877 (Sheffield City Art Galleries and Forbes Collection, London).

This could be the painting by Holl which Van Gogh referred to in 1882 as *Bereaved*, describing it as 'beautiful'. [III 364]

The scene portrayed is believed to be the churchyard of Horsham, West Sussex.
Dundee City Art Gallery

ISRAELS, JOZEF (1824-1911)

73 EXPECTATION

1874
Illustrated p.60
Oil on canvas, 181.6 x 137.2 (71½ x 54)
A young woman, presumably pregnant, is making baby's clothes. Beside her is an empty cradle. The model was a Dutch fisherman's wife at Scheveningen. Exhibited at the RA 1874. *Expectation* was reproduced in the *ILN* (6 June 1874).

This work may have influenced some of Van

Gogh's watercolours of late 1881, such as *Scheveningen Woman Sewing* (F869/H83).

Goupil's handled Israëls and two of his paintings were in their first exhibition in London in May 1875 (*Boy Fishing* and *Shepherd*). Israëls was among the few foreign-based Dutch artists who exhibited regularly at the RA in the 1870s. Among other works he showed were *The Poor of the Village* (1873), *The Anxious Family* (1874), *Waiting for the Herring* (1875), and *Returning from the Field* (1876).
Metropolitan Museum of Art, New York

LEGROS, ALPHONSE (1837-1911)

French-born painter, etcher and sculptor. In 1863 he came to England, encouraged by Whistler, and was naturalised in 1881. In 1876 he was appointed Professor of Etching at the Slade School, University College, London.

74 LA BÉNÉDICTION DE LA MER (BLESSING THE SEA)

1872
Illustrated p.61
Oil on canvas, 101 x 222 (64 x 89)
Exhibited at the RA in 1873. The painting was severely damaged during the Second World War and has been extensively restored.

Van Gogh admired the work of Legros. In September 1880 he told Theo that he had seen a dozen of his etchings in England, which 'were very beautiful'. [I 203] He singled out the Legros portrait of Carlyle as being of particular merit. [II 67, 492]
Sheffield City Art Galleries

MILLAIS, JOHN EVERETT (1829-96)

Born in Southampton, of a Jersey family. In 1848 he founded the Pre-Raphaelite Brotherhood with Dante Rossetti and William Holman Hunt. During the 1850s his style changed to using a broader and more fluid technique. He also turned to more popular subjects, including landscapes and portraits. Elected ARA in 1853, RA in 1863 and RA President in 1896. Awarded a baronetcy in 1885.

75 CHILL OCTOBER

1870
Illustrated p.41
Oil on canvas, 140.1 x 186.7 (55½ x 73½)
Millais described the scene in a letter dated 18 May 1882: '*Chill October* was painted from a backwater of the Tay just below Kinfauns near

Perth. The scene, simple as it is, had impressed me for years before I painted it... I made no sketch of it, but painted every touch from Nature, on the canvas itself, under irritating trails of wind and rain.'

When this painting was exhibited at the RA in 1871 it was widely regarded the finest landscape by Millais.

Van Gogh probably saw the painting when it was auctioned by Christie's on 24 April 1875 (selling for £3,255). In July 1877 he told Theo about Millais, saying that 'not the least beautiful of his pictures is an autumn landscape, *Chill October*'. [I 129] In August 1884 he explained that 'I have always remembered some English pictures such as *Chill October* by Millais'. [II 300, also I 417, III 322]

Van Gogh once spoke of autumn weather using Millais's phrase. 'Don't you think the weather glorious these days – a real "Chill October"? [written in English],' he asked Van Rappard in October 1882. [III 366] *Chill October* has some similarities with Van Gogh's own landscape drawings of 1881, such as *A Marsh* (F846/H8).

The painting was on long-term loan to Perth Art Gallery and Museum until it was sold at Sotheby's on 19 June 1991.
Private collection

76 WINTER FUEL

1873
Illustrated p.40
Oil on canvas, 193.5 x 149.3 (76½ x 59)
The woodcutter's daughter is sitting on a cart, loaded with silver birch which has just been collected on a late autumn day. In the background is Birnam Hill, Perthshire, of Macbeth fame. Exhibited at the RA 1874. Millais accompanied the painting with a quotation from Shakespeare: 'Bare ruined choirs, where once the sweet birds sang' (*Sonnets*, 73).
Manchester City Art Galleries

77 THE NORTH-WEST PASSAGE

1874
Illustrated p.44
Oil on canvas, 176.5 x 222.2 (69½ x 87½)
A retired captain is listening to his daughter reading extracts from his log-book (the model for the captain was Edward Trelawny). Reminders of his sailing days are around him.

Exhibited at the RA 1874. Millais accompanied the painting with the Captain's thoughts about the search for the North-West Passage: 'It might be done, and England should do it.' Eight

years later Van Gogh recalled the painting, para-phrasing the quotation (in English) as 'It might be done and if so we should do it'. [I 498]
Tate Gallery, presented by Sir Henry Tate 1894

78 THE PICTURE OF HEALTH

1874

Illustrated p.45

Oil on canvas, 110 x 89 (43¹/₂ x 35)

A portrait of the artist's young daughter, Alice. Exhibited at the RA 1874, along with six other works. It could have been after seeing this exhi-bition that Van Gogh met Millais. In July 1877 he recalled: 'Once I met the painter Millais on the street in London, just after I had been lucky enough to see several of his pictures'. [I 129]
Jersey Museums Service

PRINSEP, VALENTINE (1836-1904)

Born in Calcutta, but lived in England. Painter of portraits and historical subjects. Elected ARA 1879 and RA 1894.

79 DEVONSHIRE HOUSE

1873 (painting)

Illustrated p.137

Engraving, 78.8 x 54.0 (31 x 21¹/₄)

An engraving of the painting exhibited at the RA 1873. After seeing the exhibition Van Gogh was critical of Prinsep's *The Gaderene Swine*, but he admitted that 'there was a very clever picture' by him. [I 14] Prinsep also exhibited *Lady Teazle*, but *Devonshire House* was the one admired by the critics (both works are unlocated).
The Trustees of the Victoria and Albert Museum

TISSOT, JAMES (1836-1902)

80 THE CAPTAIN'S DAUGHTER

1873

Illustrated p.47

oil on canvas, 72.4 x 104.8 (28¹/₂ x 41¹/₄)

A young woman looks out across the Thames, while her father and her suitor are deep in conversation. Exhibited at the RA 1873. On 20 July 1873 Van Gogh told Theo that he was 'very fond' of Tissot as an artist. [I 10, 11]
Southampton Art Gallery and Museums

79

81 THE BALL ON SHIPBOARD

1874

Illustrated p.x46

Oil on canvas, 84.1 x 129.5 (33 x 51)

The main figure of a seated woman on the left is Margaret Kennedy, the model who also appears in *The Captain's Daughter* (cat.80).

Exhibited at the RA 1874. Van Gogh singled out the three Tissots exhibited in 1874 for special praise. [I 20]
Tate Gallery, presented by the Trustees of the Chantrey Bequest 1937

The Black-and-White Illustrators

ANONYMOUS

82 LIFE IN RUSSIA: DROSKY OR SLEDGE DRIVERS IN A TEA HOUSE – A HINT FOR OUR CABMEN

1874

Illustrated p.83

Engraving, 14.9 x 22.5 (5¾ x 8¾)

Published in the *Graphic*, 14 February 1874. The illustration of the Russian tea house has two details which Van Gogh may have used in *The Potato Eaters*. The woman pouring coffee in *The Potato Eaters* is an echo of the man pouring tea in the print. The man at the back of *The Potato Eaters* is holding his cup in an unusual way, similar to the Russian silhouetted in the centre of the print.

This is Van Gogh's own mounted copy.

Rijksmuseum Vincent van Gogh (Vincent van Gogh Foundation), Amsterdam

DALZIEL, EDWARD (1849-88)

English illustrator. A member of the famous family of wood-engravers. Contributed to the *Graphic*. Illustrated works by Dickens (cat.126).

83 LONDON SKETCHES – SUNDAY AFTERNOON, 1PM: WAITING FOR THE PUBLIC HOUSE TO OPEN

1874

Illustrated p.79

Engraving, 22.5 x 29.8 (8¾ x 11¾)

Published in the *Graphic*, 10 January 1874. A crowd outside a pub, waiting for opening time on Sunday. As the *Graphic* explained: 'A good many of them are decent people enough, hard-working mothers of families, who have been busy tidying the children and preparing for the Sunday dinner, and who come, jug in hand... Intermingled with these are a less respectable class of customers, persons of both sexes, unaccustomed to frequent places of worship, on whose hands the Sunday morning hangs heavily, and who very possibly have imbibed more than is good for them on the Saturday night.'

A figure in the foreground may have inspired Van Gogh's *Woman Weeping* (cat.20).

This is Van Gogh's own mounted copy.

Rijksmuseum Vincent van Gogh (Vincent van Gogh Foundation), Amsterdam

FILDES, LUKE (1843-1927)

84 HOUSELESS AND HUNGRY

1869

Illustrated p.72

Engraving, 20 x 30 (8 x 12)

Published in the first issue of the *Graphic*, 4 December 1869, along with a pointed reference to the Houseless Poor Act: 'It is by virtue of that Act that the group before us will obtain food and shelter tonight... they present themselves at a police station and ask for a ticket for admission to the casual ward of a workhouse.'

This print was also published in the *Graphic Portfolio* (cat.88). When Van Gogh acquired the portfolio in January 1882 he told Theo: 'There are things... that are superb, for instance *Houseless and Homeless* [sic] by Fildes (poor people waiting in front of a free overnight shelter).' [I 302]

Van Gogh had problems with its title, calling it 'Houseless and Homeless' [I 302], 'Homeless and Hungry' [I 384, 477] and 'Home and the Homeless' [III 359]. He may have confused this title with Faed's *Home and the Homeless* (1856, replica reproduced in Mary McKerrow, *The Faeds*, 1982, p.97), which he referred to in November 1882. [I 482]

Fildes later painted the same image and exhibited it at the RA in 1874, *Applicants for Admission to a Casual Ward* (fig.17).

This is Van Gogh's own mounted copy.

Rijksmuseum Vincent van Gogh (Vincent van Gogh Foundation), Amsterdam

85 THE EMPTY CHAIR, GAD'S HILL – NINTH OF JUNE 1870

1870

Illustrated p.93

Engraving, 49.5 x 30.4 (19½ x 12)

Published in the *Graphic*, Christmas 1870. It depicts Dickens' chair in his study at Gad's Hill, near Rochester, Kent. Fildes drew the scene on 10 June 1870, the day after the novelist's death. He later exhibited a version of *The Empty Chair* at the RA in 1871.

On 26 July 1882 Van Gogh told Theo: 'I am also very anxious to show you the wood engravings. I have a splendid new one, a drawing by Fildes, *The Empty Chair of Dickens*, from the *Graphic* of 1870'. [I 424]

In late January 1883 Van Gogh told Van Rappard that 'I hope to be able to get Fildes' *Charles Dickens' Empty Chair* for you', but a month later he apologised and said he had been unable to buy it. [III 359, 367 and 375]

There are striking similarities between Dickens'

chair in this print and the armchair which Van Gogh depicted in *Gauguin's Chair* (F499/H1636) (fig.26). Gauguin's armchair also appears in Van Gogh's portraits of the *Arlesienne* (F488-9/H1624-5) and the *Berceuse* (F504-8/H1655, H1669-72). *The Dickens House Museum, London*

FITZGERALD, MICHAEL

English illustrator. Contributed to the *ILN*.

86 A PAWN-OFFICE AT MERTHYR-TYDFIL

1875

Illustrated p.76

Engraving, 16.1 x x 23.7 (6¼ x 9¼)

Published in the *ILN*, 20 February 1875. The crowd scene has parallels with Van Gogh's *The State Lottery Office* (fig.25) (F970/H222). These similarities are even more evident in Van Gogh's original sketch, enclosed with his letter of c 1 October 1882 (H223/I 464). Van Gogh referred to the Fitzgerald print in February 1883. [III 362]

This is Van Gogh's own mounted copy.

Rijksmuseum Vincent van Gogh (Vincent van Gogh Foundation), Amsterdam

GILBERT, ACHILLE (1828-99)

French painter and engraver. Specialised in portraits.

87 PORTRAIT OF COROT

1875

Illustrated p.139

Engraving, 24.2 x 19.8 (9½ x 7¾)

Published in the *ILN*, 27 February 1875, to mark the death of Corot (who had died on 22 February in Ville d'Avray). On 6 March 1875 Van Gogh told Theo that he was sending 'a portrait of Corot from the *London News* which hangs in my room'. [I 23] This copy, with several pinholes in each corner, could be the one which Van Gogh hung in his room in Kennington – a practice which annoyed his landlords. In Dordrecht, P. Rijken complained: 'I could not stand this Van Gogh covering the walls with those drawings and driving nails into the wallpaper'. [I 111] This copy of the print also has a small burn in the top left corner, possibly made by Van Gogh's pipe.

Corot was one of Van Gogh's favourite artists. In May 1875 Van Gogh wrote about seeing 'three very fine Corots' at the Paris Salon, including *Les Bûcheronnes* (Woodcutters). [I 27] The following month he sent Theo a print of Corot's *Soleil couchant* (Sunset), which could well have been the same work he called *Soir* (Evening) and hung

87

in his bedroom. [I 28, 29] In September 1875 Van Gogh sent Corot reproductions to his father and Theo. [I 33, 35, 38] In March 1876 he saw etchings after Corot at Durand-Ruel's gallery in Paris. [I 50]
Rijksmuseum Vincent van Gogh (Vincent van Gogh Foundation), Amsterdam

GREEN, CHARLES

English painter and illustrator. Worked for the *ILN* and the *Graphic*. Illustrated Dickens.

88 HOLIDAY FOLKS AT THE NATIONAL GALLERY

1874
Illustrated p.15
Engraving, 22.6 x 30.1 (9 x 11¾)

An illustration in the *Graphic*, which was later published in the *Graphic Portfolio* in 1877.

The caption explains: 'This picture of London life represents a scene which may be observed any Saturday afternoon, when, owing to unfavourable weather, indoor amusements are specially in favour. The two figures in the centre represent a couple of Greenwich pensioners, who are gazing at Turner's picture of the death of Nelson... The illustration is from a drawing by Mr Charles Green, made in 1874, and it may be noticed that chalk has been largely used by the artist, and that the effect of the broad marks has been well preserved by the engraver'.

Van Gogh acquired the *Graphic Portfolio* in January 1882. [I 302, 384, III 363-4, 376]
The Board of Trustees of the Victoria and Albert Museum

HERKOMER, HUBERT

89 SUNDAY AT CHELSEA HOSPITAL

1871
Illustrated p.74
Engraving, 29.3 x 22.3 (11½ x 8¾)

Published in the *Graphic*, 18 February 1871. The pensioner at the end of the bench has apparently just died, and his friend is checking his pulse. Herkomer painted this same scene, showing a slightly larger area of the Royal Chapel, which was exhibited at the RA in 1875 as *The Last Muster – Sunday at the Royal Hospital, Chelsea* (cat.68).

In January 1883 Van Gogh told Van Rappard about the *Graphic's* initial reaction to Herkomer's first drawing: 'When Herkomer showed it for the first time, *not one* of the members of the *Graphic* board thought the drawing good, with only one exception – the manager, who published the sketch immediately and ordered a more elaborate drawing. So you see, things may change in the world – for instance, later on the *Graphic* published a sheet representing the spectators looking at the ultimate painting of *The Last Muster*' (cat.98). [III 357] A few days later he told Theo that 'his first sketch of the *Last Muster at Chelsea Hospital* – a drawing which differs relatively little from the final composition [the painting], but has a certain rough aspect – was almost rejected'. [I 533, also III 347]

Herkomer also published a detail of this work, showing the two principal characters, in the *Graphic*, 15 May 1875. It was entitled *The Last Muster: Sunday at the Royal Hospital, Chelsea* (Reproduced in *English Influences*, p.33). Van Gogh acquired this double-size print, which he called 'the large Herkomer', in January 1882 and in January 1883 he said it was among 'the *most beautiful*' of the *Graphic's* illustrations. [I 302 and III 350] He later frequently referred to the print of *The Last Muster*. [I 533, II 26, 144, III 347, 350, 355, 357]

The influence of Herkomer can also be seen in Van Gogh's watercolour *Church Pew with Worshippers* of September 1882, which includes his orphan man model in the back row, second figure from left (F967/H225).

This is Van Gogh's own mounted copy.
Rijksmuseum Vincent van Gogh (Vincent van Gogh Foundation), Amsterdam

90 HEADS OF THE PEOPLE: THE AGRICULTURAL LABOURER – SUNDAY

1875
Illustrated p.78
Engraving, 29.8 x 22.5 (11¾ x 8¾)

Published in the *Graphic*, 9 October 1875. As the *Graphic* explained: 'No more worthy men are to be found in the world than some of our farm-labourers... If, however, such a patriarch as is here represented can read, we may be pretty sure that he spends some of his well-earned leisure over the well-worn pages of the family Bible.'

Herkomer's 'head of the people' from the Graphic helped inspire Van Gogh's own series of peasant heads (cat.25, 26, 27 and 29).

This is Van Gogh's own mounted copy.
Rijksmuseum Vincent van Gogh (Vincent van Gogh Foundation), Amsterdam

91 HEADS OF THE PEOPLE: THE COASTGUARDSMAN

1879
Illustrated p.78
Engraving, 30.1 x 22.5 (11¾ x 8¾)

Published in the *Graphic*, 20 September 1879. This illustration inspired Van Gogh's *Fisherman in Sou'wester* (cat.19). Of all the artists who drew 'Heads of the People' for the *Graphic*, Herkomer was the artist he appreciated most. [I 384] Van Gogh collected the 'Heads' in a separate portfolio, along with *The Agricultural Labourer – Sunday* (cat.90) and Herkomer's *The Brewer's Drayman* (*Graphic*, 20 November 1875).

This is Van Gogh's own mounted copy.
Rijksmuseum Vincent van Gogh (Vincent van Gogh Foundation), Amsterdam

HOLL, FRANK

92 AT A RAILWAY STATION – A STUDY

1872
Illustrated p.140
Engraving, 30 x 50.5 (11¾ x 20)

Published in the *Graphic*, 10 February 1872. The engraving is a study of third-class passengers for a *Leaving Home* (cat.70), which was exhibited at the RA in 1873. The *Graphic* explained: 'The persons represented are about to travel by the humblest of the three classes into which the social world of railways is divided... The young lady at the end of the bench on the left we may suppose to be a governess, whose purse, to all appearance, is lighter than her heart; while at the other end is a young soldier, who has been on furlough to his native village, and is now bidding good-bye to his father and mother.'

In 1882 Van Gogh sent Van Rappard a small reproduction of this work, later describing the larger *Graphic* engraving as 'infinitely more beautiful'. [III 357]

Van Gogh, who lived near the Rhine Railway Station in The Hague, also tackled the same theme. It is significant that he chose to draw the third-class passengers, rather than their wealthier counterparts.

In mid January 1882 Van Gogh wrote to Theo: 'I often make sketches in the soup kitchens or in the third-class waiting room, and such places'. [I 306] Among these works is *Waiting Room* (F909/H94) of January 1882. On 3 March he added: 'When I draw separate figures, it is always with a view to a composition of more figures, for instance, a third-class waiting room.' [I 317-8]

On 28 May 1882 he added: 'Rather interesting too are the public soup kitchens and under all circumstances the third-class waiting rooms.' [III 322] On c13 September Van Gogh told Van Rappard: 'I myself am working at trying to do things that interest me more and more – scenes in the street, the third-class waiting room.' [III 329] And on 28-30 December 1882 he again told Theo about drawing third-class waiting rooms [I 517, the English edition of letters incorrectly translates this as 'first-class' waiting rooms].

Three years later, on 10-11 October 1885, Van Gogh sent Theo a small picture painted in Amsterdam, 'in the waiting room of the station, when I was too early for the train'. [II 418] Anton Kerssemakers later recalled that his friend Van Gogh 'made an appointment to meet me... in the third-class waiting room of the Central Station at Amsterdam.' Kerssemakers added: 'When I

came into this waiting room I saw quite a crowd of people of all sorts, railway guards, workmen, travellers, and so on and so forth, gathered near the front windows of the waiting room, and there he was sitting, surrounded by the mob, in all tranquility, dressed in his shaggy ulster and his inevitable fur cap, industriously making a few little city views'. [II 446]
Private collection

93 LONDON SKETCHES – THE FOUNDLING

1873
Illustrated p.74
Engraving, 29.8 x 50.3 (11¾ x 19¾)
Published in the *Graphic*, 26 April 1873. This is an early study for *Deserted* (cat.71) exhibited at RA 1874.

On c20 January 1883 Van Gogh described Holl's *The Foundling* as 'superb!'. [III 355] This was presumably a reference to the version in the *Graphic*. A few days later he explained: 'It represents some policemen in their waterproof capes who have picked up a baby exposed among the beams and planks of the Thames Embankment. Some inquisitive people are looking on, and in the background one sees the grey silhouette of the town through the mist'. [III 356-7]

On 4 February 1883 Van Gogh wrote to Van Rappard, telling him about Sien: 'When a mother has been deserted, and is in dire distress, one should not avert one's eyes and go on – at

least that's what I think. This one [Sien] is a figure like some Holl or Fildes have drawn'. [III 351]
Private collection

MILLAIS, JOHN EVERETT (1829-96)

94 CHRISTMAS STORY-TELLING

1862
Illustrated p.141
Engraving, 23.8 x 34.3 (9½ x 13½)
Published in the *ILN*, 20 December 1862. On c2 July 1883 Van Gogh told Van Rappard that he had acquired this print, which he described as 'a beautiful sheet'. [III 392]

This is Van Gogh's own mounted copy.
Rijksmuseum Vincent van Gogh (Vincent van Gogh Foundation), Amsterdam

MURRAY, WILLIAM BAZETT

Scottish artist. Contributed to the *ILN*.

95 JUTE INDUSTRY: MAT WEAVING IN ENGLAND

1881
Illustrated p.76
Engraving, 22.7 x 29.8 (9 x 11¾)
This copy of the print, entitled *L'industrie du jute: Le tissage des nattes en Angleterre (The Jute Industry: Mat Weaving in England)* was published in *L'Univers Illustré*. It was also reproduced in the *ILN*, 28 May 1881.

The illustration depicts the weaving of matting, such as hemp or jute. There are parallels with Van Gogh's drawings and paintings of weavers in Nuenen (cats.22 and 23).

This is Van Gogh's own mounted copy.
Rijksmuseum Vincent van Gogh (Vincent van Gogh Foundation), Amsterdam

PINWELL, GEORGE (1842-75)

English genre painter and illustrator. Contributed to the *Graphic*.

96 THE SISTERS

1871
Illustrated p.141
Engraving 30 x 22.4 (11¾ x 8¾)
Published in the *Graphic*, 6 May 1871. Two women in a room, one hanging up her coat and the other smelling a flower on a table. Accompanying the illustration was a poem entitled 'The Sisters' by a 'J.A.H.'

92

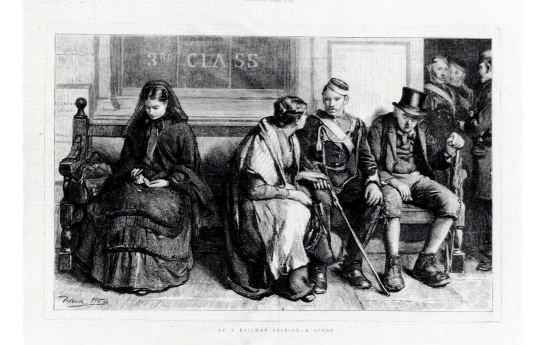

CHRISTMAS STORY-TELLING.—DRAWN BY J. E. MILLAIS.

94

THE SISTERS

96

In late January 1883 Van Gogh wrote to Theo about their personal relationships (he was living with Sien, while his brother had a mistress called Marie). Van Gogh explained: 'I was thinking of the two women now, and at the same time I thought of a drawing by Pinwell, *The Sisters*, in which I find that Dolorosa expression. That draw-ing represents two women in black, in a dark room: one has just come home and is hanging her coat on the rack. The other is smelling a primrose on the table while picking up some white sewing... [Pinwell] was such a poet that he saw the sublime in the most ordinary, common-place things. His work is rare – I saw very little of it, but that little was so beautiful that now, at least ten years later, I see as clearly as I did the first time'. [I 529]

Van Gogh also wrote to Van Rappard in late January 1883 saying that 'Pinwell draws two women in black in a dark room, a composition of the utmost simplicity, into which he has brought a serious sentiment that I can only compare with the full warble of the nightingale on a spring night'. [III 357]

This is Van Gogh's own mounted copy.
Rijksmuseum Vincent van Gogh (Vincent van Gogh Foundation), Amsterdam

RIDLEY, MATHEW (1836-88)
English illustrator. Contributed to the *Graphic*.

97 HEADS OF THE PEOPLE VI: THE MINER

1876
Illustrated p.78
Engraving, 29.3 x 22.5 (11½ x 9)
Published in the *Graphic*, 15 April 1876. The Van

Gogh Foundation has two copies of this print. One of the prints has pin holes in the corners and it is thought that it hung in Van Gogh's studio in The Hague.

On 1 November 1882 Van Gogh compared Ridley's *The Miner* to later illustrations in the *Graphic*, arguing that standards were falling. [III 341] His own portrait of the bookseller Blok has parallels with Ridley's head (F993/H254). Van Gogh wrote about his Blok portrait on 2-3 November 1882, just a day or two after his comment on Ridley. [I 478-9]

On c25-9 January 1883 Van Gogh again referred to *The Miner*, describing it as a 'serious and elaborate' work. [III 357] Van Gogh's period in the Belgian coal-mining district of the Borinage (December 1878-October 1880) is likely to have heightened his interest in this subject. Van Gogh also had in his collection a print of *Tip Girls*, by Samuel Waller, which was published in the *ILN*, 27 February 1875 [III 355] (reproduced in *English Influences*, p.67). On c15 May 1885 Van Gogh told Theo that 'if all goes well – if I earn a little more – so that I can travel more – then I hope to go and paint the miners' heads some-day'. [II 382]

This is Van Gogh's own mounted copy.
Rijksmuseum Vincent van Gogh (Vincent van Gogh Foundation), Amsterdam

ROBERTS, CHARLES
English illustrator. Contributed to the *Graphic*.

98 THE PARIS EXHIBITION – A SKETCH IN THE ENGLISH FINE ART COURT

1878
Illustrated p.39
Engraving, 30.1 x 22.5 (11¼ x 8¾)
Published in the *Graphic*, 29 June 1878. It shows a crowd admiring Herkomer's *The Last Muster* (fig.16, cat.68).

On c25-9 January 1883 Van Gogh wrote to Van Rappard, saying that after publishing Herkomer's *Sunday at Chelsea Hospital*, 'later on on the *Graphic* published a sheet representing the spectators looking at the ultimate painting of *The Last Muster*.' [III 357] On 3 February 1883 he wrote to Theo exclaiming that the painting of *The Last Muster* had 'gained the wonder and admiration of the best, in Paris, as well as London'. [I 533]

This is Van Gogh's own mounted copy.
Rijksmuseum Vincent van Gogh (Vincent van Gogh Foundation), Amsterdam

SMALL, WILLIAM (1843-1929)

Scottish illustrator. Contributed extensively to the *Graphic* in the early 1870s.

99 A Queue in Paris

1871

Illustrated p.76

Engraving, 22.4 x 29.6 (8¾ x 11¼)

Published in the *Graphic*, 11 March 1871. In January 1883 Van Gogh described *A Queue in Paris* as 'excellent.' [III 358] Again there are parallels with *The State Lottery Office* (fig.25). On c29 October 1882, soon after Van Gogh had completed *The State Lottery Office*, he had described Small as 'amazingly clever.' [III 337]

This is Van Gogh's own mounted copy.

Rijksmuseum Vincent van Gogh (Vincent van Gogh Foundation), Amsterdam

100 Heads of the People I: The British Rough

1875

Illustrated p.142

Engraving, 29.8 x 22.5 (11¾ x 8¾)

The first in the 'Heads of the People' series to be published in the *Graphic*, on 11 December 1875. Van Gogh wrote about the *Graphic*'s 'Heads of the People' on c11 December 1882, singling out Herkomer, Small and Ridley for special praise. [I 511]

101

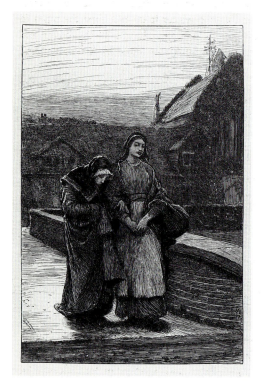

The pose of Small's *Rough* is similar to Van Gogh's sketches of a long-necked man which he drew in Nuenen in 1884-5 (H559, H634).

This is Van Gogh's own mounted copy.

Rijksmuseum Vincent van Gogh (Vincent van Gogh Foundation), Amsterdam

WALKER, FRED (1840-1875)

English painter and illustrator. Elected ARA 1871.

101 The Harbour of Refuge

1877

Illustrated p.142

Engraving, 25.4 x 17.3 (10 x 6¾)

Published in the *Graphic*, 7 April 1877, it depicts an old woman, walking with her daughter in the garden of an almshouse. The *Graphic* explained: 'The subject is commonplace enough, just two female figures, the one upright and stalwart, rejoicing in her youth, the other bent with the infirmities of years.' The print is a detail from Walker's painting of the same title exhibited at the RA 1872 (Tate Gallery).

In late January 1883 Van Gogh mentioned this print to Van Rappard [III 357] and on c9 February sent him a copy, explaining: 'I often spoke to you, amice, about Pinwell and Walker. Well, here is a genuine Walker, first rate. Have I praised it too highly?' [III 361] After hearing Van Rappard's response, Van Gogh wrote on c27 February 1883 to say that 'personally I cannot imagine anything more beautiful than *Harbour of Refuge*'. [III 366] On c5 March 1883 Van Gogh added: 'The English especially have found the *soul* of the wood engravings... for instance... *The Harbour of Refuge* by Walker.' [III 372]

Van Gogh liked the expression 'harbour of refuge'. Using the phrase in English, he told Theo on 2 April 1883 that 'my ideal is to work with more and more models, quite a herd of poor people to whom the studio would be a kind of harbour of refuge on winter days, or when they are out of work or in great need'. [II 21]

Van Gogh also told Theo about the Walker print. On 4-5 May 1885 he wrote: 'I just read an article in the *Graphic* on an exhibition of twenty-five drawings by Fred Walker. Walker died some ten years ago, you know. Pinwell too – while I'm on this subject, I'm thinking of their work too, and how very clever they were. How they did in England exactly what Maris, Israëls, Mauve, have done in Holland, namely restored nature over convention; sentiment and impression over academic platitudes and dullness. How they were the first tonists. But I remember peasants

in the field by Pinwell, *The Harbour of Refuge* by Walker, of which one might say, "peints, avec de la terre" [painted with the earth].' [II 376]

This is Van Gogh's own mounted copy.

Rijksmuseum Vincent van Gogh (Vincent van Gogh Foundation), Amsterdam

WIRGMAN, THEODORE (1848-1925)

Born of a Swedish family in Belgium. Studied in London at the RA Schools. Contributed to the *Graphic*.

102 Some 'Graphic' Artists

1881

Illustrated p.73

Engraving, 41.9 x 31.1 (16½ x 12¼)

Reproduced in the *Graphic*, Christmas 1882, although originally published in *Harper's Magazine*. It shows ten leading artists who worked for the *Graphic* (from left): Green, Herkomer, Sydney Hall, Edward Gregory, G. Durand, Holl (holding a copy of the *Graphic*), Henry Woods, Fildes, Small and Joseph Nash. On the wall behind the artists is the *Graphic*'s most famous illustration, Fildes' *Houseless and Hungry* (cat.84).

Van Gogh sent this illustration to Theo on c11 December 1882. In the accompanying letter he explained how the artistic standards of the once great *Graphic* were now falling: 'I enclose a copy of the *Graphic*, Christmas 1882. Read it carefully, it is worth while. What a colossal institution, isn't it, what an enormous circulation... Look at that group of great artists, and think of foggy London and the bustle in that small workshop... I am sorely oppressed by the way things are going and can no longer think of those magazines with pleasure and enthusiasm. The *Graphic* neglects to say that many in the group of artists [in this illustration] refuse to give their work, and withdraw more and more.' [I 508-9] This was reiterated by Van Gogh in a rather obscure annotation on the bottom of this illustration: 'retireen zich meer & meer als ik de jaargangen volg' (withdraw more and more, when going through the back numbers). Alongside this comment he has noted six of his favourite artists he believed had stopped working for the *Graphic*: Green, Herkomer, Holl, Fildes, Small and Nash.

This is Van Gogh's own copy.

Rijksmuseum Vincent van Gogh (Vincent van Gogh Foundation), Amsterdam

Memorabilia

103 VAN GOGH'S POETRY ALBUM PREPARED FOR THEO

February 1875

15.6 x 9.6 (6¼ x 3¾)

A notebook of 70 pages, filled with poetry and writings for Theo. It is reproduced in facsimile in Pabst, pp. 18-37).

In February 1875 Van Gogh told Theo: 'I have quite filled your little book, and I think it turned out well... I shall send you your little book at the first opportunity'. [I 23] On 6 March he added: 'Today we are sending a box [from Goupil's] in which I have enclosed the little book of poetry'. [I 23]

The notebook contains three pages of Carlyle, including extracts from *Past and Present*, *On Heroes, Hero-worship and the Heroic in History* and *Sartor Resartus*. In March 1883 Van Gogh re-read Carlyle's *Sartor Resartus*, saying that 'I find in him a love of humanity'. [III 374] In October 1883 Van Gogh described *On Heroes, Hero-worship and the Heroic in History* as 'a very beautiful little book. [II 170] Van Gogh also read *The French Revolution* and *Oliver Cromwell's Letters and Speeches*.

The notebook for Theo includes Longfellow's poem *Afternoon in February*, which Van Gogh had copied out in his letter of 10 August 1874 (omitted from English edition) [I 22], on the print by Van der Maaten, *Burial in the Cornfield* (cat.105) and the autograph book of Annie Slade-Jones (Pabst, p.63).

Theo himself copied out the first seven extracts in the notebook (by Jan Willems, Jules Breton and Jan van Beers). The remainder of the notebook includes extracts Van Gogh copied out from Jules Michelet, Charles Sainte-Beuve, Alfred de Musset, Ernest Renan, Emile Souvestre, Heinrich Heine, Ludwig Uhland and Johann Goethe.

The Van Gogh Foundation also has an earlier poetry album which Van Gogh prepared for Theo, probably dating from the early 1870s (Pabst, pp.6-17).

Rijksmuseum Vincent van Gogh (Vincent van Gogh Foundation), Amsterdam

104 'ECCE HOMO' CARD

1877

Illustrated p.6

Photograph on card 10.5 x 6.3 (4½ x 2½)

A small picture of Christ's head, entitled *Ecce Homo* and with the text 'met dichterlijk bijschrift van J.J.L. ten Kate (with poetical inscription by J.J.L. ten Kate). On the reverse it is noted (probably by Jo Bonger): 'bijschrift van Vincent van Gogh' (Inscribed by Vincent van Gogh). 'Ecce Homo' (Behold the Man) was Pontius Pilate's annoucement when he presented the scourged Christ to the crowd.

The inscription in ink surrounding Christ's head has been added by Van Gogh: 'NOTHING SHALL SEPARATE US FROM / THE LOVE OF CHRIST NOR / THINGS PRESENT NOR THINGS TO COME'. Van Gogh probably sent this card to Theo, most likely in 1877. The Van Gogh Foundation has another copy of this *Ecce Homo* card, to which Van Gogh has added a religious inscription in Dutch.

The source of the inscription appears to be a combination of Romans 8:35 and 39 (Verse 35 reads 'Who shall separate us from the love of Christ?' and Verse 39 reads 'Nor height, nor depth, nor any other creature, shall be able to separate us from the love of God, which is in Christ Jesus our Lord'). Van Gogh also quoted this text in his letters to Theo of 7-8 February 1877 and 7 September 1877. [I 94, 139]

Jan ten Kate was a Dutch theological writer whom Van Gogh admired [I 47, 134, 283 and references in letters of 18 August and 19 November 1877, omitted from English edition]. In Van Gogh's letter of 18 August 1877 he talked of hearing Ten Kate at a church in Bickerseiland, Amsterdam, where he preached on the text Romans 1: 15-7.

Rijksmuseum Vincent van Gogh, Amsterdam

105 JACOBUS VAN DER MAATEN'S, *Burial in the Cornfield*, WITH EXTENSIVE INSCRIPTIONS BY VAN GOGH

1863

Illustrated p.68

Lithograph, 22 x 34 (8¼ x 13½)

Van der Maaten (1820-79) was a Dutch landscape artist. Van Gogh mentioned in June 1875 that there was a print of *Burial in a Cornfield* in his father's study. [I 28] Van Gogh himself hung the print in his own room in Paris in July [I 29] and later in Amsterdam in May-June 1877 [I 115, I 125].

This copy of the print was given to Maurits Mendes da Costa, who taught Latin and Greek to Van Gogh in Amsterdam in 1877-8. Mendes da Costa later recalled that Van Gogh often brought him prints, 'but they were always completely spoiled: the white borders were literally covered with quotations from Thomas à Kempis and the Bible'. [I 171]

On the right side of the print Van Gogh copied out Longfellow's poem, 'Afternoon in February'. It is an apt choice as an accompanying text for its beginning reads:

> The day is ending
> The night is descending...
> While through the meadows
> Like fearful shadows
> Slowly passes
> A funeral train...

Van Gogh copied this same poem several times, including in the poetry book which he prepared for Theo in February 1875 (cat.103).

On the left side of the print Van Gogh wrote out a Dutch hymn. At the bottom of the print he added four extracts from the Gospel in Latin (John 12: 24-5; Mark 4: 26-9; John 5: 24,25, 28-9; and Luke 9: 24). On the reverse is a long extract from John 20: 1-17, as well as Mendes da Costa's stamp and a note confirming that it was presented to him by Van Gogh.

The subject matter of Van der Maaten's prints has obvious links with Van Gogh's own paintings of wheatfields, particularly those done in Auvers (May-July 1890). The presence of the church in the background is also reminiscent of many of his drawings, including those dating from 1873-76 (cat.3).

Amsterdam University Library (inv. no.M8 XIII C13a)

106 TURNHAM GREEN MINUTES BOOK

The minutes of the teachers' meeting of the Congregational Church at Turnham Green. The book was discovered in 1963, when the exceptionally cold winter froze and burst the pipes in the church. A cupboard had to be cleared out and the minute book was found by the Revd. Mary Wyatt (see Taylor).

On 19 November 1876 it is recorded in the minutes book that 'Mr Vincent van Gof be accepted as co-worker'. The same meeting also decided that 'we ought to have a service for the young, on some evening, so that the influence gained by the teachers on the scholars might be strengthened'. Van Gogh himself described the difficulties in a letter to Theo on 17-8 November: 'There are children enough, but the difficulty is to get them together regularly'. [I 75]

At the following meeting, on 4 December, it was 'proposed by Mr Sims seconded by Mr Vincent that we hold a children's service every Thursday evening, that the time for commencing be ½ past 6 to close at ½ past 7, & that the secretary prepare a plan & also to get gentlemen to come and address the children.' Another motion decided that 'it be optional with teachers whether they visit their own scholars or Mr Vincent visit

them.' Finally it was agreed that, 'Mr Vincent be supplied with all the names & addresses of the scholars in the school & that he go round to each class for particulars of those who require visiting.'

Van Gogh left England on *c*20 December 1876. On 5 February 1877 the Turnham Green meeting decided that 'Mr Vincent be written to & asked for his resignation, as he had left the country'. Presumably this decision followed Van Gogh's letter to the Revd. Slade-Jones on 14 January, explaining that he was not returning. [I 92]

These records back up Van Gogh's complaint that foreigners could never pronounce his name, and he therefore preferred to be called 'Vincent'. [II 447-8, 537]

Corporation of London, Greater London Record Office (ref: N/C/35/6)

107 COLLECTING CARD FOR TURNHAM GREEN CHURCH

1875
Illustrated p.66
Engraving on card, 7.6 x 11.4 (3 x 4½)

A collecting card for donations for the rebuilding of Turnham Green Congregational Church's lecture room, which had burned down on 12 May 1875. Half of the card shows a view of the exterior of the planned new church and the other half is an appeal for funds, written by Thomas Slade-Jones and dated 1 June 1875. The reverse of the card was intended to be used for noting contributions.

109

This illustration was probably used as a basis for Van Gogh's sketch of the church at the end of his letter to Theo dated 25 November 1876 (fig. xx)(I 7/Fxxviii). The Petersham church may also have been drawn from an illustration or photograph, because foliage shown in the drawing would be unusual in late November.

The Turnham Green 'tabernacle' shown on the card was opened in September 1875. It was replaced by a stone church in 1881, in Chiswick High Road, and the tabernacle served as a Sunday School until its demolition in 1909 (the stone church was demolished in 1974).
John H Taylor

108 BRITISH MUSEUM VISITORS' BOOK

The visitors' book for the Department of Prints and Drawings. The entry for 28 August 1874 lists 'Van Gogh' as the fourth visitor of the day.

A comment made by Van Gogh three years later suggests that this may have been the occasion when he saw a 'Rembrandt' drawing of Martha and Mary. On 18 September 1877 he wrote to Theo: 'Rembrandt... produced... that drawing in sepia, charcoal, ink, etc. which is in the British Museum, representing the house in Bethany'. [I 142] The drawing is no longer attributed to Rembrandt (see Pollock, *Vincent van Gogh, Rembrandt and the British Museum*).
The Trustees of the British Museum

109 SAMUEL PLOWMAN
Three Children on a Horse

Early 1874
Illustrated p.144
Pen on paper, 22.9 x 33 (9 x 13)

A drawing by the fiancée of Eugenie Loyer, Samuel Plowman (1852-*c*1904), who was an amateur artist and by profession an engineer. The picture is a copy of a painting by Briton Rivière, *Equo ne Credite Teucri* (Trojans, Trust not the Horse!), reproduced in the *ILN*, Christmas 1873. Plowman's drawing is dated '74' and signed 'SP'. It was given to Eugenie Loyer when they were courting.

One other surviving work by Plowman is known, a picture of two stags dated August 1874.
Molly Eugenie de la Chaumette Woods

110 LOYER FAMILY PHOTOGRAPHS

Two photographs of the Loyer family. The photograph of Ursula Loyer, Van Gogh's landlady in Brixton, probably dates from the early 1850s. The other photograph shows Eugenie, the daughter with whom Van Gogh fell in love. It probably dates from the early 1900s. Both are reproduced in *Young Vincent*, pp.26-7.
Mrs. Kathleen Maynard

110A GOLD LOCKET

Illustrated p.11
The locket of Eugenie Loyer containing photographs of herself and Samuel Plowman. They married on 20 April 1878 at St Mary's, Lambeth. This day was also the birthday of them both; Eugenie was twenty-two and Samuel, twenty-six.
Molly Eugenie de la Chaumette Woods

111 GLADWELL FAMILY PHOTOGRAPHS

The frame contains photographs of Harry (Henry William) Gladwell (1857-1927), his son Henry William who died at the age of two (1880-2) and his wife, Caroline Arney Gladwell (1857-1943). Harry and Caroline married on 31 May 1879 in Lewisham. On the back of the frame is an inscription by Harry's son Ernest Arney. He adds that on the reverse of Caroline's photograph is the dedication: 'With fond love to Harry, 26 September 1878'.

Van Gogh became close friends with Harry Gladwell in the autumn of 1875. They kept in contact until 1878.
Private Collection

112 THOMAS DIBDIN
The Gladwell Gallery

1882

Illustrated p.145

Watercolour and ink on paper, 78.1 x 55.2 (30¼ x 21¾)

In Paris in October 1875 Van Gogh became close friends with Harry Gladwell, the son of the London gallery owner. On 7 October 1876, Van Gogh visited the Gladwell Gallery in London which was then at 20-1 Gracechurch Street. [I 70]

Thomas Dibdin (1810-93) was an English artist who specialised in landscapes and architectural scenes. Dibdin appears to have taken liberties in drawing the neighbouring buildings in Gracechurch Street. Gladwell's, probably the longest-established art dealer in Britain, had been set up in the mid-eighteenth century. The business was sold by the family in 1964, but still operates under the same name from 69 Queen Victoria Street, EC4.

Guildhall Library, Corporation of London

113 GOUPIL'S GALLERY IN PARIS

c 1860

Illustrated p.29

Two prints, dating from c 1860, of the interior of Goupil's gallery in Paris at 9 rue Chaptal. One is signed Morin, and the other is by Félix Thorigny (1824-70).

Van Gogh worked at Goupil's in Paris in November-December 1874 and May 1875-March 1876. Theo was later transferred to Goupil's in Paris in 1880. He later became manager of their branch at 19 Boulevard Montmartre.

Bibliothèque Nationale, Paris

114 GOUPIL'S GALLERY IN PARIS

1859

Illustrated p.29

A print by Auguste Jourdain of Goupil's gallery at 9 rue Chaptal.

Bibliothèque Nationale, Paris

115 ILLUSTRATED JOURNALISM IN THE ILN, 30 AUGUST 1879

Illustrated p.73

A long series of articles on the history of illustrated journalism appeared in the *ILN* in 1879. These included this illustrated feature on the weekly magazine in their issue of 30 August. It depicts the *Publishing Office of the Illustrated London News*.

In February 1883 Van Gogh told Van Rappard that ten years previously, in London, he used 'to

112

go every week to the shop windows of the printing offices of the *Graphic* and the *Illustrated London News* to see the new issues'. [III 347] The *ILN* was at 198 Strand and the *Graphic* at 190 Strand. Both offices were therefore just a few minutes walk from Goupil's.

Private collection

Printed Books

116 CHARLES BARGUE, *Des Modeles de Dessin*

Published 1868

Bargue's *Cours de Dessin* (Drawing Course), which was published by Goupil's in 1868-70, consisted of 70 plates after plaster casts and 67 plates after master drawings. This book is the text which accompanies the large volumes of plates.

While in London Van Gogh hung *Anne of Britanny* (plate 39) and *Young Woman* (plate 53) in his room, and he wrote about these same images in December 1877. [I 153-4, 157] This raises the intriguing question of whether Van Gogh made copies after the Bargue exercises in London (none survive).

In September 1880 Van Gogh again saw Bargue's *Cours de Dessin* when Tersteeg, the manager of Goupil's in The Hague, lent him a copy. He then made two copies after master

drawings by Holbein: *The Daughter of Jacob Meyer* (plate 10) (F847) and *Figure of a Woman* (plate 27) (F848). He later copied *The Daughter of Jacob Meyer* a second time in July 1881 (F833/H13).

Van Gogh also borrowed from Tersteeg a copy of Bargue's *Exercises au Fussain* (Charcoal Exercises), a set of 60 plates published in 1871. Two of Van Gogh's copies survive: *Study of Sitting and Standing Nude* (plates 1 and 5) (not in De la Faille) and *Study of Sitting Nude* (plate 1) (F1609v), which date from August-September 1880.

Ten years later, in June 1890, Van Gogh wrote: 'I am terribly anxious to copy once more all the charcoal studies by Bargue, you know, the nude figures'. [III 278, also 275]

The Board of Trustees of the Victoria and Albert Museum

117 HARRY GLADWELL'S BIBLE (*The Book of Common Prayer* AND *The Holy Bible*)

Published by Eyre and Spottiswoode in 1849-50. These copies are both inscribed: 'To Harry Gladwell/June 8, 1875/A Token of Affection/ from Grand Mama'. They were therefore given to Van Gogh's friend, Harry Gladwell, just before he went to Paris, where he lived with Van Gogh.

Gladwell and Van Gogh probably read these volumes in their room in Montmartre. On 11 October 1875 Van Gogh wrote to Theo: 'Every evening we go home together and eat something in my room; the rest of the evening I read aloud, generally from the Bible. We intend to read it all the way through.' [I 41]

Private Collection

118 GEORGE BOUGHTON
Sketching Rambles in Holland

1885

Illustrated p.146

Van Gogh saw Boughton's illustration in issues of *Harper's Magazine* of January-April 1883.

On 3 June 1883 Van Gogh wrote to Theo: 'Boughton and Abbey together are making drawings called 'Picturesque Holland' for *Harper's* in New York (agent for the *Graphic* too). I saw those illustrations at Rappard's (very thoroughly done, small as though they are and undoubtedly made after larger drawings). Now I say to myself, if the *Graphic* and *Harper's* send their draughtsmen to Holland, perhaps they would not be unwilling to take a draftsman from Holland if he can produce some good work and not too expensively. I should prefer being put on regular monthly

wages to selling a drawing now and then at a relatively high price'. [II 44]

Van Gogh thought *In the Potato Field* the 'most beautiful of all' the Boughton illustrations and saw a parallel with his own work. 'I am working on the *Potato Diggers*; I also have a single figure of an old man and then a series of rough studies done during the potato harvest,' he told Van Rappard in July 1883. [III 392-3] Van Gogh's *Potato Grubbers, Five Persons* (F9/H385) seems to have been directly influenced by Boughton's illustration.

The Board of Trustees of the Victoria & Albert Museum

119 JOHN BUNYAN, *The Pilgrim's Progress*

Illustrated p.146

First published in 1678, Bunyan's *The Pilgrim's Progress* was particularly popular during the Victorian period. This edition was published by A. Fullarton in 1865. It was illustrated by the Scottish painter and illustrator, David Scott (1806-49) and etched by his brother William Scott (1811-90).

Among the illustrations is *Christian passes the Lions that guard the Palace Beautiful*. On 30 May 1877, Van Gogh told Theo about one of his favourite passages from *The Pilgrim's Progress*, where the 'traveller' sees a lion by the side of the road. Van Gogh explained: 'When he reaches the spot then he finds out that the lion is chained and is only there to test the courage of the travellers'(omitted from the English edition).

Christian passes the Lions that guard the Palace Beautiful.

119

In September 1877 Van Gogh's friend, Harry Gladwell, gave him a copy of an unidentified edition of the book when he visited him in Amsterdam. [I 140] On 30 October 1877 Van Gogh told Theo: 'I also have an abridged edition of Bunyan's *Pilgrim's Progress*. [I 149] His tutor in Amsterdam, Maurits Mendes da Costa, later

recalled Van Gogh telling him: 'John Bunyan's *Pilgrim's Progress* is of much more use to me, and Thomas à Kempis and a translation of the Bible; and I don't want anything more. I really do not know how many times he told me this'. [I 170] Van Gogh also referred to *The Pilgrim's Progress* in July 1880 [I 196] and August 1888 [III 3]. *The Board of Trustees of the Victoria & Albert Museum*

120 JOHN BUNYAN, *The Pilgrim's Progress*

Illustrated p.147

Published in 1874-5 by Cassell, Petter and Galpin. Illustrated by the English painter and lithographer, Henry Selous (1811-90) and M. Paulo Priolo.

The Board of Trustees of the Victoria & Albert Museum

121 CHARLES DICKENS, *Hard Times* and *Pictures from Italy*

Illustrated p.89

1866 edition, published by Chapman & Hall. Van Gogh read *Hard Times* in June 1879. [I 189, 190, also III 375]

This edition was illustrated by Arthur Boyd Houghton (1836-75). The frontispiece illustration shows Mr Gradgrind, with his head buried in his hands, after he learned that his son Thomas was a bank robber. It probably influenced Van Gogh's *At Eternity's Gate* (cat.18 and 33). *The Dickens House Museum, London*

122 CHARLES DICKENS, *Edwin Drood*

Illustrated p.92

1870 Household Edition, published by Chapman & Hall. This edition has 12 illustrations by Luke Fildes.

Van Gogh admired the Household Edition of Dickens's works when he was in England. [I 148] Nearly a decade later, in 1883, he decided to try to collect all of Dickens' works in this edition. [III 375, also 336, I 382, 450, 511]

Van Gogh read *Edwin Drood* in June 1882. [I 387,389] He was excited to discover how Fildes had been commissioned to illustrate *Edwin Drood* on the suggestion of Millais. [I 509]

Sleeping it Off (chapter xxiii) is the last illustration in *Edwin Drood*. John Jasper, collapsed on a bed, is being comforted after the death of Drood. Beside the four-poster bed is a chair on which there is a lighted candle. The chair and the candle probably influenced Van Gogh's painting of *Gauguin's Chair* (fig.26) (F499/H1636). *Jarndyce Booksellers, London*

118

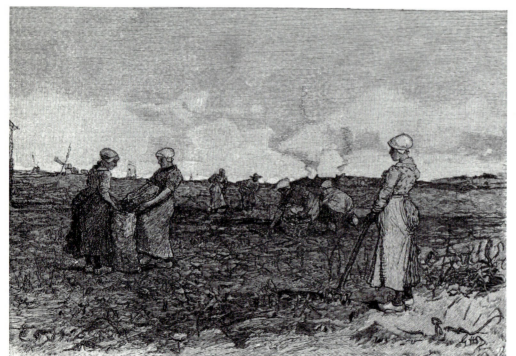

120

123 CHARLES DICKENS, *The Life and Adventures of Martin Chuzzlewit*

Illustrated p.88

1872 Household Edition, published by Chapman & Hall.

This edition of *Martin Chuzzlewit* has 59 illustrations by Fred Barnard (1846-96). Van Gogh read *Martin Chuzzlewit* in 1882 in The Hague.

[III 341] He particularly liked Barnard's illustrations. [I 382, 524, III 374]

Barnard's illustration *Brother and Sister* echoes Van Gogh's images of a man with his head in his hands, including *At Eternity's Gate* (cats.18 and 33). *The Dickens House Museum, London*

124 CHARLES DICKENS, *Little Dorrit*

Illustrated p.87

1873 Household Edition, published by Chapman & Hall. This edition has 58 illustrations by Irish-born James Mahoney (1810-79).

Van Gogh read *Little Dorrit* in The Hague in 1882. [I 504-5, 532, III 374, 383]. He particularly admired the illustrations by Mahoney. [I 450, III 336-7]
The Dickens House Museum, London

125 CHARLES DICKENS, *A Tale of Two Cities*

1874 Household edition, published by Chapman & Hall. Illustrated by James Mahoney.

Van Gogh referred to *A Tale of Two Cities* in 1877 [I 144], 1880 [I 196, 205] and 1883 [III 374, 385]. His particular knowledge of London and Paris may have given the book a special appeal.
The Dickens House Museum, London

126 CHARLES DICKENS, *Christmas Stories*

Illustrated p.89

1879 Household Edition, of *Christmas Stories from 'Household Words' and 'All the Year Round'*, published by Chapman & Hall.

Van Gogh re-read *Christmas Stories* in March 1889 in Arles. [III 146, 148, 451] He depicted a copy of *Christmas Stories* in his paintings of the *Arlésienne* of February 1890 (F540/H1892-5, also sketch H1896/III 471).

This edition has 23 illustrations by Edward Dalziel. Dalziel's illustration of a sailor echoes

Fig.37 Vincent van Gogh *Convict Prison*, February 1890. (Pushkin Museum, Moscow)

127

128

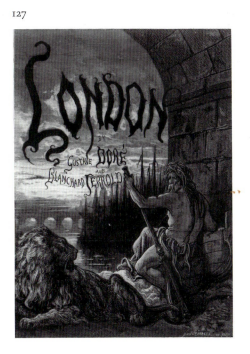

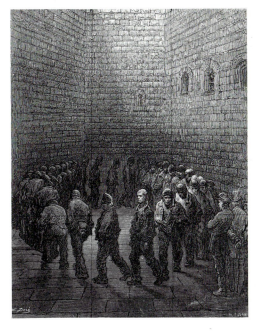

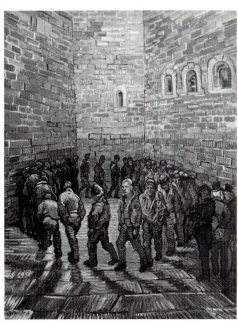

Van Gogh's drawings of fishermen, including *Fisherman in Sou'wester* (cat.19).
The Dickens House Museum, London

127 GUSTAVE DORÉ and BLANCHARD JERROLD, *London – A Pilgrimage*

Illustrated frontispiece, 14, 18, 19, 65, 147
1872 edition, published by Grant & Co. Illustrated by Doré with text by Jerrold.

Van Gogh greatly admired this book for its illustrations. He discovered the book in England and wrote of it several times in 1877. [I 92, 99, 138] He again mentioned Doré's *London* in January 1881 and tried to buy a copy in May 1882. [I 213, 381, 384, III 332, 333]
Guildhall Library, Corporation of London

128 *Newgate – Exercise Yard*

1872
Illustrated p.147
Engraving
This illustration from Doré's *London – A Pilgrimage* was reprinted in the Dutch periodical *De Katholieke Illustratie*. It portrays convicted prisoners taking exercise in Newgate.

This copy of the print was squared-up by Van Gogh for the painting *Convict Prison* (fig.37), in February 1890 (F669/H1885). Theo probably sent this copy of *Newgate – Exercise Yard* after Van Gogh had requested some prints on *c*12-5 January 1890. [III 248-9] On *c*10 February 1890 Van Gogh told Theo that 'I have tried to copy... *Convict Prison* by Doré; it is very difficult'. [III 254]
Rijksmuseum Vincent van Gogh (Vincent van Gogh Foundation), Amsterdam

129 EDMUND ROCHE, *Poésies Posthumes*

Illustrated p.148
1863 edition, published by Michael Levy.

The book includes the poem 'L'Étang', dedicated to Camille Corot (1796-1875) on p.99. The following page has an etching of a landscape of Ville d'Avray, entitled *L'Étang au Batelier* (The Pond and the Boatman).

Van Gogh copied the etching at the bottom of his letter to Theo of 18 April 1875 (Fxxi/I 25). He also wrote out the poem, saying that 'you will probably be curious to know the one that describes the etching by Corot'. [I 25]

On 8 August 1875 Van Gogh visited Ville d'Avray, then a village eight miles west of the centre of Paris, where he saw three Corot pictures in its church. [I 31, 168]
The British Library Board

129

130 CHARLES SPURGEON *The Metropolitan Tabernacle: Its History and Work*

Illustrated p.65
Published by Passmore & Alabaster, 1876.
Spurgeon (1834-92) was an English evangelist who had been brought up as a Congregationalist and became a Baptist in 1850. He was the author of dozens of religious tracts.

The frontispiece depicts the Metropolitan Tabernacle, which was built in 1861 to hold 6,000 worshippers. Rebuilt twice, it still stands at the Elephant & Castle roundabout.

Van Gogh was a great admirer of Spurgeon's evangelical work. He was also interested in two of Spurgeon's American followers, the evangelist Dwight Moody and hymn writer Ira Sankey. On 12 May 1876 Van Gogh said: 'I am sorry indeed that I did not hear Moody and Sankey when they were in London. There is such a longing for religion among the people in the large cities'. [I 57]
Guildhall Library, Corporation of London

131 CHARLES SPURGEON, *Spurgeon's Gems, being Brilliant Passages from the Discourses of the Rev. C. H. Spurgeon*

Published by Passmore & Alabaster, 1859.
Van Gogh called this book of extracts from Spurgeon's sermons, 'Little Gems'. He acquired the book in England and it was among his favourite reading matter whilst working in Dortrecht in 1877. [II 113, III 596]
The Evangelical Library, London

Bibliography

The bibliography concentrates on works relating to Van Gogh's period in England and the influences of English influences, although it also lists the main reference books on Van Gogh. It does not attempt to list works on individual English artists of the 1870s (for further details see Forbes, Hutchison, Maas, Treuherz and Wood). The place of publication is London unless indicated.

Alex Reid & Lefevre 1926-1976, (Lefevre Gallery, 1976).

Anon, 'Our History' (on Turnham Green Congregational Church) in *Chiswick High Road Illustrated Monthly Magazine*, February-April 1890.

Bailey, Martin, *Young Vincent: The Story of Van Gogh's Years in England*, (Allison & Busby, 1990).

Bailey, Martin, 'Van Gogh and the *ILN*', *ILN*, Royal Issue 1990, pp.80-5.

Bailey, Martin, *Van Gogh: Letters from Provence*, (Collins & Brown, 1990).

Bergeon, Annick, article on Goupil's in *Nouvelles de L'éstampe*, October-November 1991, pp.42-5.

Bionda, Richard and Blotkamp, Carel (eds), *The Age of Van Gogh: Dutch Painting 1880-1895*, (Zwolle: Waanders, 1990).

Brink, G. van den and Frijhof, W., *De wevers en Vincent van Gogh*, (Zwolle: Waanders, 1990).

Brown, Ruth, 'Happy Times Here in Ramsgate for Vincent van Gogh', (unpublished paper available at Ramsgate Reference Library, 1982).

Bruxner, David, 'Van Gogh's Sermon', *Country Life*, 11 November 1976, pp.1426-8.

Burns, Francis, *A Short History of Methodism in Richmond*, (privately published, 1968).

Cheetham, Charles, *The Role of Vincent van Gogh's Copies in the Development of his Art*, (New York: Garland, 1976).

De la Faille, Jacob, *The Works of Vincent van Gogh*, (Weidenfeld & Nicolson, 1970).

De Leeuw, Ronald; Sillevis, John and Dumas, Charles, *The Hague School: Dutch Masters of the 19th Century*, (Weidenfeld & Nicolson, 1983).

De verzameling Engelse prenten van Vincent van Gogh, (Rijksmuseum Vincent van Gogh, 1975).

Du Quesne-Van Gogh, Elizabeth, *Personal Recollections of Vincent van Gogh*, (Constable, 1913).

Eck, Xander van, 'Van Gogh and George Henry Boughton', *Burlington Magazine*, August 1990, pp.539-40.

Edwards, Cliff, *Van Gogh and God: A Creative Spiritual Quest*, (Chicago: Loyola University Press, 1989).

Ewals, Leo, *Ary Scheffer bewonderd door Vincent van Gogh*, (Dordrechts Museum, 1990).

Forbes, Christopher, *The Royal Academy Revisited 1837-1901*, (New York: Forbes Collection, 1975).

Free, R., *Victorian Social Conscience*, (Sydney: Art Gallery of New South Wales, 1976).

Fridlander, Ernest, *Matthew Maris*, (Warner, 1921).

Gelder, Jan van, 'The Beginnings of Vincent's Art' in *Catalogue of Vincent van Gogh*, (Rijksmuseum Kröller-Müller, 1959), pp.xv-xx.

Gelder, Jan van, 'Juvenilia', in *De la Faille*, pp.600-7.

Gogh, Vincent van, *Complete Letters of Vincent van Gogh*, (Thames & Hudson, 1958), three volumes.

Gogh, Vincent W. van, *Vincent van Gogh on England*, (Rijksmuseum Vincent van Gogh, 1968).

Gogh, Vincent van, *De Brieven van Vincent van Gogh*, (The Hague: SDU, 1991), four volumes.

Gould, Brian, *Two Van Gogh Contacts: E.J. van Wisselingh and Daniel Cottier*, (privately published, 1969).

Graves, Algernon, *The Royal Academy: Dictionary of Contributors 1769-1904*, (London, 1905-6), 8 volumes.

Groot, Reindert and De Vries, Sjoerd, *Vincent van Gogh in Amsterdam*, (Amsterdam: Stadsuitgeverij, 1990) (in Dutch).

Hammacher, Abraham, *Van Gogh: A Documentary Biography*, (Thames & Hudson, 1982).

Hartrick, Archibald, *A Painter's Pilgrimage through Fifty Years*, (Cambridge University Press, 1939), especially chapter IV 'Vincent van Gogh', pp.39-53.

Honeyman, Tom, 'Van Gogh: A Link with Glasgow' in *Scottish Arts Review*, no.2, 1948, pp.16-21.

Hulsker, Jan, *The Complete Van Gogh*, (Phaidon, 1980).

Hulsker, Jan, *Vincent and Theo van Gogh*, (Ann Arbor: Fuller Publications, 1990).

Hulsker, Jan, 'The elusive Van Gogh, and what his parents really thought of him', *Simiolus*, no.4, 1989, pp.243-63.

Hulsker, Jan, 'Van Gogh's Family and the Public Soup Kitchen', *Vincent* (journal), no.2 (1973), pp.12-15.

Hutchison, Sidney, *The History of the Royal Academy 1768-1986*, (Robert Royce, 1986).

Johnson, William Branch, *Welwyn, By and Large*, (privately published, 1967).

Kaldenbach, Kees and Didier, Michel, *Pilgrimage through Life: Travelling in the Footsteps of Vincent van Gogh 1853-90*, (Amsterdam: Cultuurtoerisme, 1990).

Kodera, Tsukasa, *Vincent van Gogh: Christianity versus Nature*, (Amsterdam: John Benjamins, 1990).

Lawrence, George, 'The Methodism of Vincent van Gogh', (unpublished paper available at Rijksmuseum Vincent van Gogh, 1979).

Leistra, Josefine, *George Henry Boughton: God Speed!* (Rijksmuseum Vincent van Gogh, 1987) (in Dutch).

Les sources d'inspiration de Vincent van Gogh, (Paris: Institute Néerlandais, 1972).

Lubin, Albert, *Stranger on the Earth: A Psychological Biography of Vincent van Gogh*, (New York: Henry Holt, 1972).

Maas, Jeremy, *Victorian Painters*, (Barrie & Jenkins, 1969)

Maas, Jeremy, *Gambert: Prince of the Victorian Art World*, (Barrie & Jenkins, 1975).

Mast, Michiel van der and Dumas, Charles, *Van Gogh en Den Haag*, (Zwolle: Waanders, 1990).

A Man of Influence; Alex Reid 1854-1928, (Scottish Arts Council, 1967).

Meyers, Jan, *De Jonge Vincent*, (Amsterdam: De Arbeiderspers, 1990).

Mills, R.S. (pseudonym), 'Vincent van Gogh at Petersham' in *Petersham: People and Stories*, (Petersham: Manor Press, 1985).

Pabst, Fieke, *Vincent van Gogh's Poetry Albums*, (Rijksmuseum Vincent van Gogh, 1988).

Pickvance, Ronald, *English Influences on Vincent van Gogh*, (Arts Council, 1974) (revised edition).

Pickvance, Ronald, *Van Gogh in Arles*, (New York: Metropolitan Museum of Art, 1984).

Pickvance, Ronald, *Van Gogh in Saint-Rémy and Auvers*, (New York: Metropolitan Museum of Art, 1986).

Pollock, Griselda, 'Vincent van Gogh, Rembrandt and the British Museum', *Burlington Magazine*, November 1974, pp.671-2.

Pollock, Griselda, *Vincent van Gogh in zijn Hollandse jaren*, (Rijksmuseum Vincent van Gogh, 1980).

Pollock, Griselda, 'Van Gogh and the Poor Slaves: Images of Rural Labour as Modern Art', *Art History*, September 1988, pp.406-32.

Pollock, Griselda, 'Stark Encounters: Modern Life and Urban Work in Van Gogh's Drawings of The Hague 1881-83', *Art History*, September 1883, pp.330-58.

Pring, K.L., 'In Search of Vincent van Gogh' (on the possible link with Vineyard Congregational Church, Richmond), (unpublished paper, 1981, at the Tate Gallery Archive).

Rewald, John, 'Theo van Gogh as an Art Dealer' in *Studies in Post-Impressionism*, (Thames & Hudson, 1986), pp.7-103.

Rozemeyer, J., *Van Gogh in Etten*, (Etten: Stichting Vincent van Gogh, 1990) (in Dutch).

Stein, Susan (Ed), *Van Gogh: A Retrospective*, (Macmillan, 1987).

Sund, Judy, 'Favoured Fictions: Women and Books in the Art of Van Gogh', *Art History*, June 1988, pp.255-67.

Szymanska, Anna, *Unbekannte Jugendzeichnungen Vincent van Goghs*, (Berlin: Henschel, 1968).

Taylor, John, 'Van Gogh in England' in *Burlington Magazine*, September 1964, pp.419-20.

Tilburg, Louis van, 'Vincent van Gogh and English Social Realism' in *Hard Times* (edited by Julian Treuherz), (Lund Humphries, 1987), pp.119-25.

Tralbaut, Marc, *Vincent van Gogh*, (Chartwell Books, 1969).

Treuherz, Julian, *Hard Times: Social Realism in Victorian Art*, (Lund Humphries, 1987).

Uitert, Evert van and Hoyle, Michael (eds), *The Rijksmuseum Vincent van Gogh*, (Rijksmuseum Vincent van Gogh, 1987).

Van den Eerenbeemt, H. 'The Unknown Vincent van Gogh 1866-68', *Vincent* (journal), vol.2, no.1 (1972), pp.2-12 and no.2 (1973), pp.2-10.

Van Gogh à Paris, (Paris: Musée d'Orsay, 1988).

Van Gogh in Brabant, (Zwolle: Waanders, 1987).

Van Gogh's Life in his Drawings, (Marlborough Fine Art, 1962).

Verkade-Bruining, A., 'Vincent's Plans to become a Clergyman', in *Vincent* (journal), vol.3, no.4 (1974), pp.14-23 and vol.4 no.1 (1975), pp.9-13.

Vincent van Gogh: A Detailed Catalogue, (Rijksmuseum Kröller-Müller, 1980).

Vincent van Gogh: Catalogue of 278 Works, (Rijksmuseum Kröller-Müller, 1983).

Vincent van Gogh 1853-1890: An Exhibition of Paintings and Drawings, (Arts Council, 1948).

Vincent van Gogh: Paintings & Drawings, (Arts Council, 1955).

Vincent van Gogh: Paintings and Drawings, (Arts Council, 1968).

Vincent van Gogh from Dutch Collections: Religion – Humanity – Nature (Osaka: National Museum of Art, 1986)

Vincent van Gogh, (Tokyo: National Museum of Western Art, 1985).

Vincent van Gogh: The Influences of Nineteenth Century Illustrations, (Tallahassee: Florida State University, 1980).

Vincent van Gogh (*Paintings* and *Drawings* volumes of centenary exhibition in the Netherlands), (Thames & Hudson, 1990).

Walther, Ingo and Metzger, Rainer, *Vincent van Gogh: The Complete Paintings*, (Cologne: Taschen, 1990), 2 volumes.

Werness, Hope, 'Vincent van Gogh and a Lost Painting by G.H. Boughton' in *Gazette des Beaux-Arts*, 1985, pp.71-5.

Wilkie, Kenneth, *The Van Gogh Assignment*, (Souvenir, revised ed., 1990).

Wolk, Johannes van der, *The Seven Sketchbooks of Vincent van Gogh*, (Thames & Hudson, 1987).

Wood, Christopher, *Victorian Panorama*, (Faber, 1976).

Wylie, Anne, 'Vincent's Childhood and Adolescence', *Vincent* (journal), vol.4, no.2 (1975), pp.4-17.

Zemel, Carol, 'Sorrowing Women, Rescuing Men: Van Gogh's Images of Women and Family', *Art History*, September 1987, pp.351-68.

List of Lenders

Barbican Art Gallery gratefully acknowledges the support of all the lenders underlisted and those who chose to remain anonymous.

BRITAIN
The British Library Board
The Trustees of the British Museum
Nathalie Crompton-Roberts
The Dickens House Museum, London
Dundee Art Galleries and Museums
National Gallery of Scotland, Edinburgh
The Evangelical Library, London
Greater London Record Office, Corporation of London
Guildhall Art Gallery, Corporation of London
Guildhall Library, Corporation of London
Jersey Museums Service
Kirkcaldy Museum and Art Gallery
Stephanie Knapp
Walker Art Gallery, Liverpool
Manchester City Art Galleries
Mrs Kathleen Maynard
The Trustees of the National Gallery
Sheffield City Art Galleries
Southampton City Art Gallery
The Trustees of the Tate Gallery
John H. Taylor
The Board of Trustees of the Victoria and Albert Museum
Witt Library, Courtauld Institute of Art
Molly Eugenie de la Chaumette Woods

OTHER EUROPEAN COUNTRIES
Rijksmuseum Vincent van Gogh, Amsterdam
Rijksmuseum Vincent van Gogh (Vincent van Gogh Foundation), Amsterdam
Universiteitsbibliotheek, Amsterdam
Musée Goupil, Conservatoire de l'Image Industrielle, Bordeaux
Musées Royaux des Beaux-Arts de Belgique, Brussels
Rijksbureau voor Kunsthistorische Documentatie, The Hague
Teylers Museum, Haarlem, Netherlands
Rijksmuseum Kröller-Müller, Otterlo, Netherlands
Bibliothèque Nationale, Paris
Museum Boymans-van Beuningen, Rotterdam

UNITED STATES OF AMERICA
The FORBES Magazine Collection, New York
The Metropolitan Museum of Art, New York

Acknowledgements

Barbican Art Gallery gratefully acknowledges the support of the Vincent van Gogh Foundation for allowing us to publish Van Gogh's sermon of 1876 and for giving permission for Van Gogh's paintings and drawings to be reproduced in this catalogue. Similarly we wish to thank all the lending galleries who have made available, and allowed the reproduction of their transparencies. We also gratefully acknowledge the support of Thames & Hudson who have allowed us to publish excerpts from Van Gogh's letters.

We would like to thank the underlisted photographers for their contribution to the successful fruition of this catalogue.

Prudence Cuming Associates
Derek Greaves, Sheffield
Graham Matthews, Swansea
Yoke Matze, London
Godfrey New Photographics

Further thanks are due to the Bridgeman Art Library, Garwood & Voigt, Jarndyce Booksellers, Postaprint, and Ramsgate Library for their valuable assistance.

Artist Index

References in *italics* indicate page number of illustrated work.